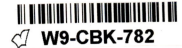
How to Draw
Animals
In Simple Steps

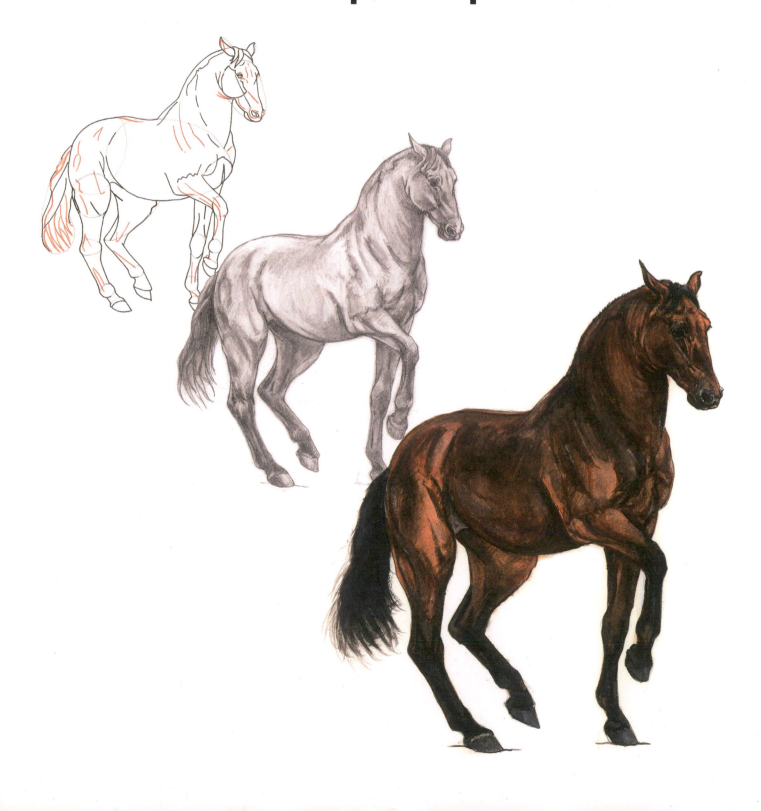

First published in Great Britain 2011 by

Search Press Limited
Wellwood, North Farm Road,
Tunbridge Wells, Kent TN2 3DR

Reprinted 2011, 2012 (twice), 2013, 2014, 2015 (twice), 2016

How to Draw Animals is a compendium volume of illustrations
taken from the How to Draw series: How to Draw Cats;
How to Draw Dogs; How to Draw Horses;
How to Draw Wild Animals; How to Draw Birds.

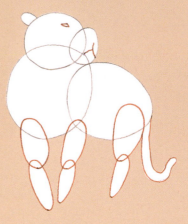

ISBN: 978-1-84448-664-9

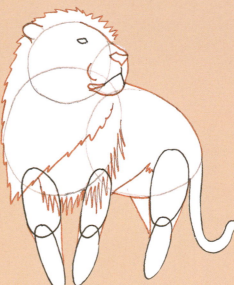

Printed in China

How to Draw
Animals
In Simple Steps

Polly Pinder, Susie Hodge
Eva Dutton, Jonathan Newey

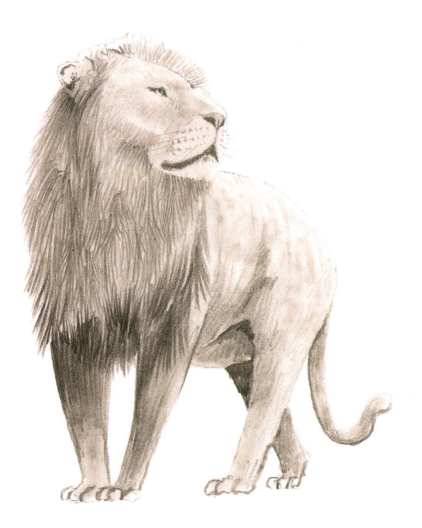

Search Press

Contents

Introduction

Cats

Dogs

Horses

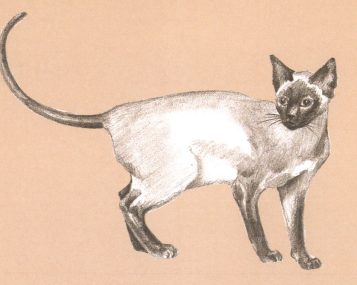

Introduction

Animals are a pleasure to draw, whether they are beautiful cats, cute or scruffy dogs, handsome horses or wild animals. The following pages also include a wonderful selection of birds, chosen for the diversity of their plumage and their fascinating characteristics.

We hope that the drawings will inspire you and act as a starting point to help you develop an understanding of the subjects and an ability to capture their characters. The method of illustration is simple: basic geometric shapes evolve, stage by stage, into the finished forms and in order to make the sequences easier to follow, we use different coloured pencils for each of the stages. The colours act as a guide, with new shapes built on to old shapes, and distinguishing features are added as the images develop. The penultimate stages show tonal representations of the animals and birds, and the final stage is a full colour image of the finished drawing.

When you are following the steps, use an HB, B or 2B pencil. Draw lightly, so that any intial, unwanted lines can be erased easily. Your final work could be a detailed pencil drawing, or the pencil lines can be drawn over using a ballpoint, felt-tip or technical pen. At this point, gently erase the original pencil lines.

When you feel more confident about your drawing, you may want to introduce colour. Throughout the book we have chosen our preferred medium, but you might prefer to use watercolours, coloured pencils, acrylics or pastels to create good effects.

I hope you will draw all the animals and birds in this book and then go on to draw more, perhaps from your own photographs, using the simple construction method we have shown. You can make the process easier if you use tracing paper to transfer shapes and lines to your drawing. Once you become familiar with the general anatomy of these animals, you will grow in confidence and soon develop your own style.

Happy drawing!

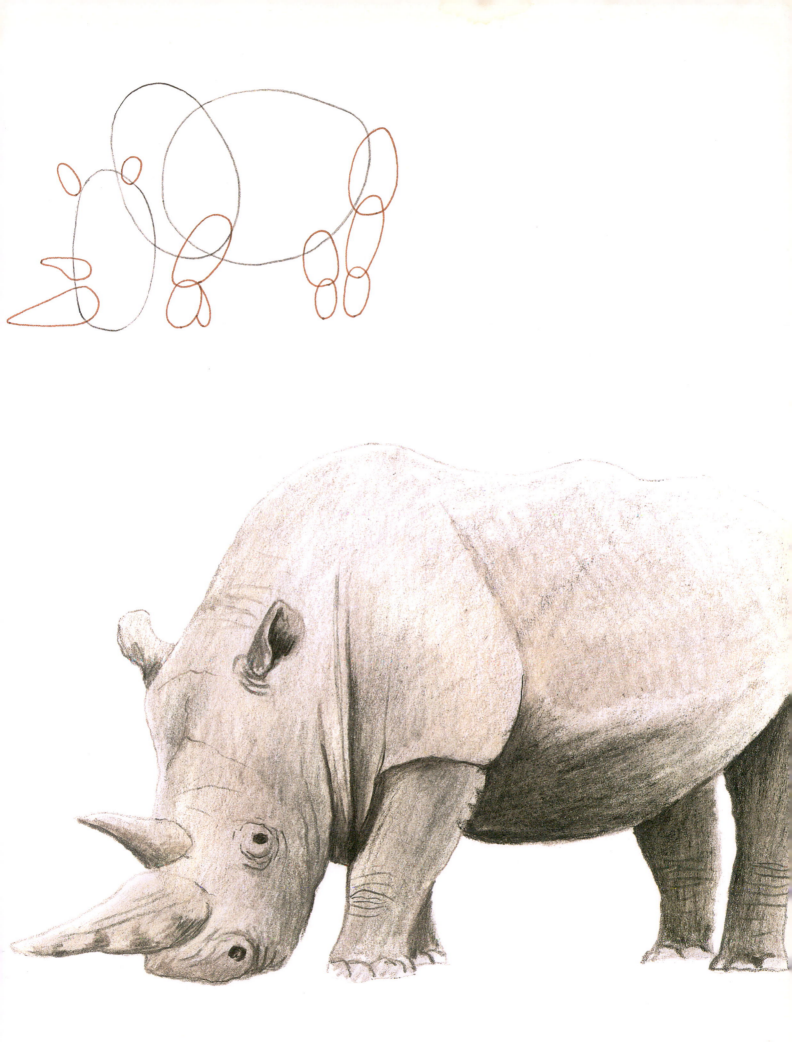

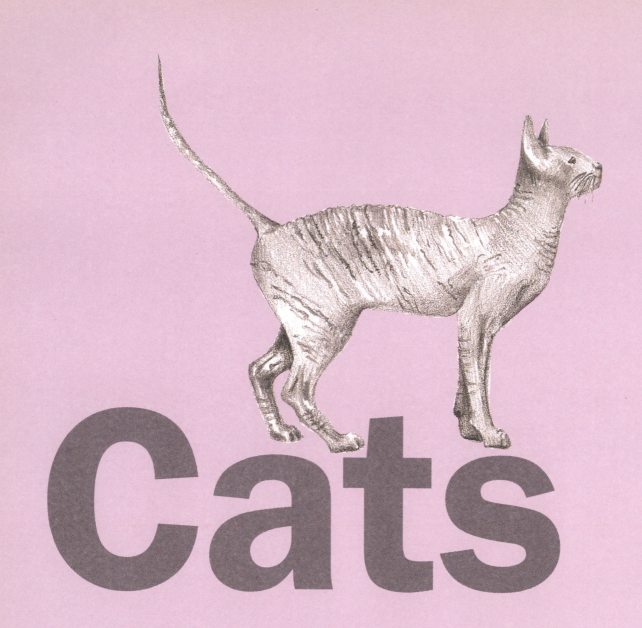

Cats

There is no denying that cats are beautiful animals to observe and draw, whether your chosen subject is a sweet, naughty kitten with large, beguiling eyes or a striking, sophisticated Siamese. Here, a variety of breeds are included, with basic shapes evolving, stage by stage, into the unmistakable form of specific cats. As you grow in confidence, you may want to take photographs of your own pet and draw it using this method. Once you become familiar with the general anatomy of cats, you will soon begin to develop your own style of drawing.

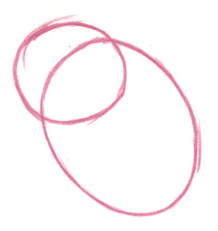
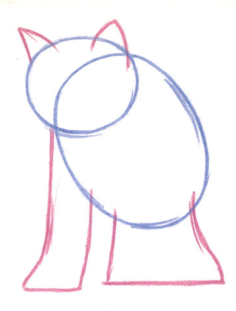
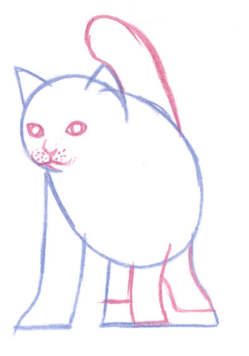
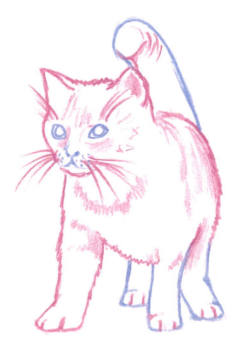
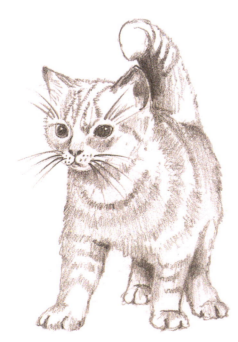
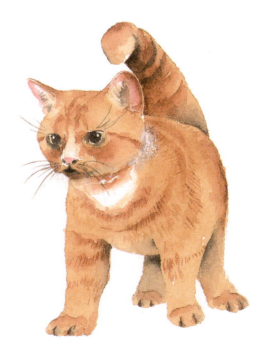

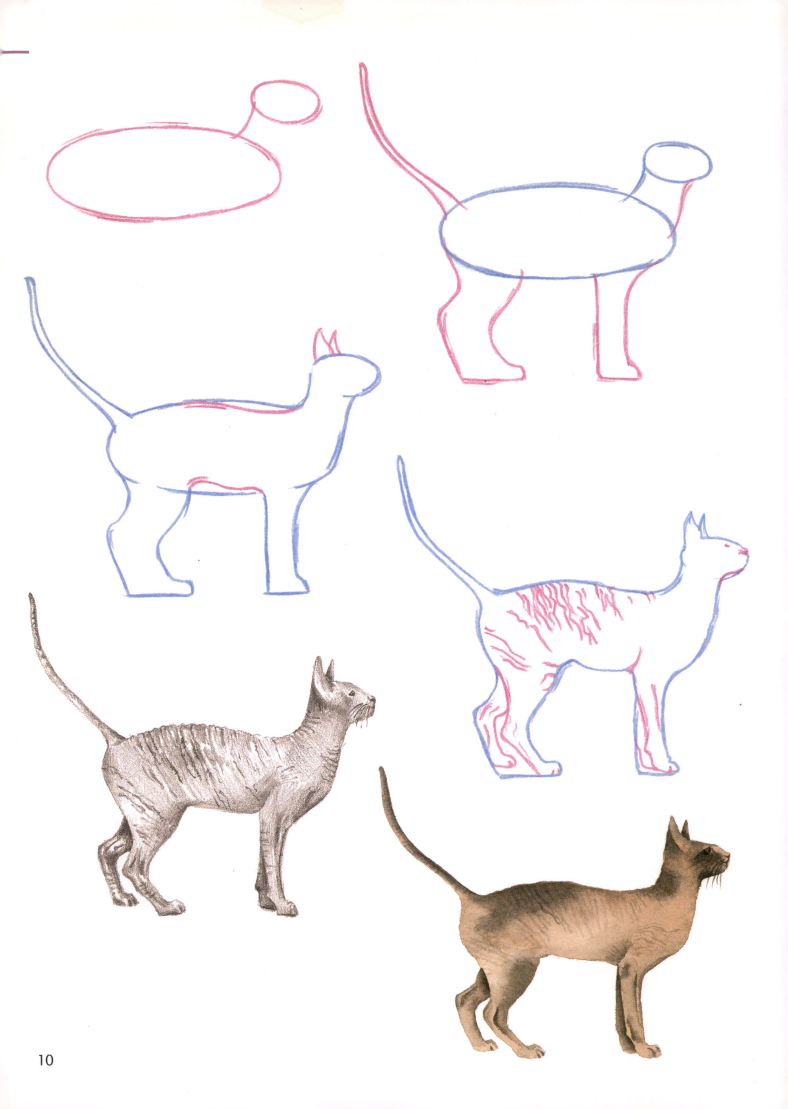

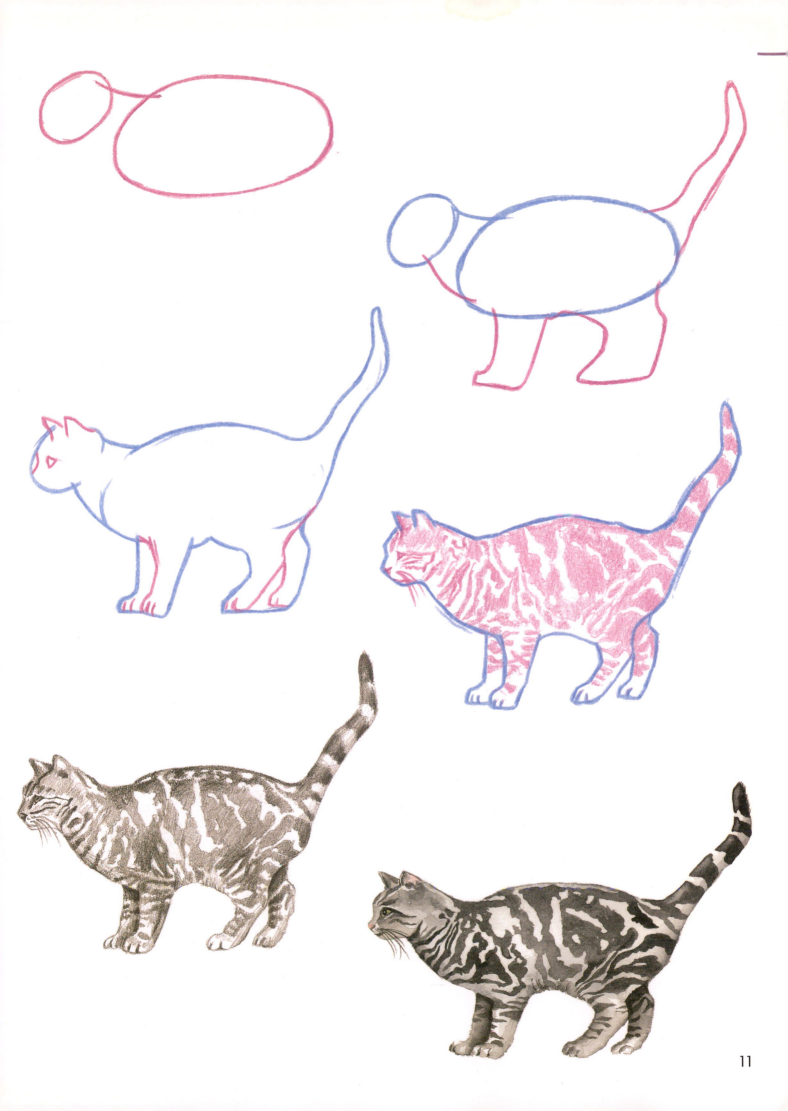

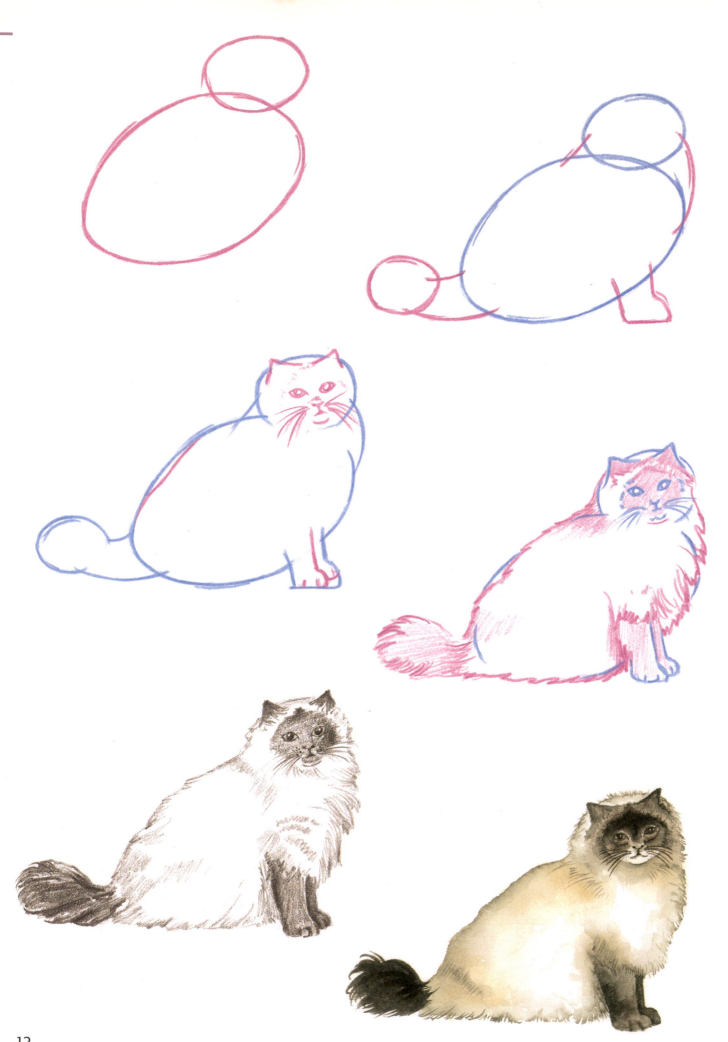

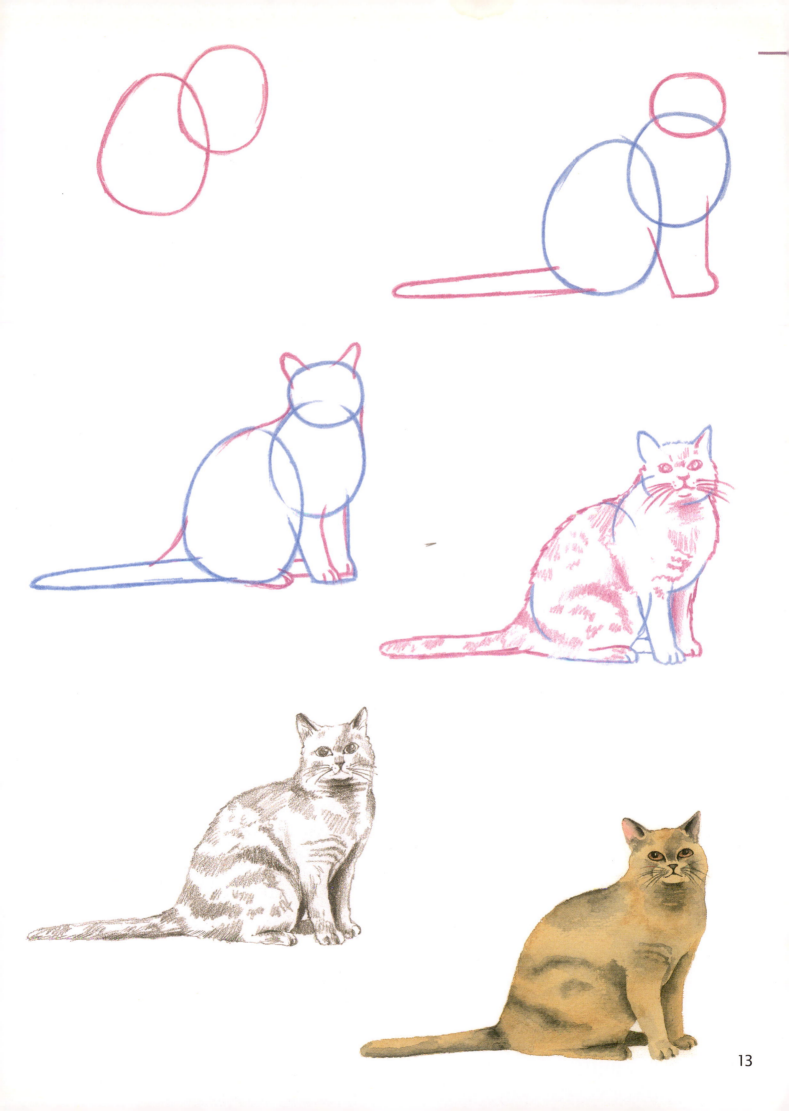

13

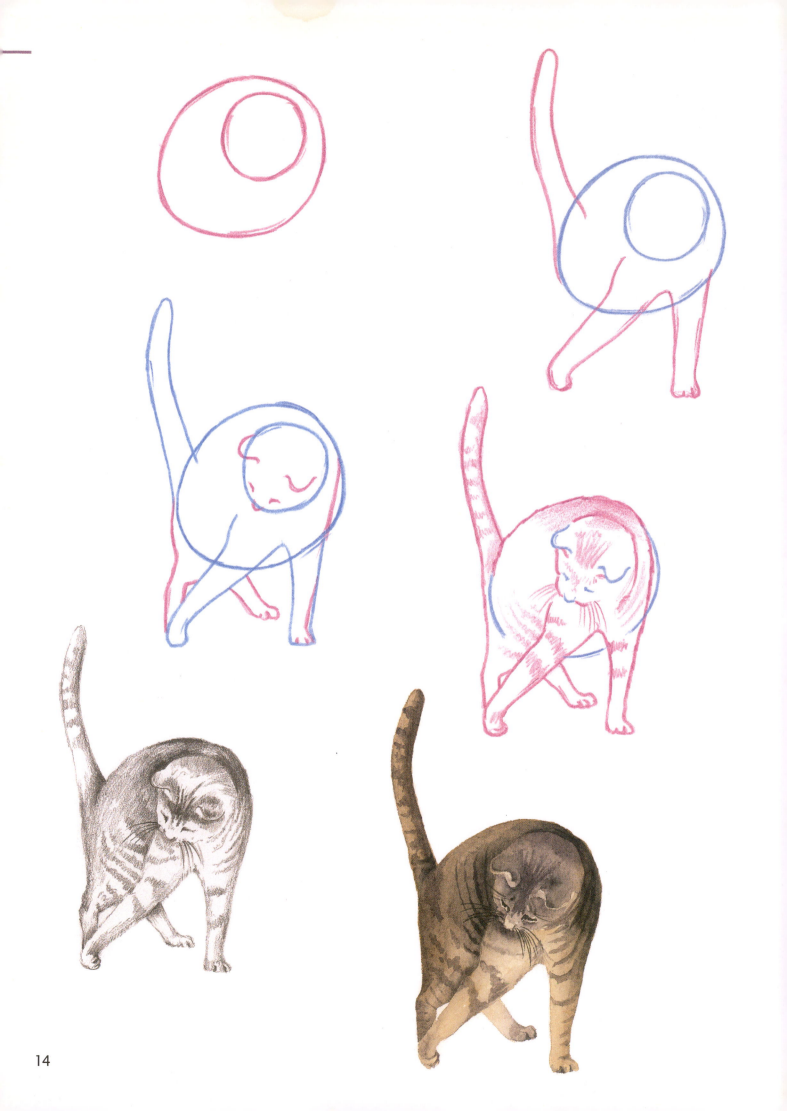

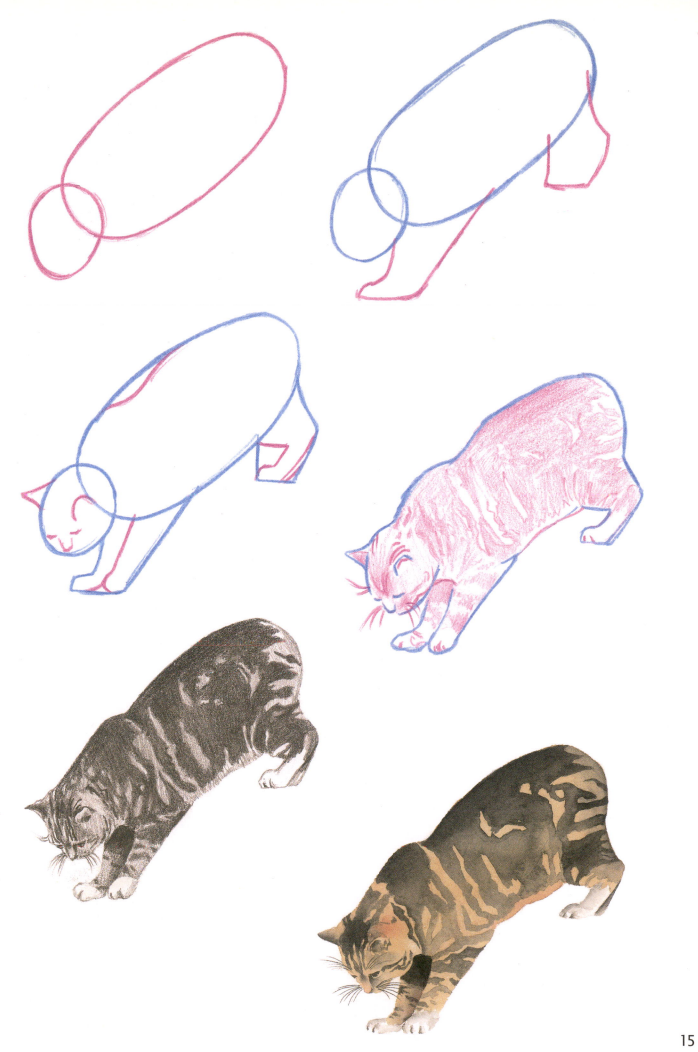

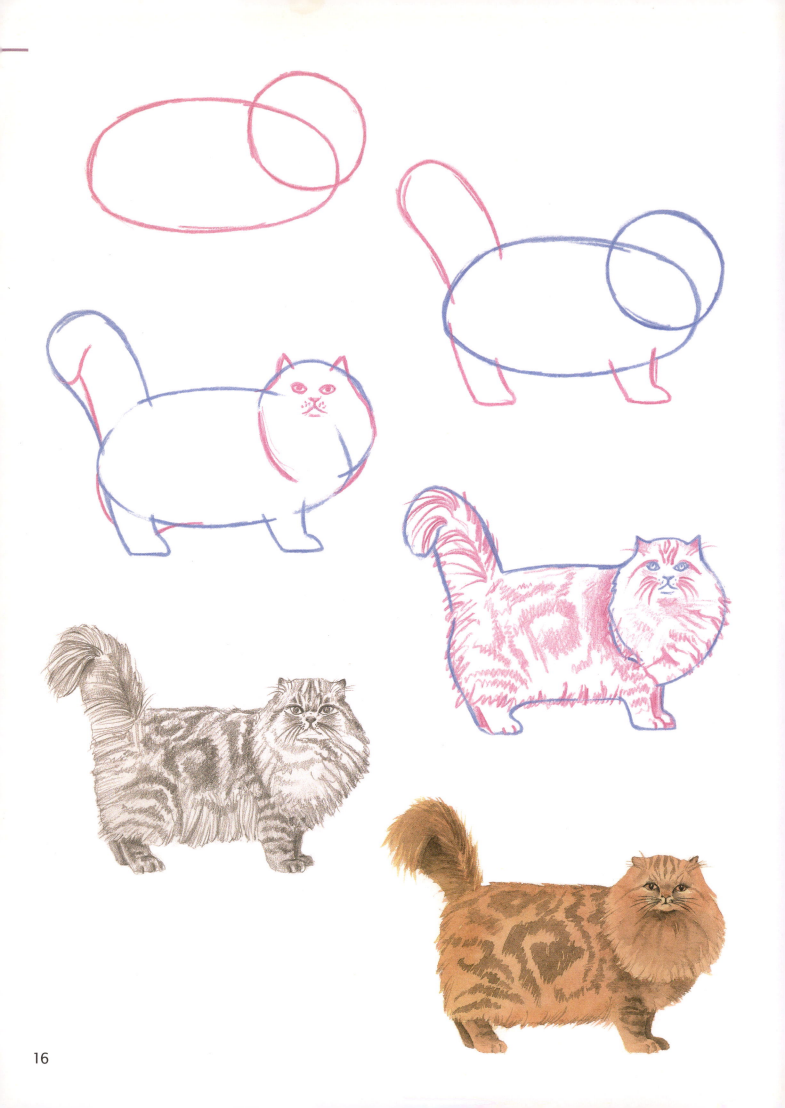

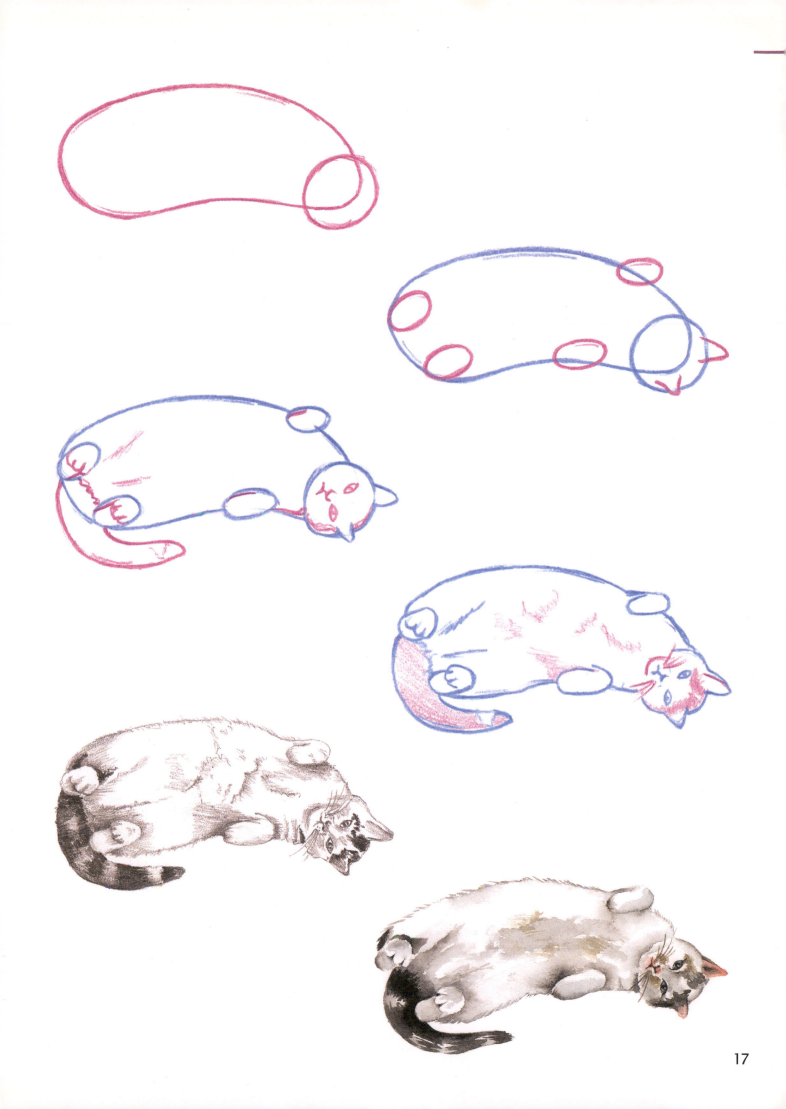

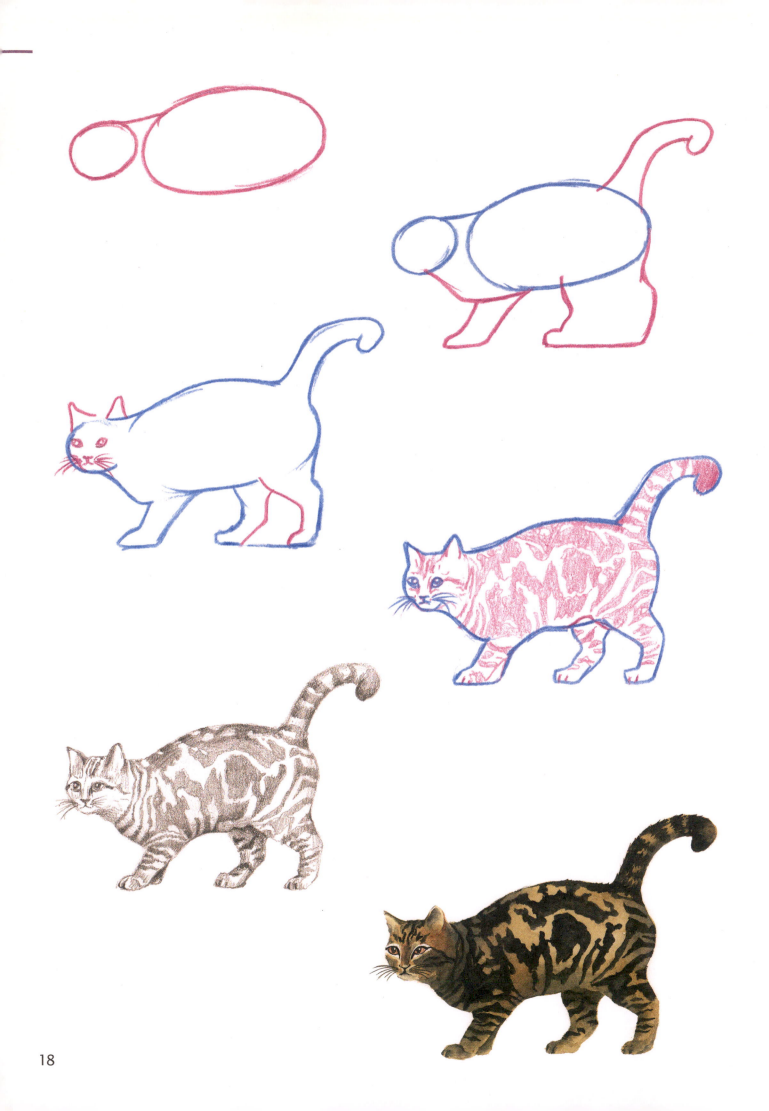

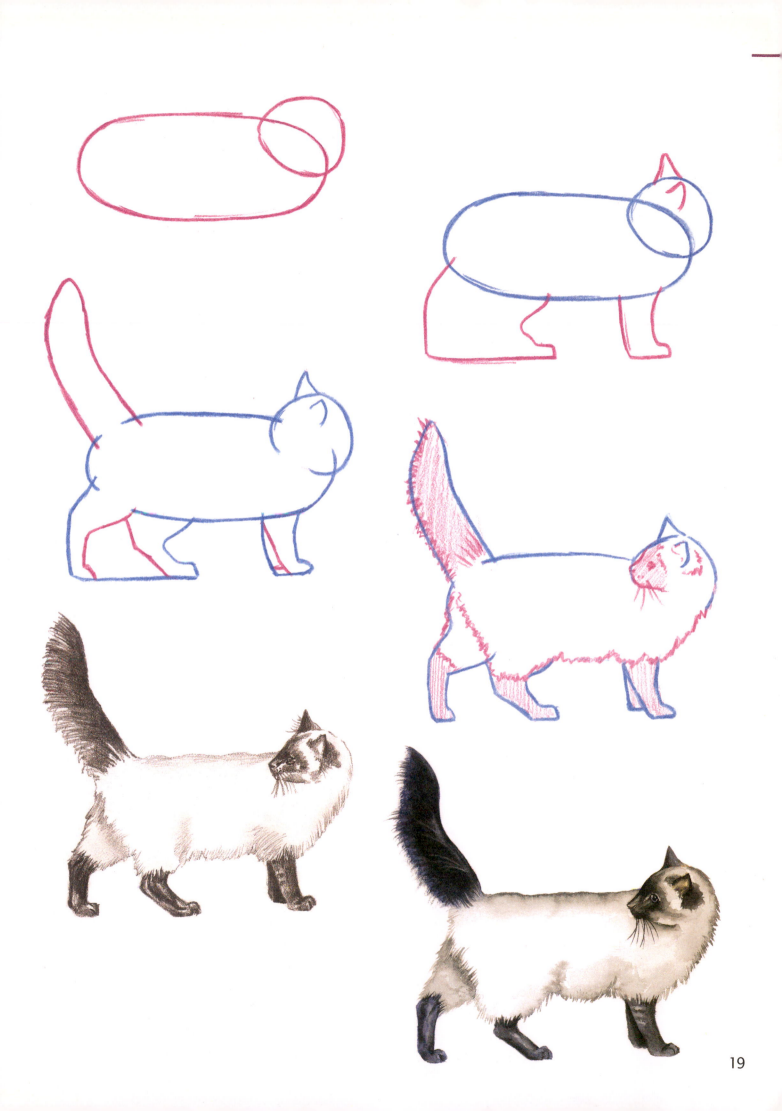

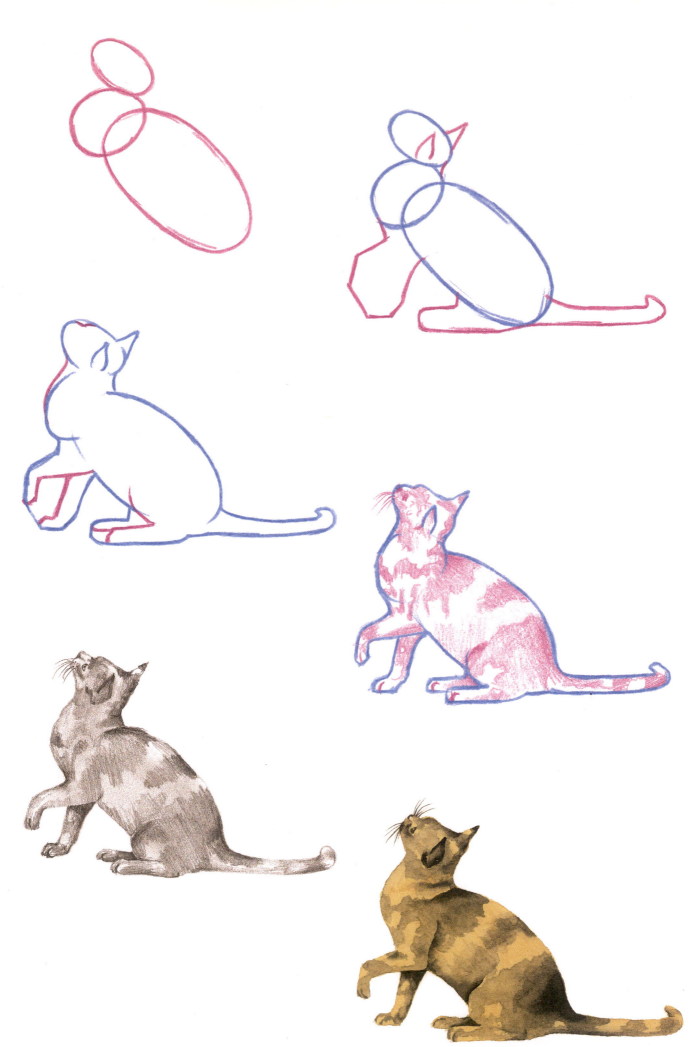

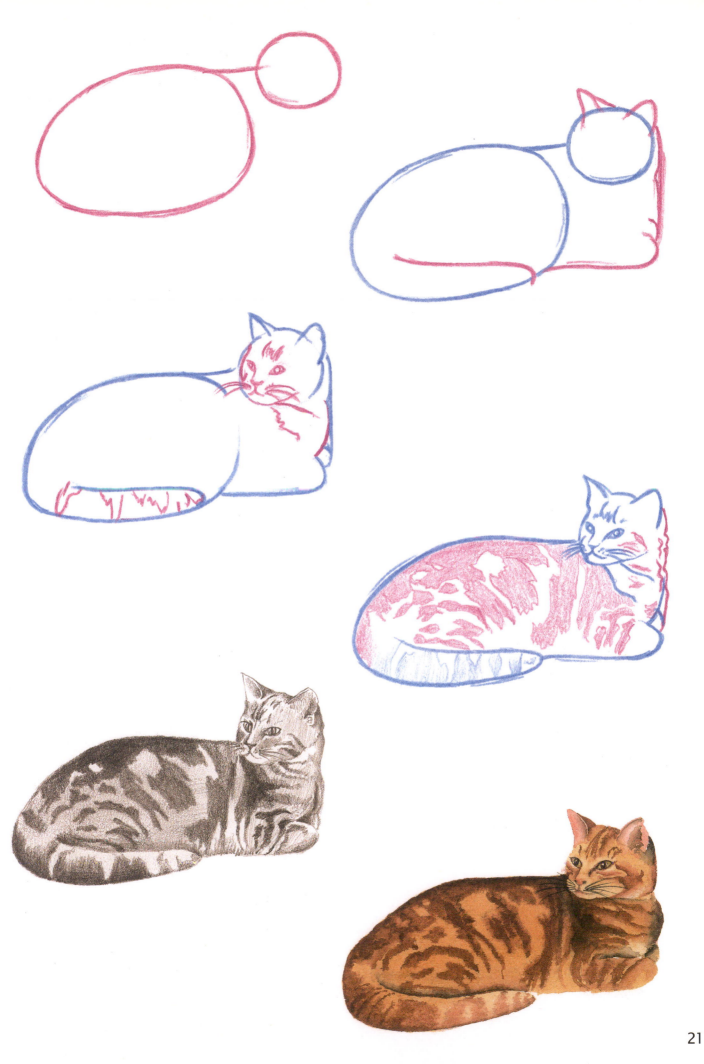

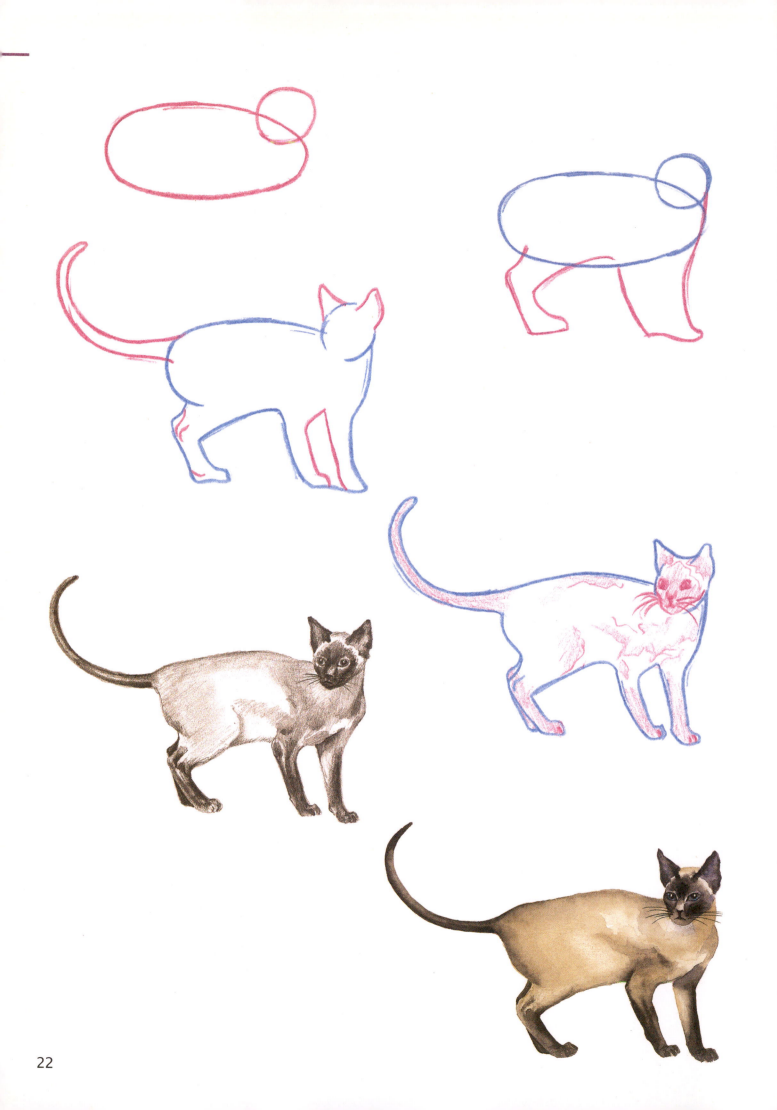

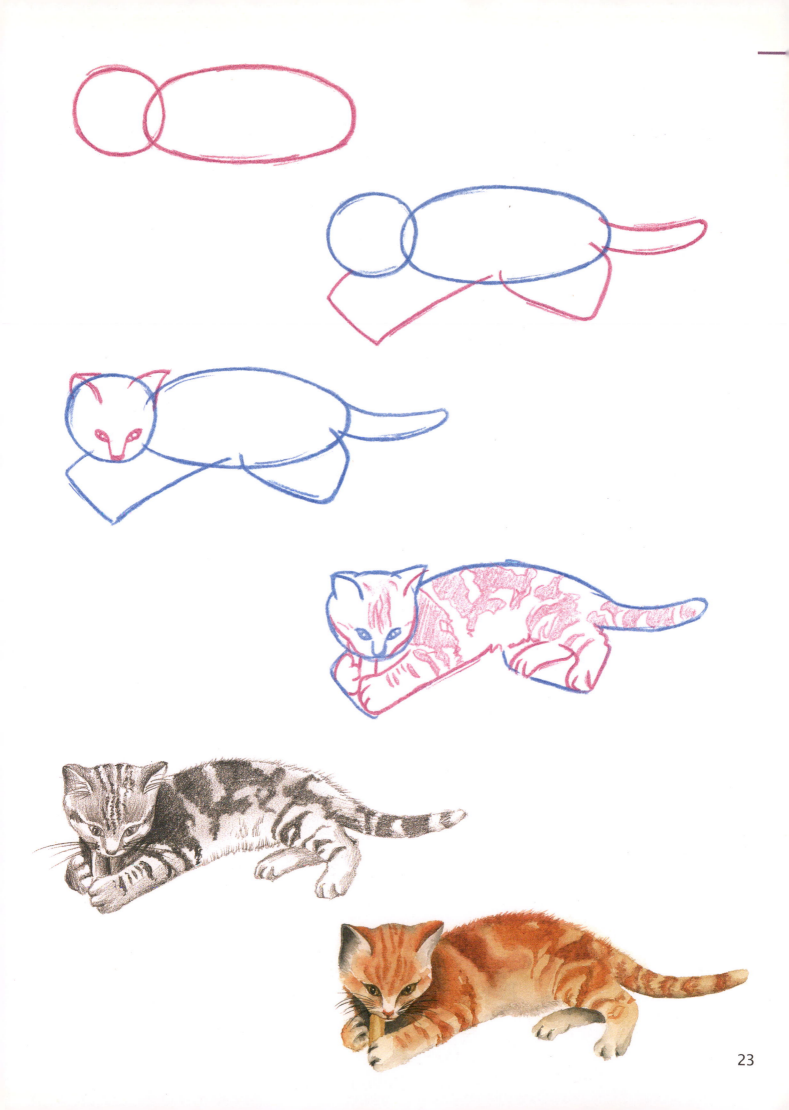

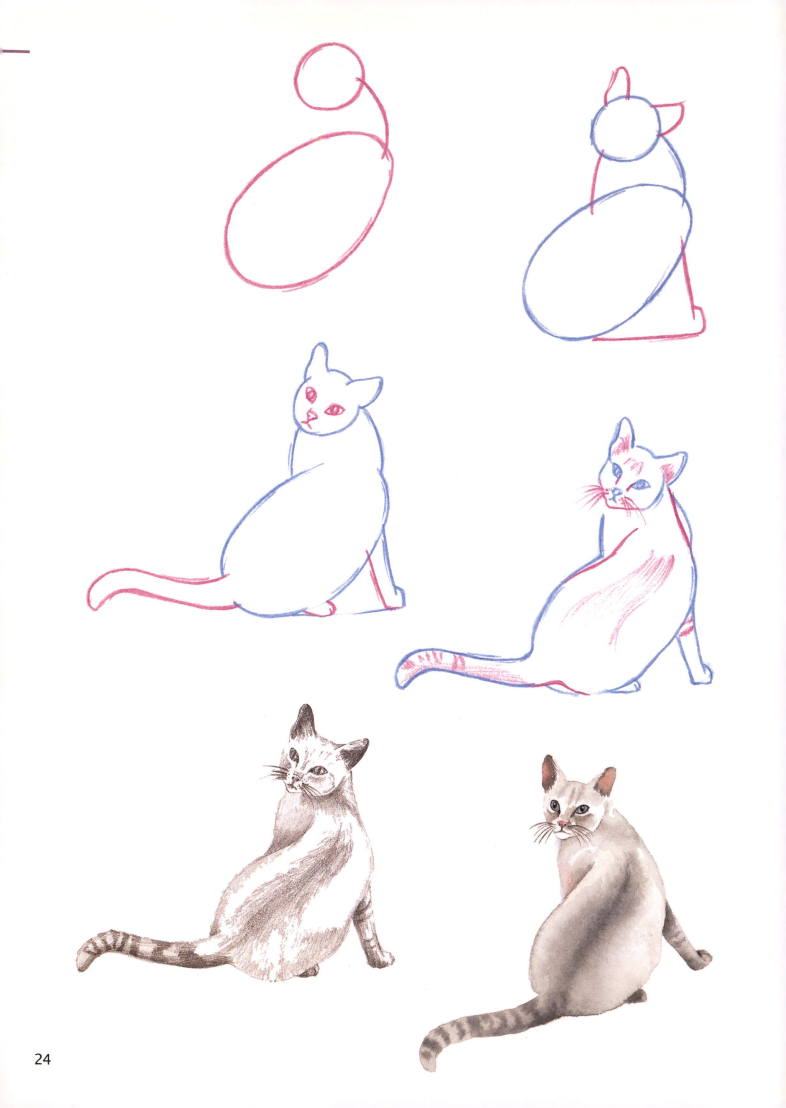

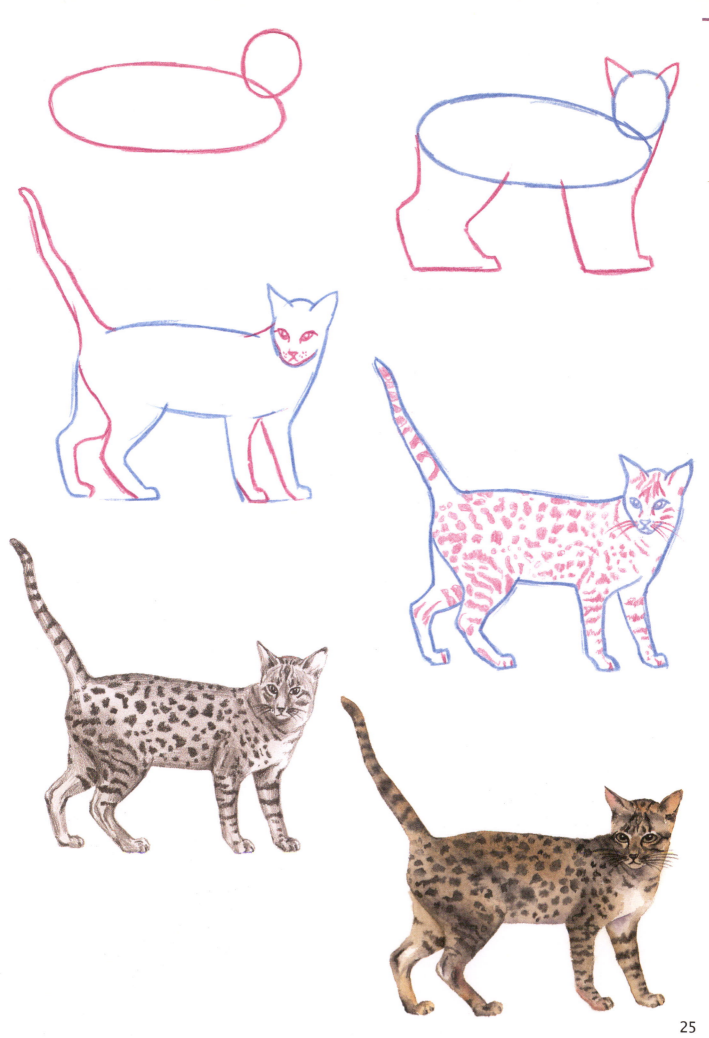

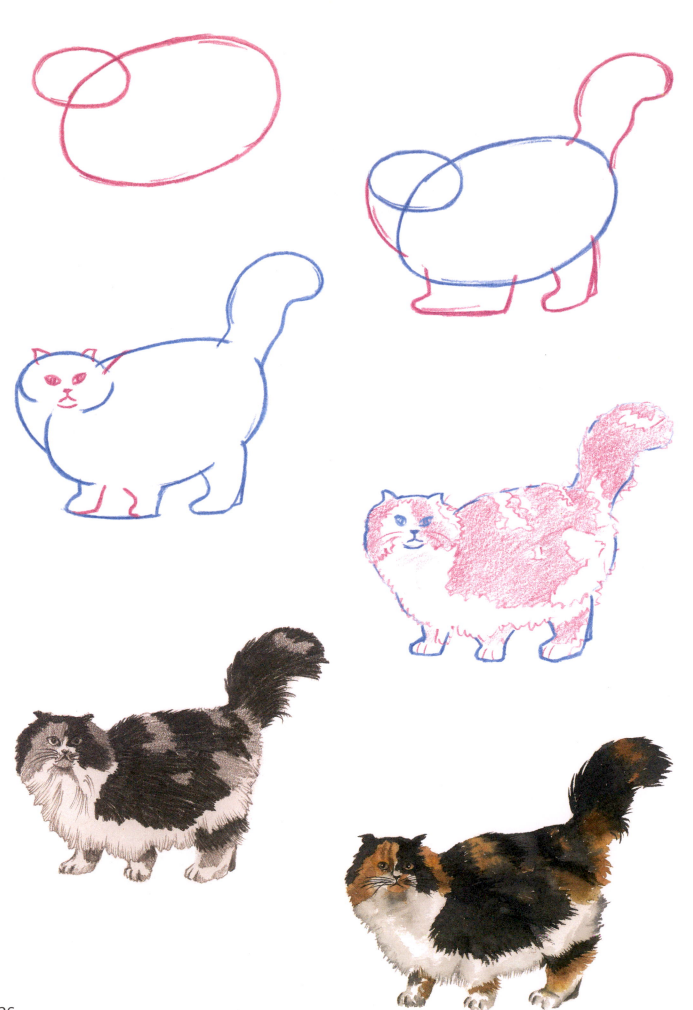

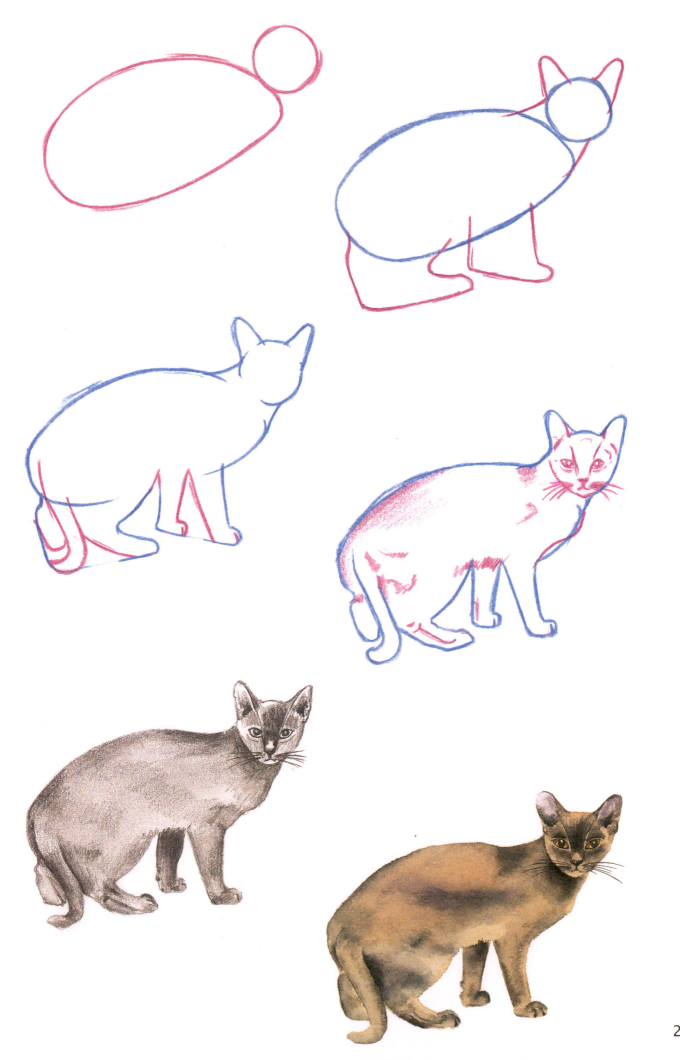

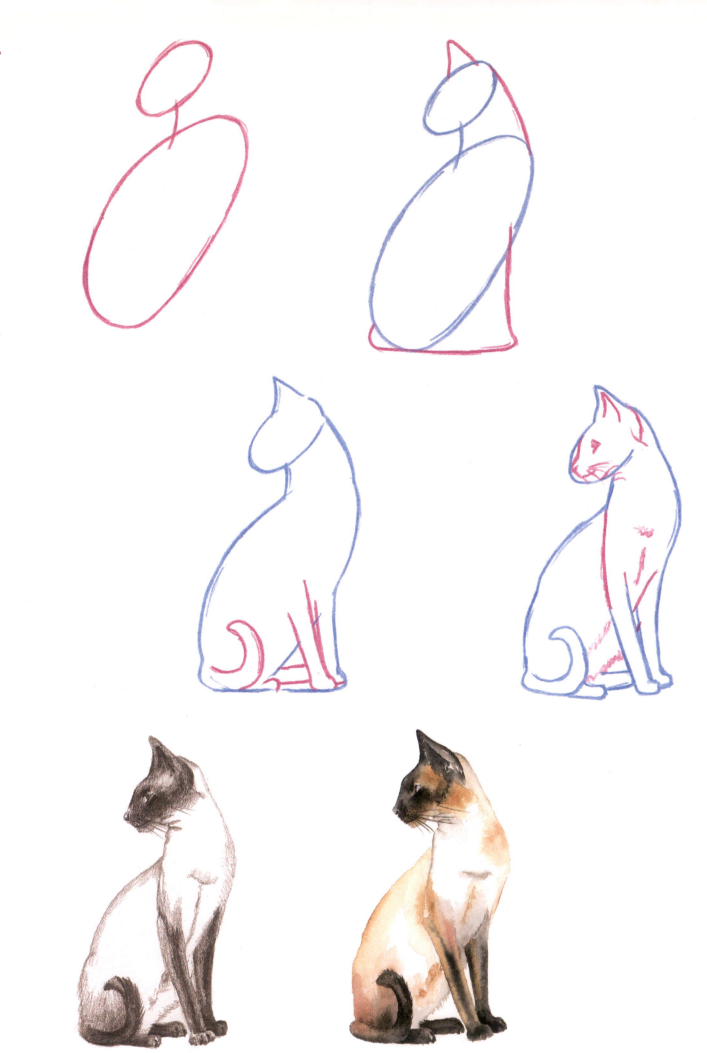

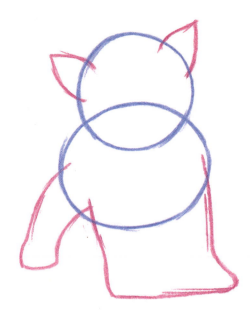
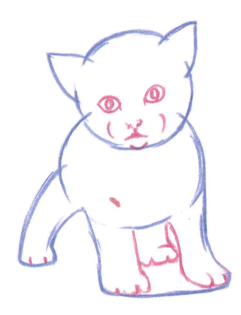
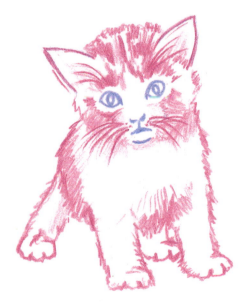
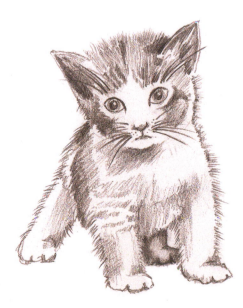
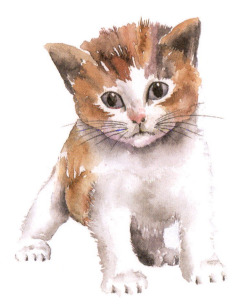

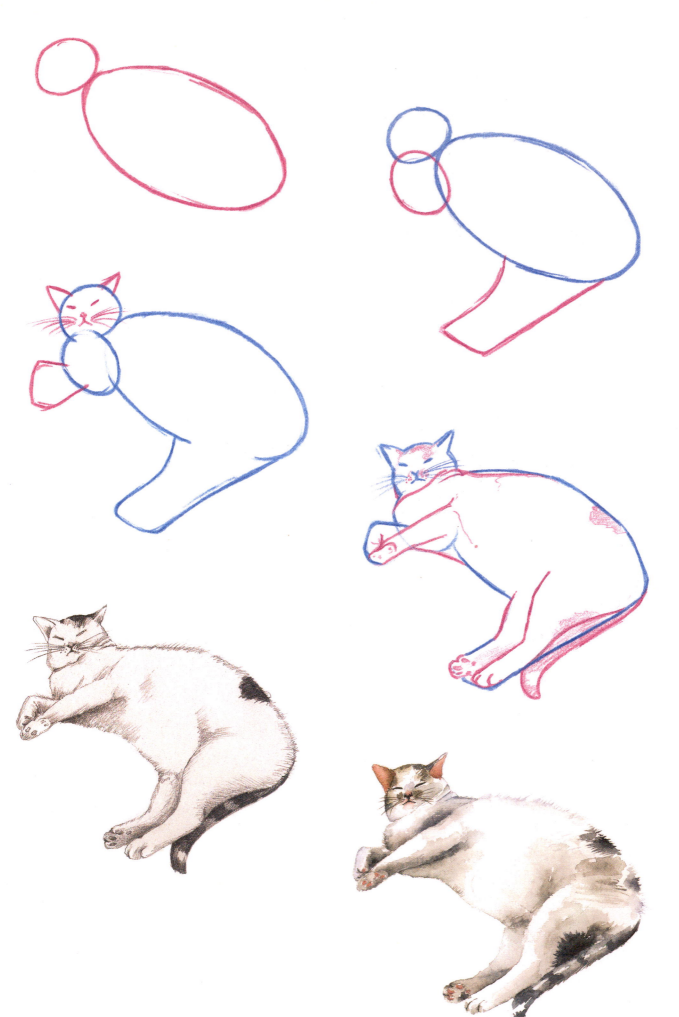

30

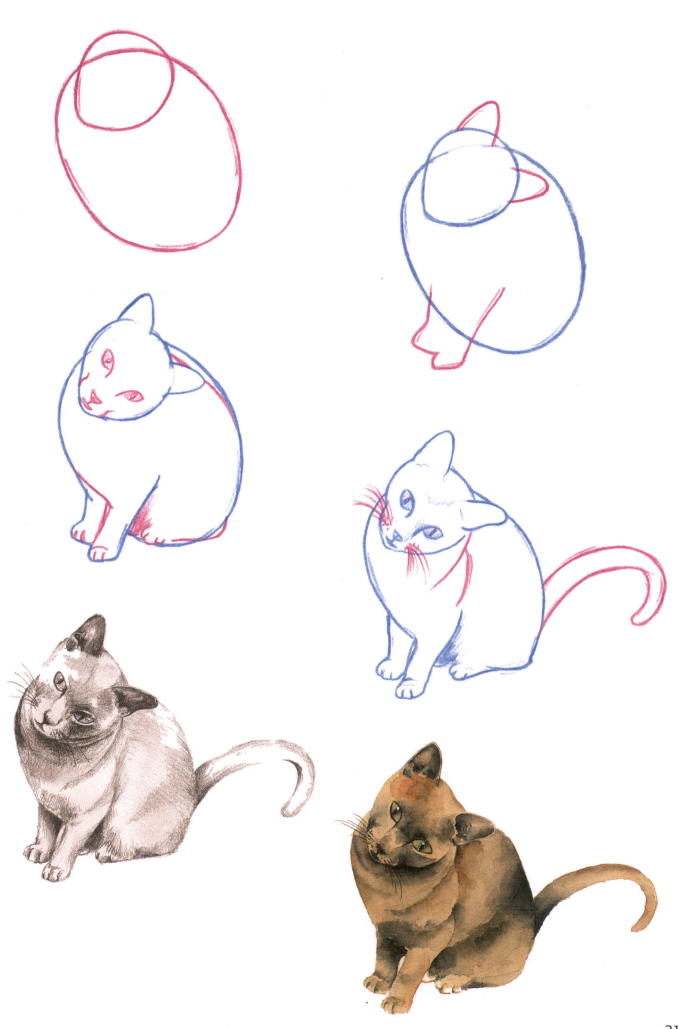

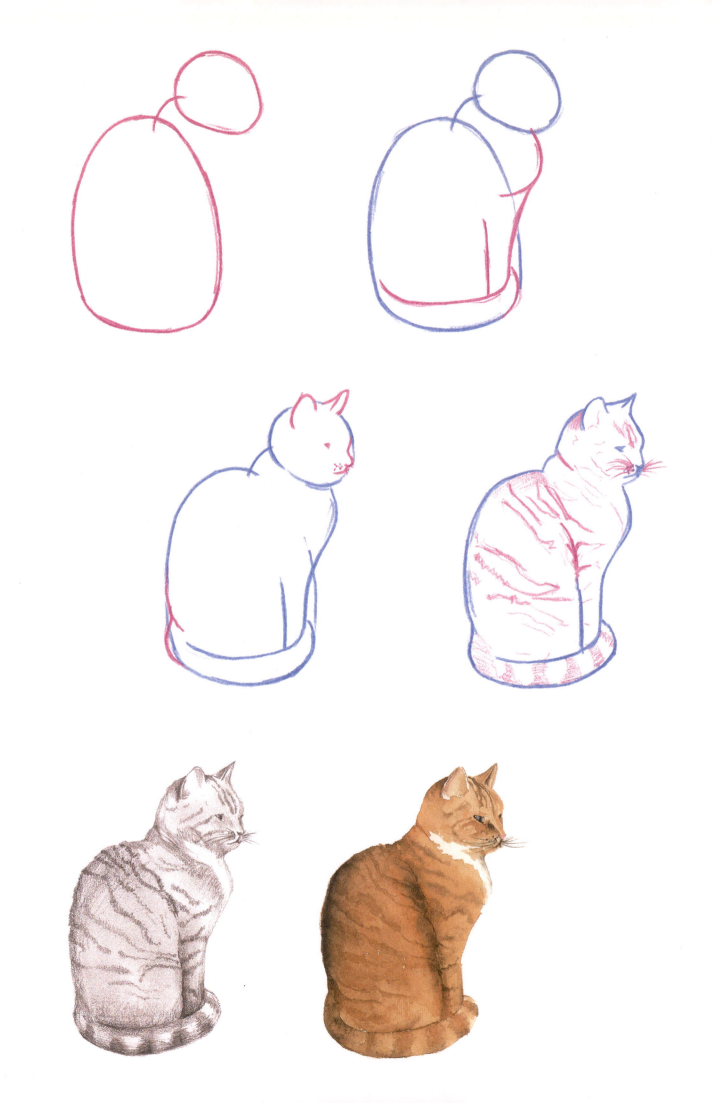

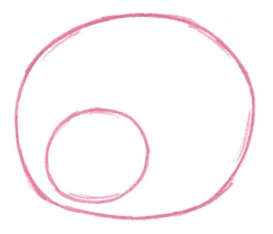

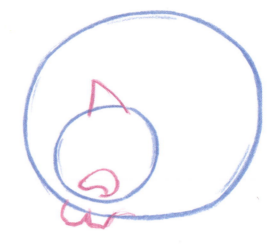

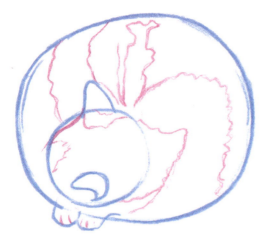

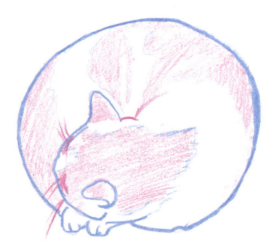

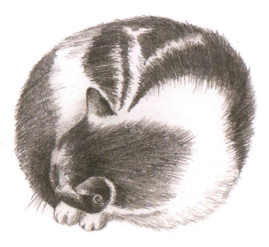

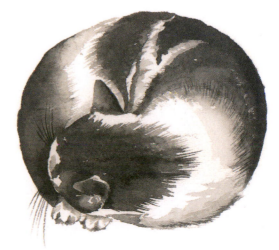

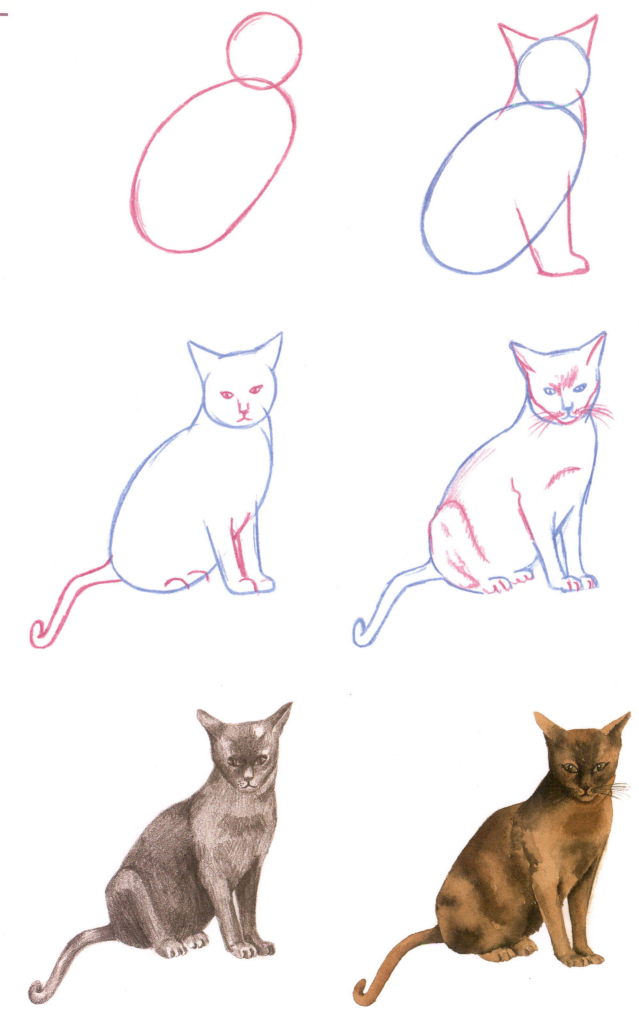

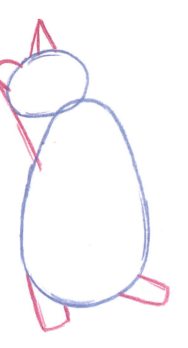
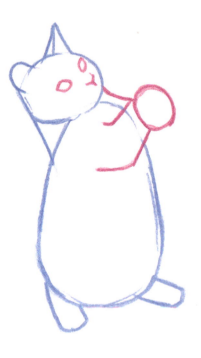
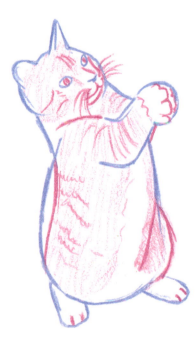
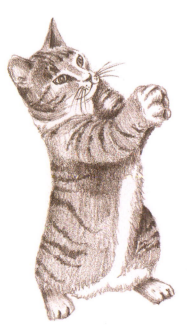
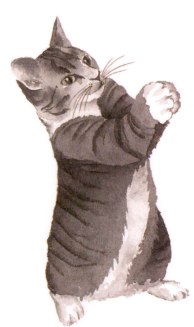

Dogs

Happy, healthy dogs are a pleasure to draw, whether they are handsome, cute, dignified, elegant, funny or scruffy. A variety of breeds are included on the following pages, starting with simple shapes and building these up in stages to produce drawings of specific dogs. I hope you will draw all of them and then go on to draw more, perhaps from photographs of your own, or friends' pets, using this simple construction method. Once you become familiar with the general anatomy of these loyal and affectionate animals, you will grow in confidence and soon develop your own style.

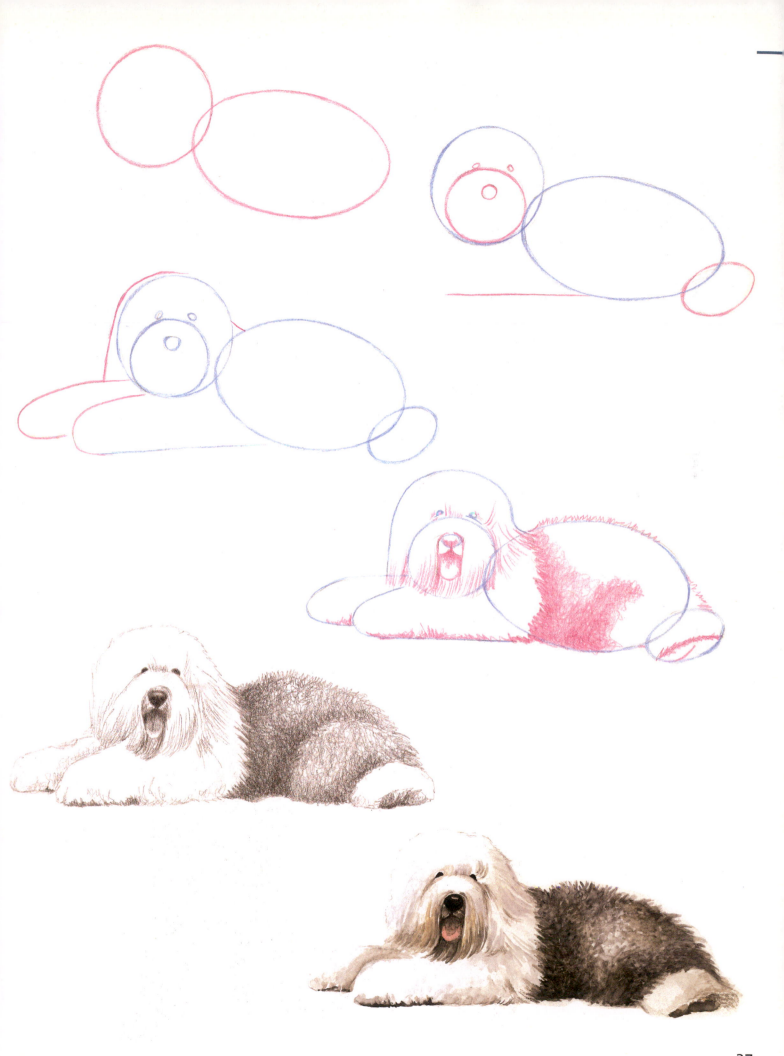

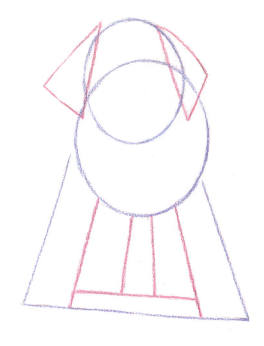

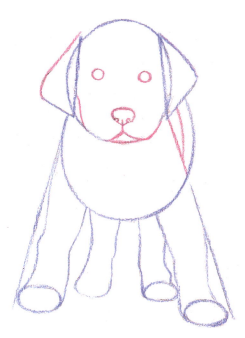
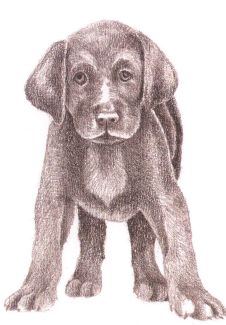
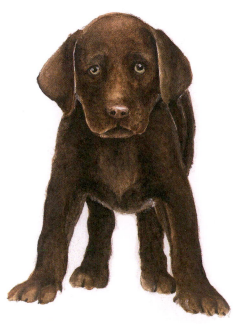

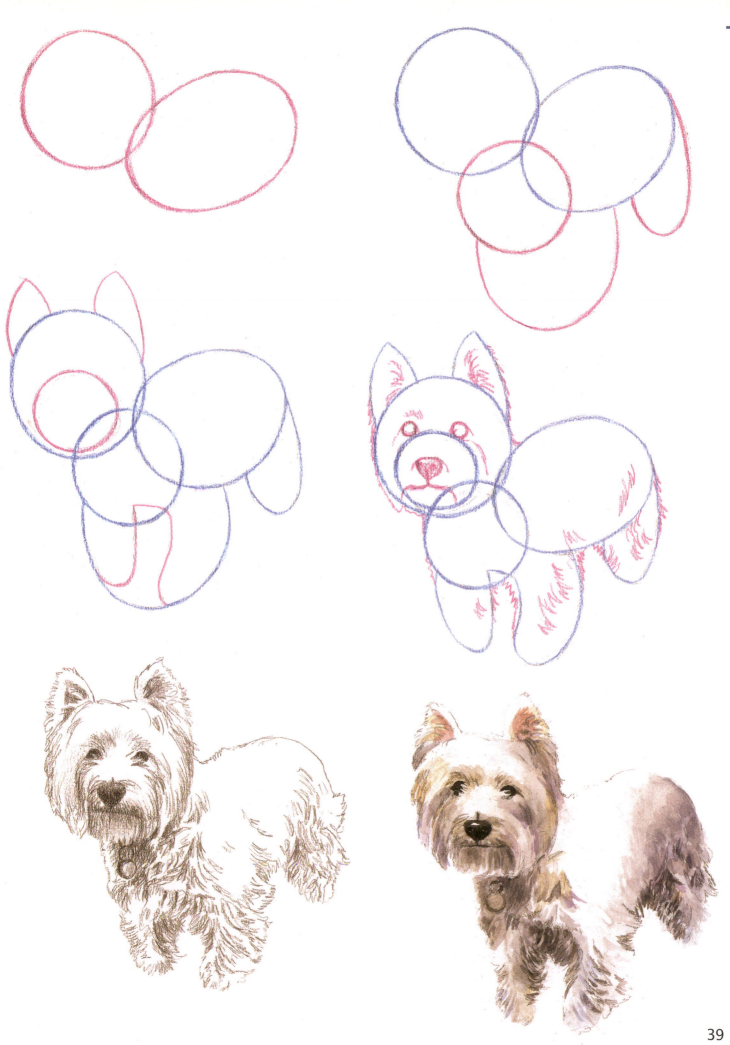

39

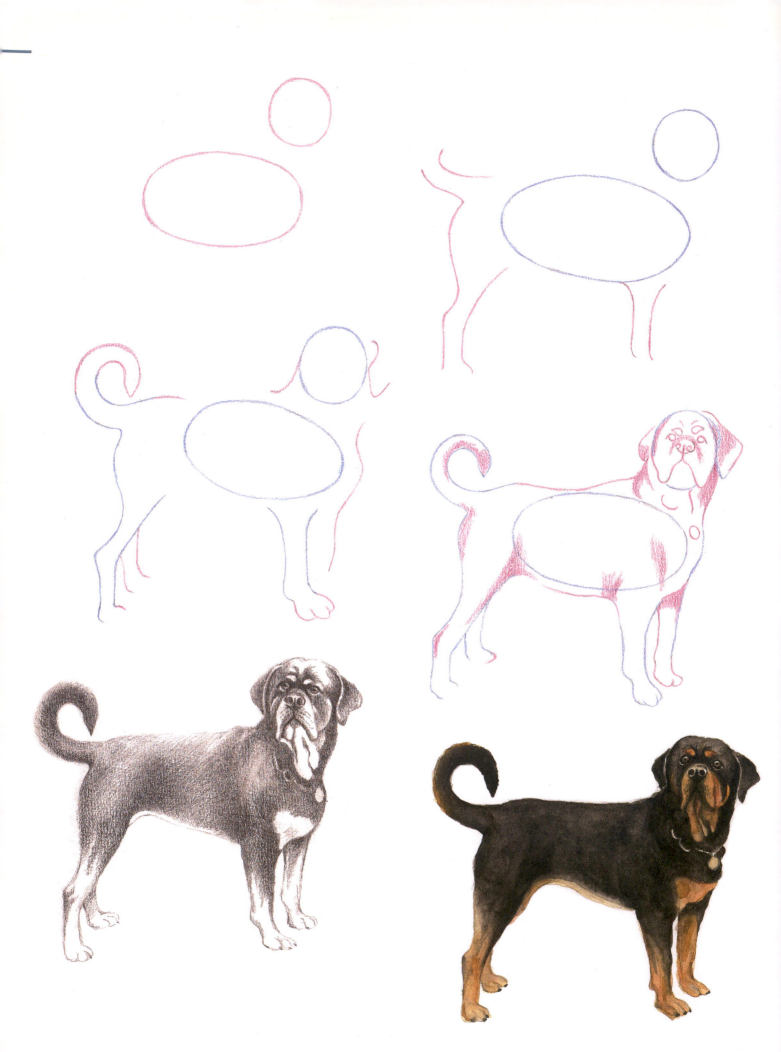

40

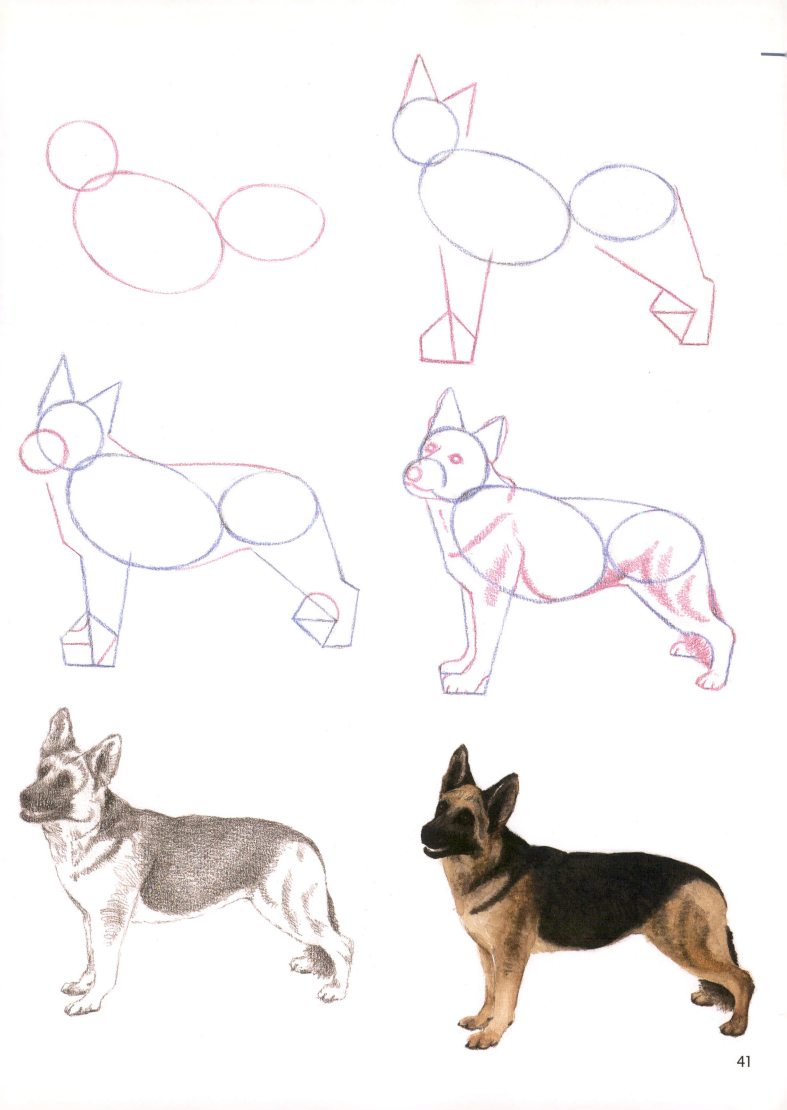

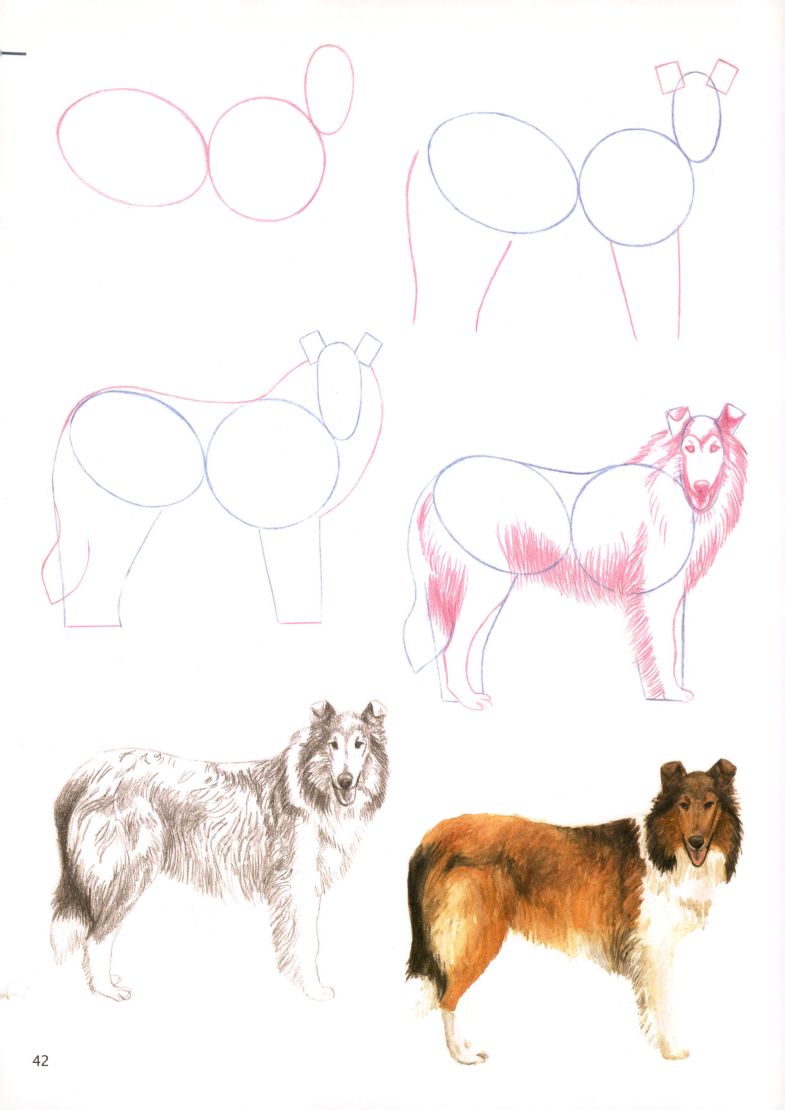

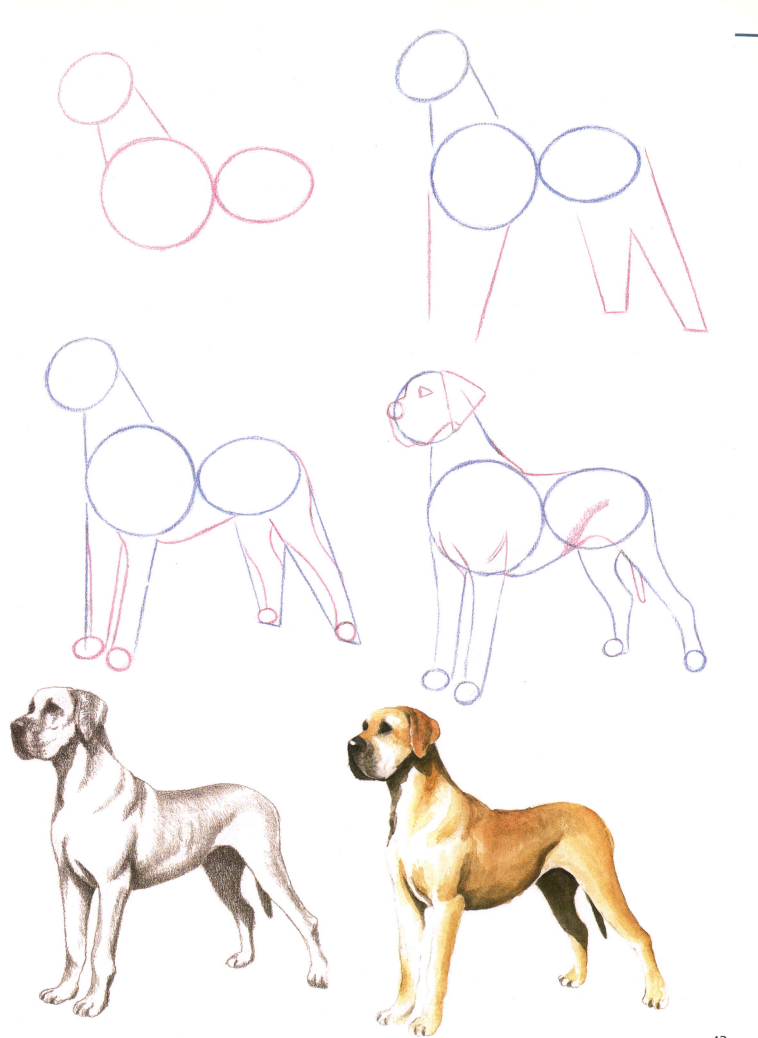

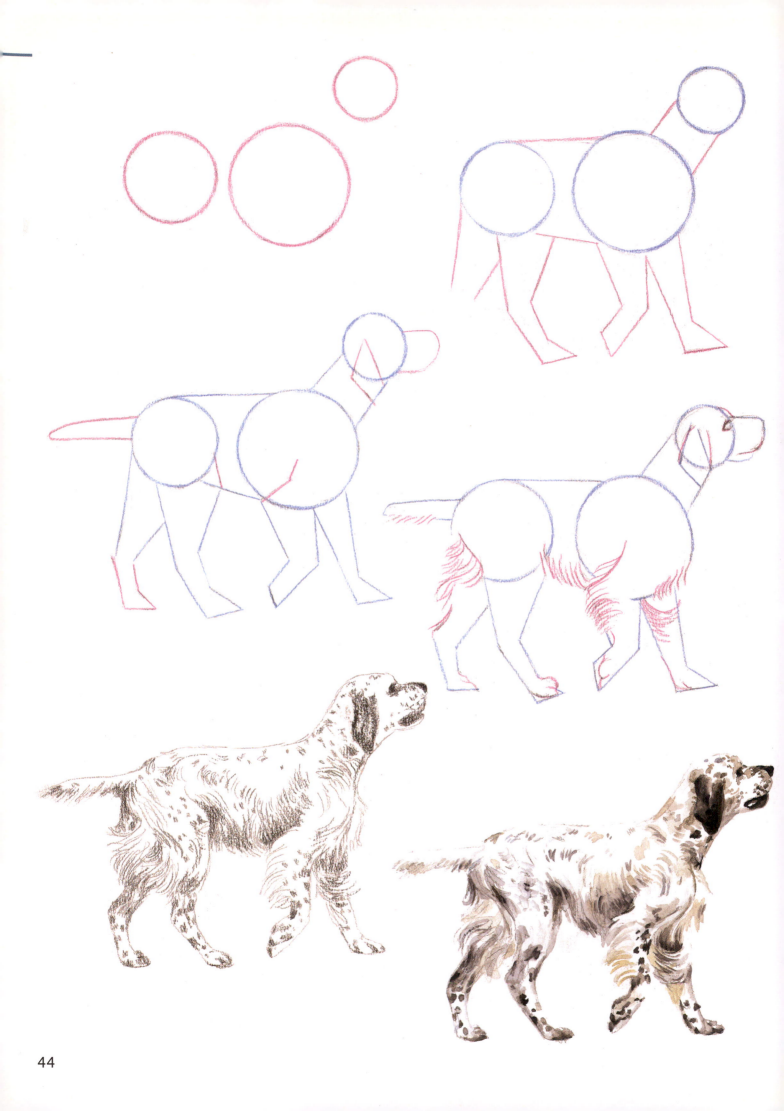

44

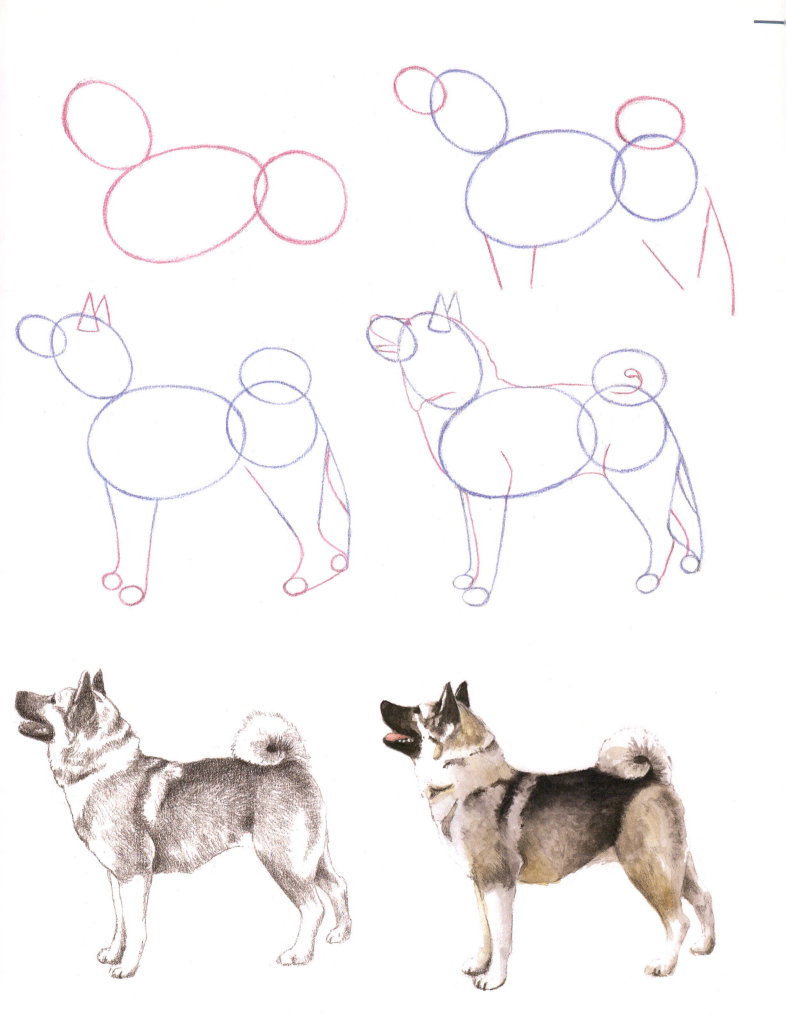

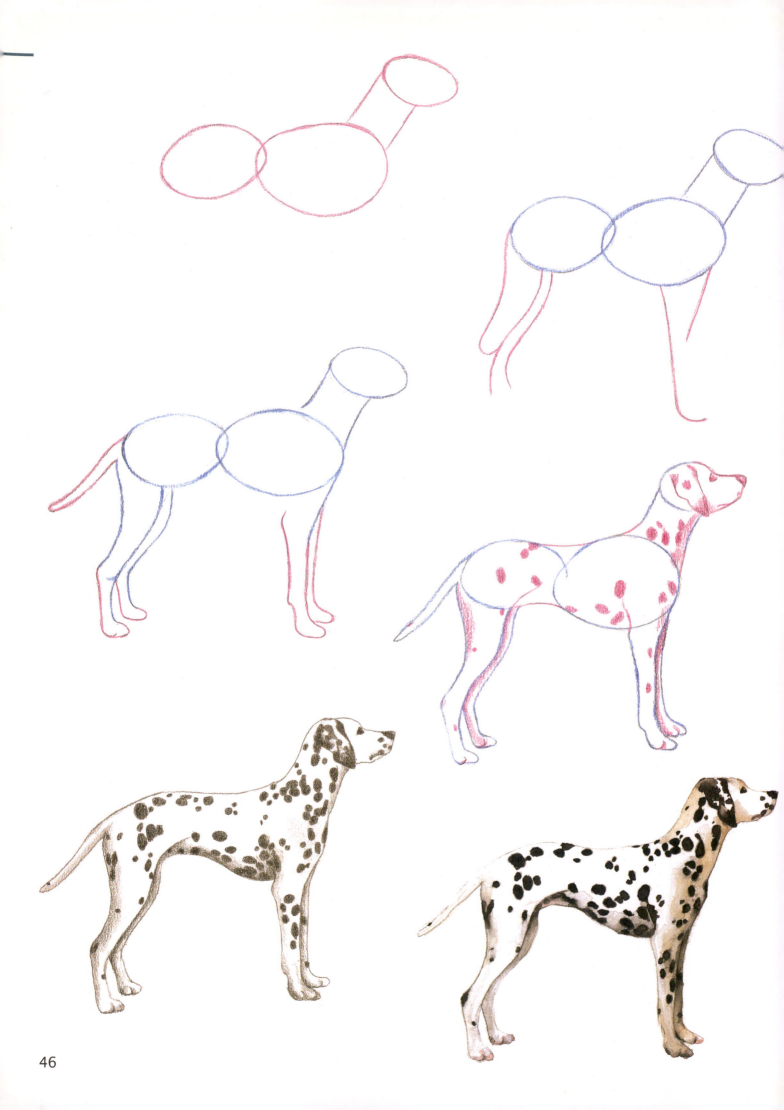

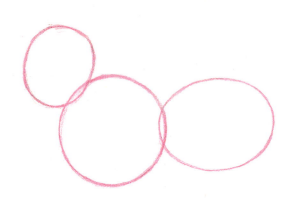

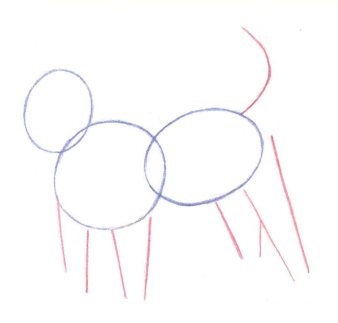

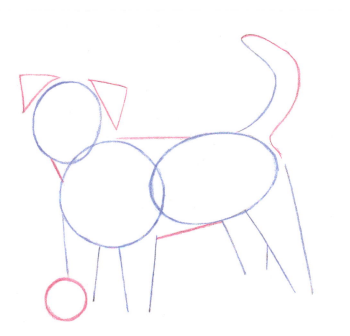

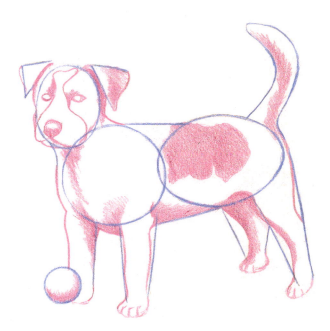

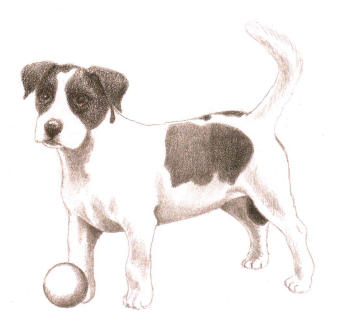

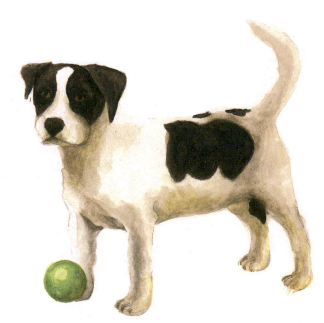

47

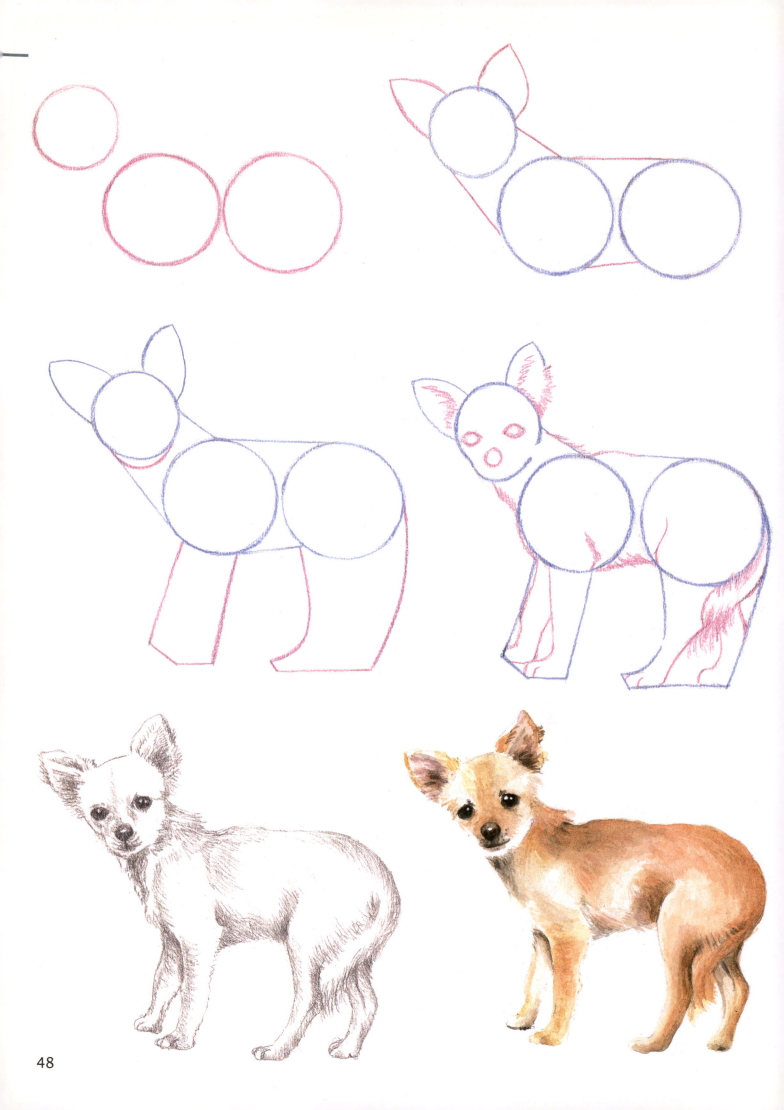

48

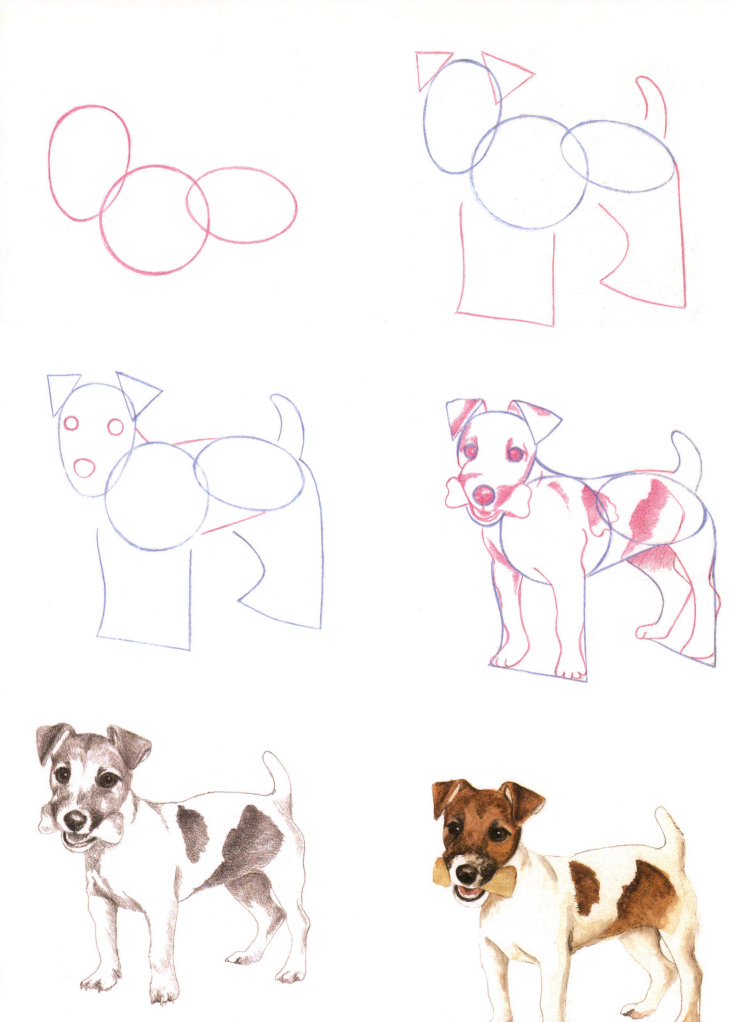

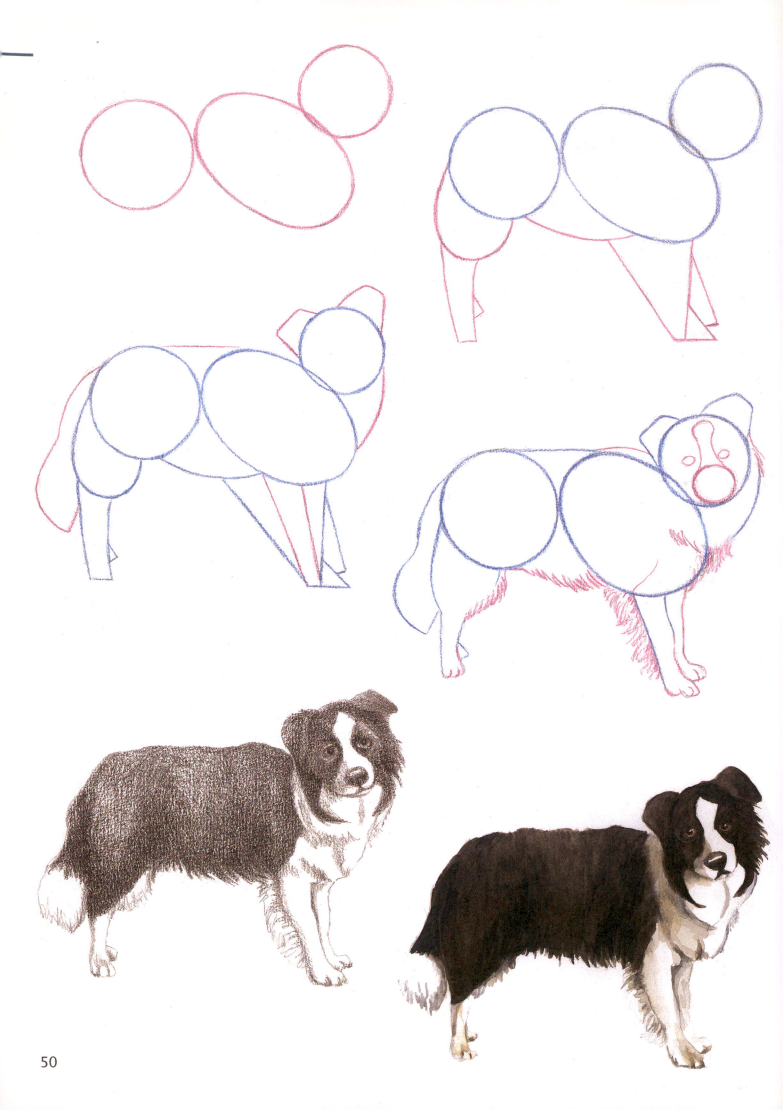

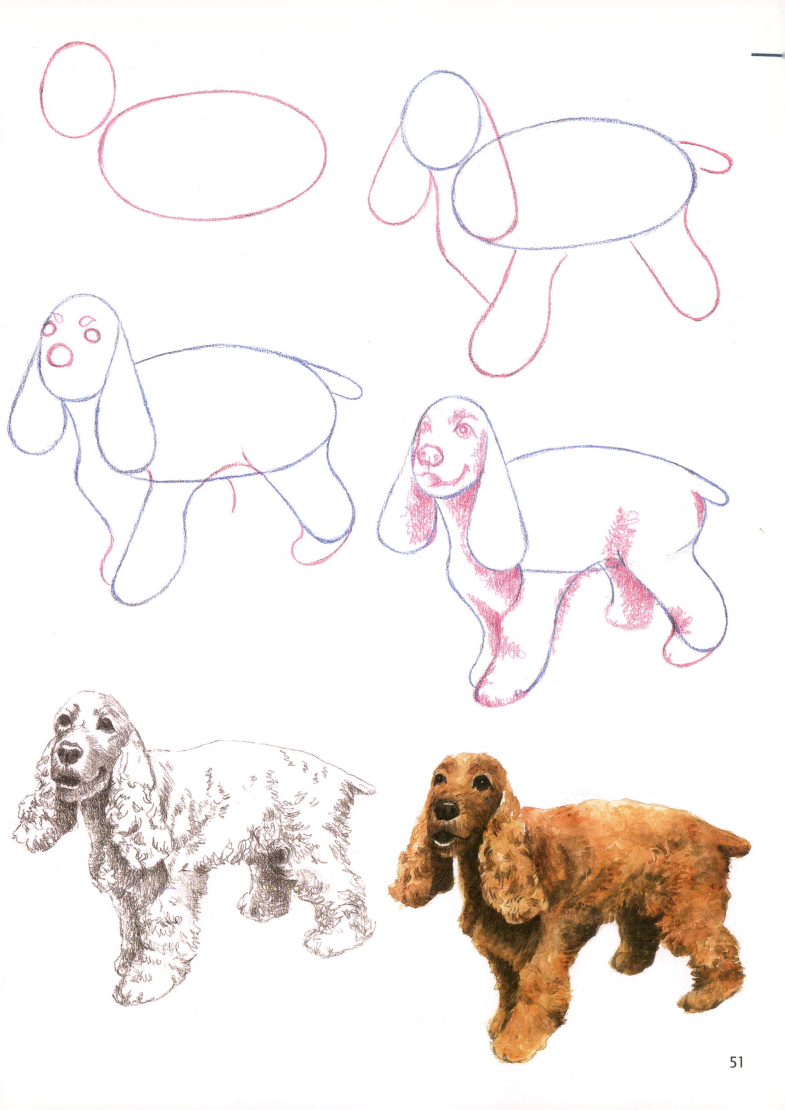

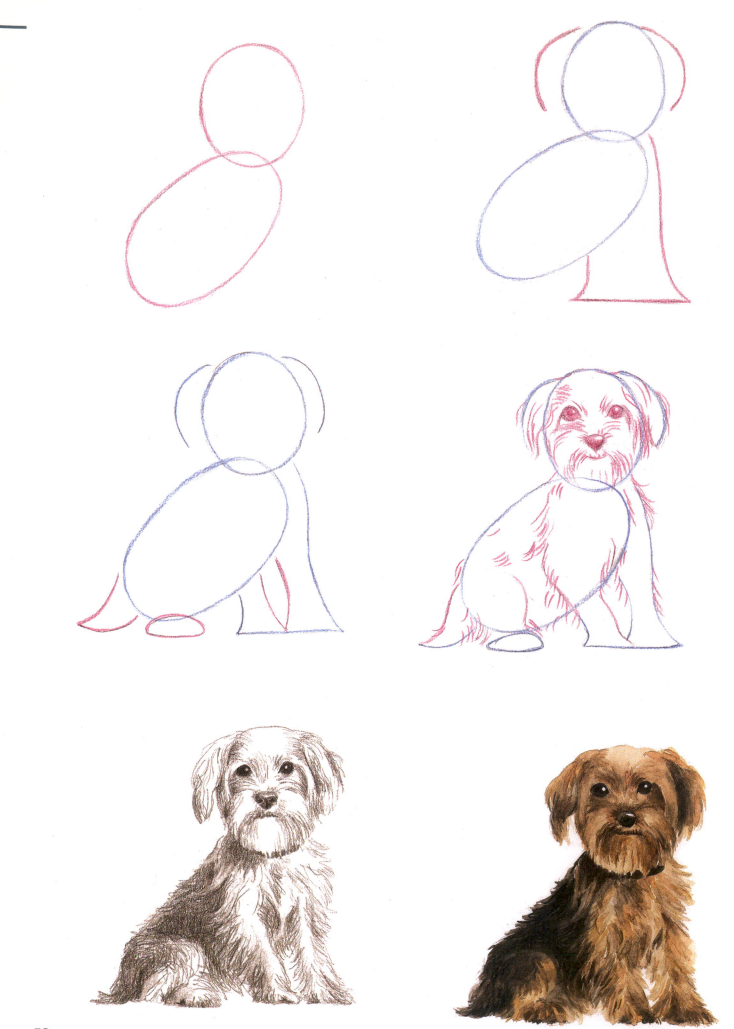

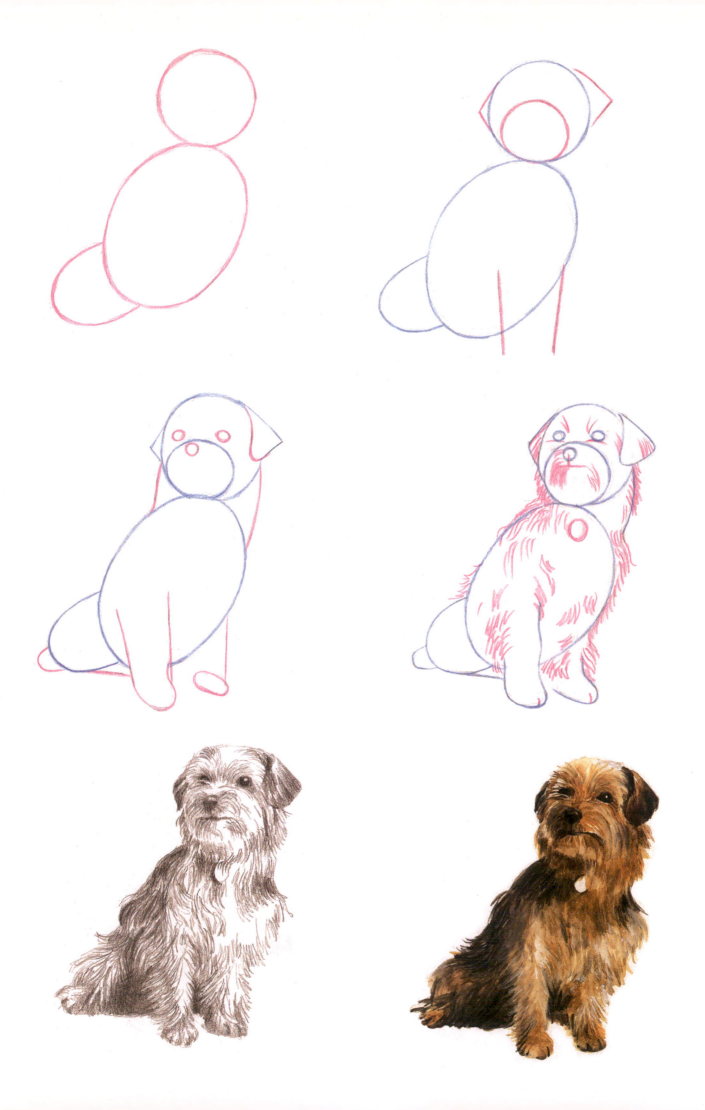

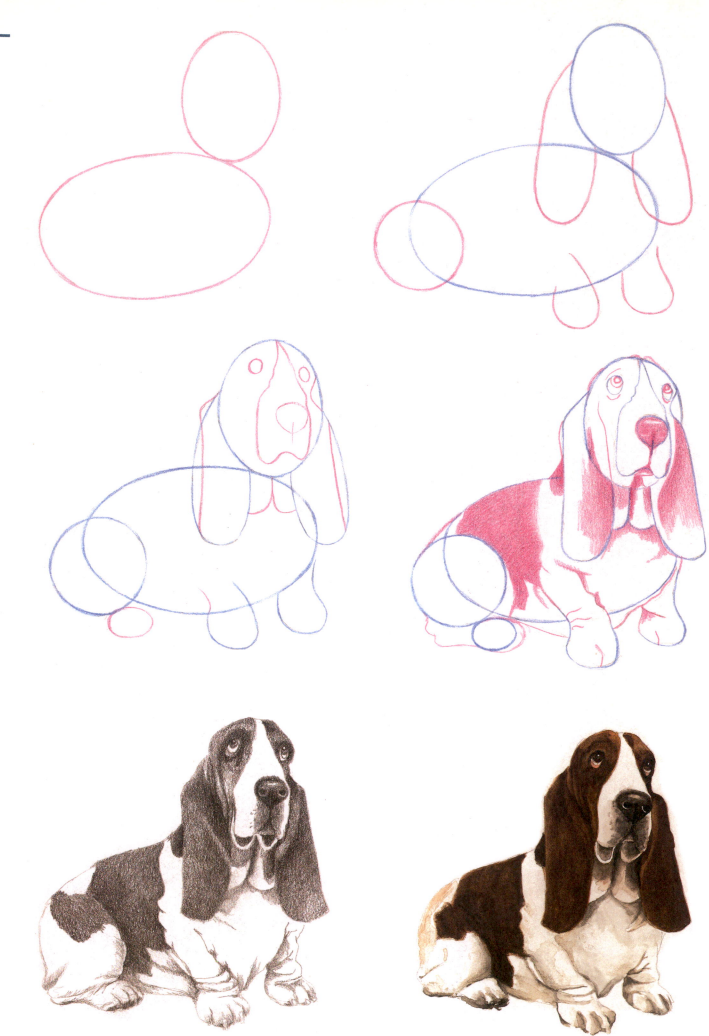

54

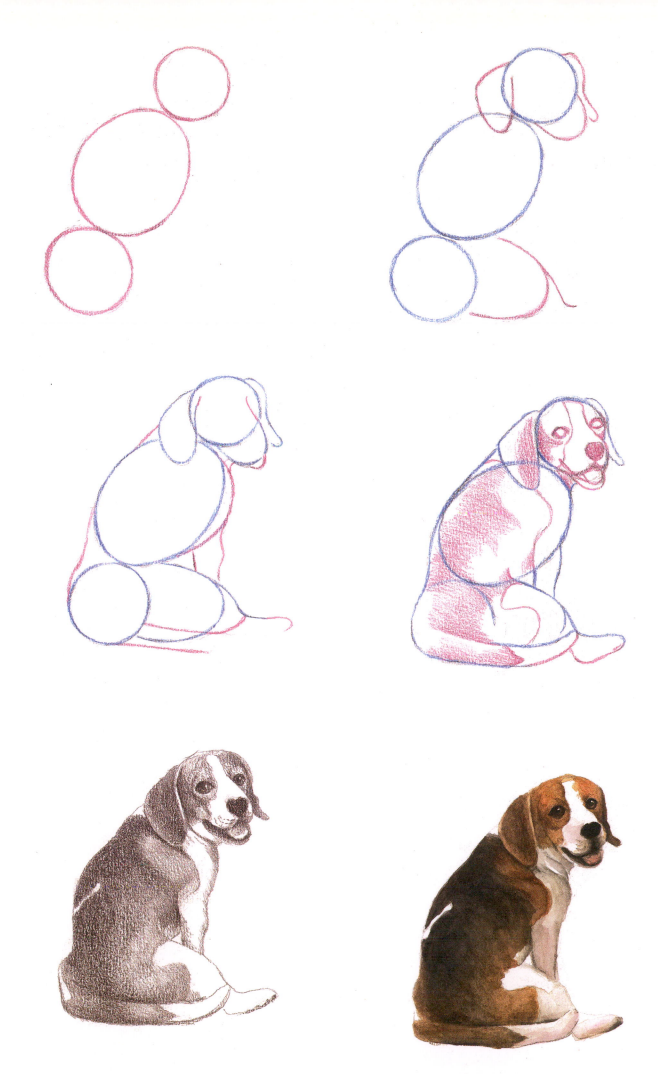

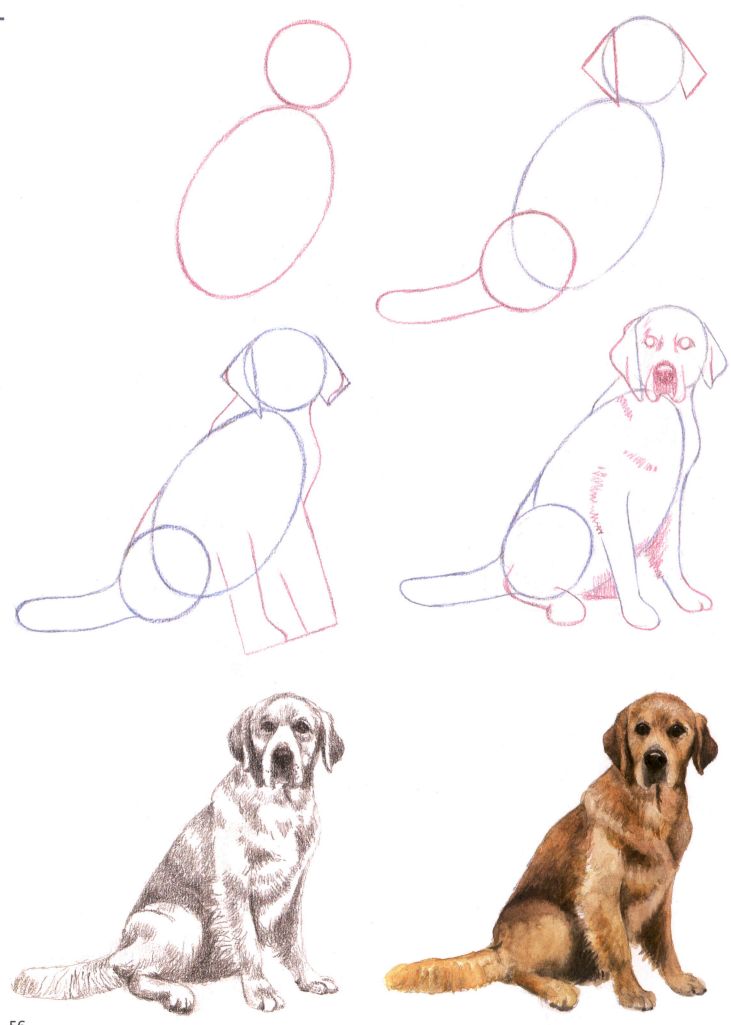

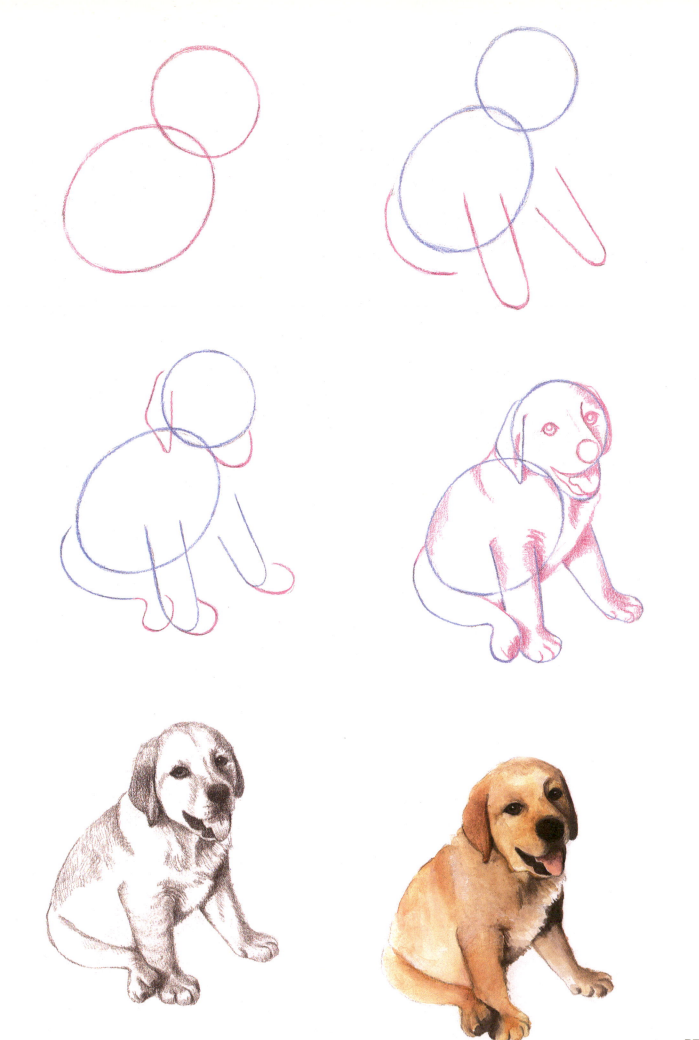

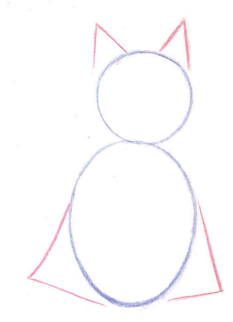
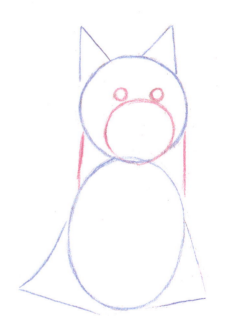
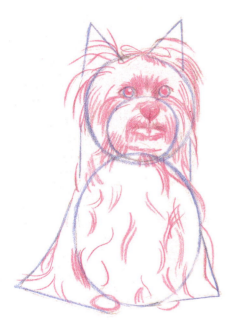
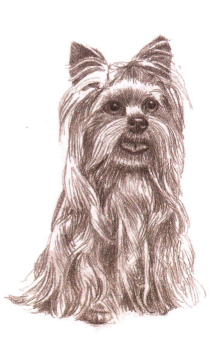
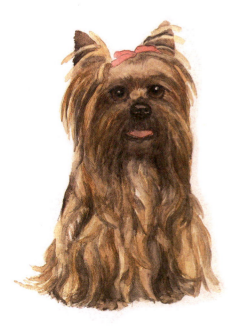

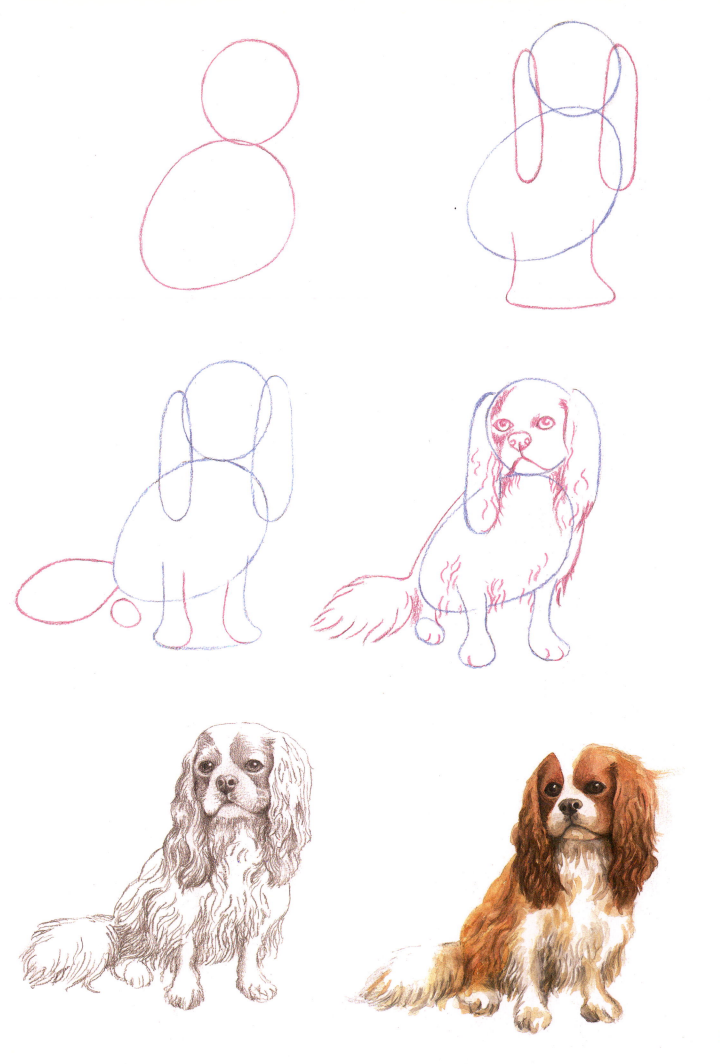

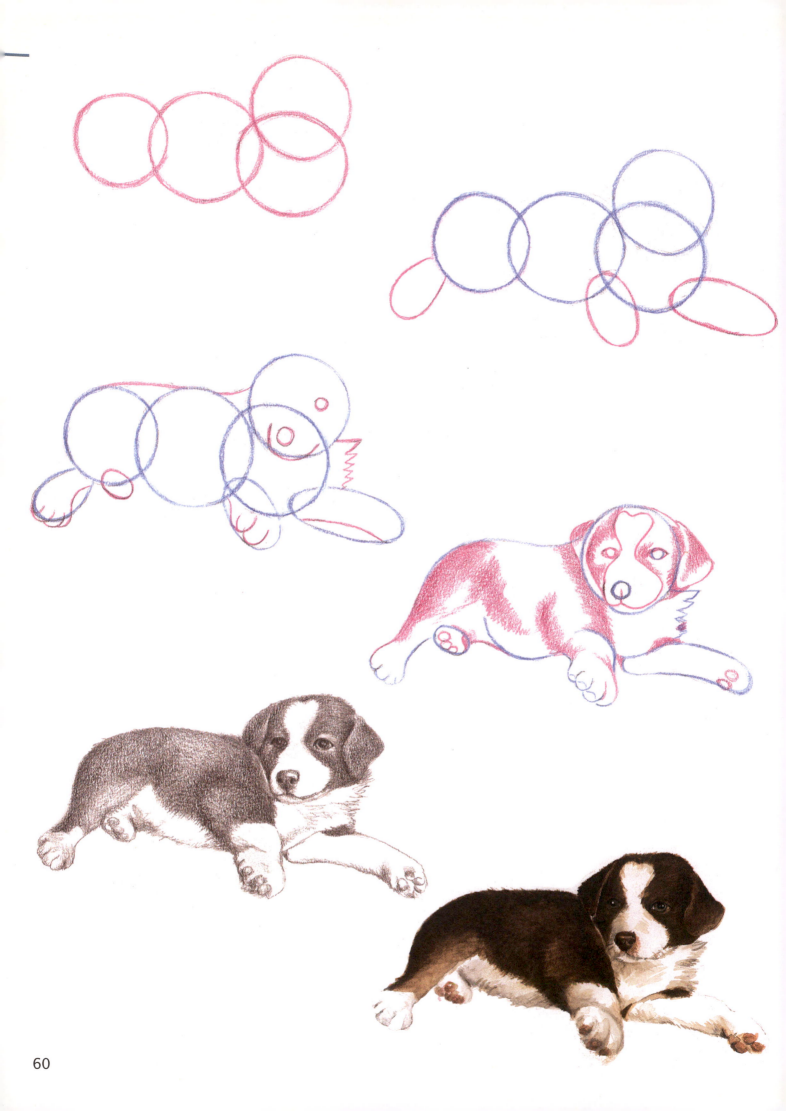

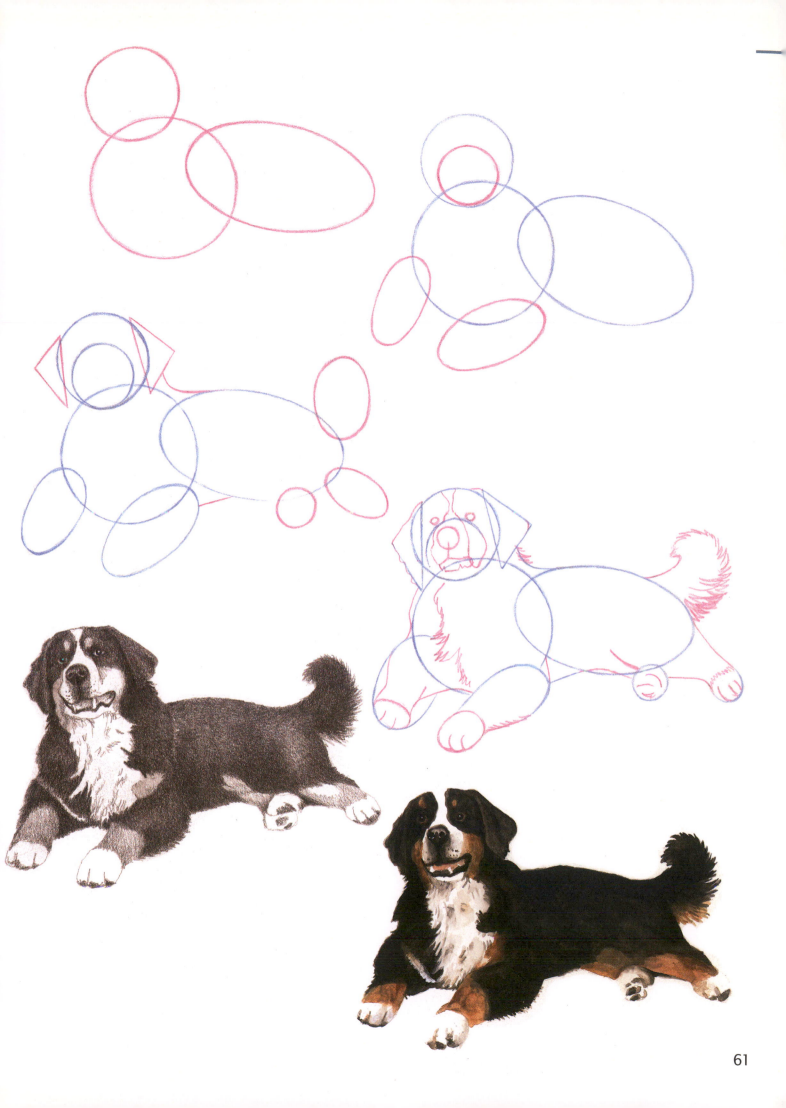

61

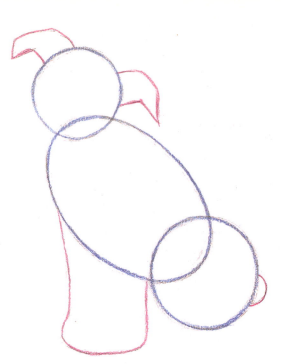

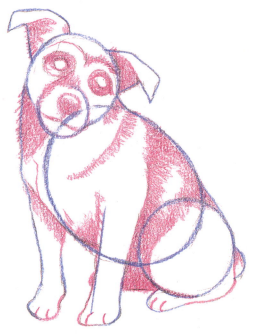

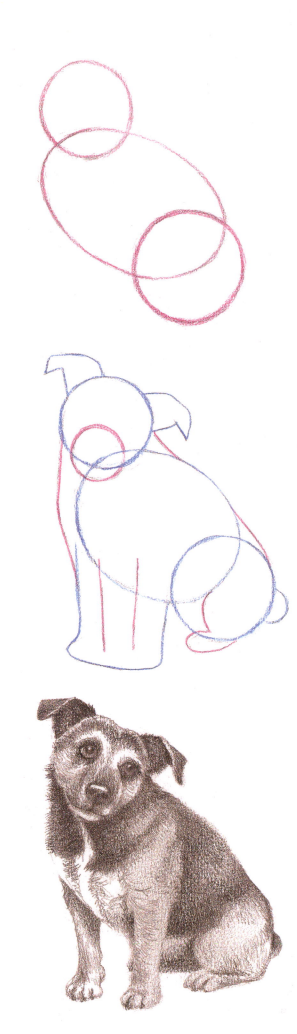

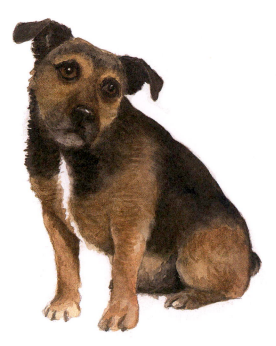

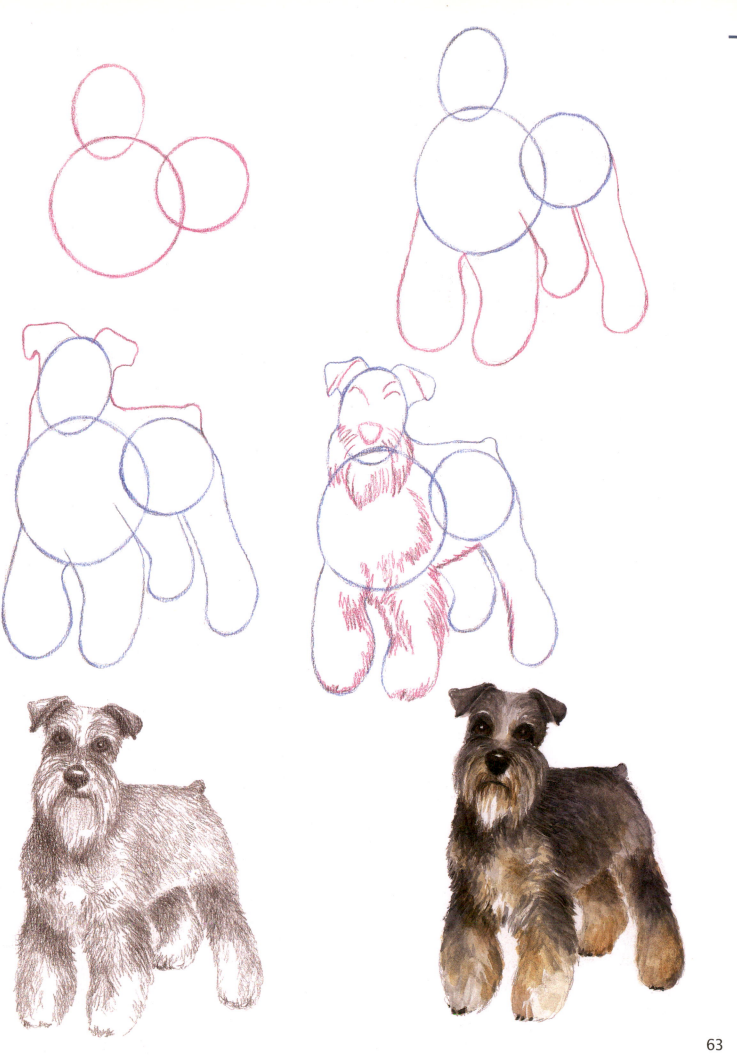

Horses

This chapter will inspire you and act as a starting point to help you develop an understanding of horses and an ability to capture their characters. A broad range of these animals are here in both static and dynamic positions, from rolling to rearing and from standing to galloping. Different breeds are included, with varying colours and markings. Look at paintings and sculptures and this will teach you about the form, energy and essence of horses. In the following pages a series of simple shapes demonstrate how to draw a horse's structure, proportions and basic anatomical detail.

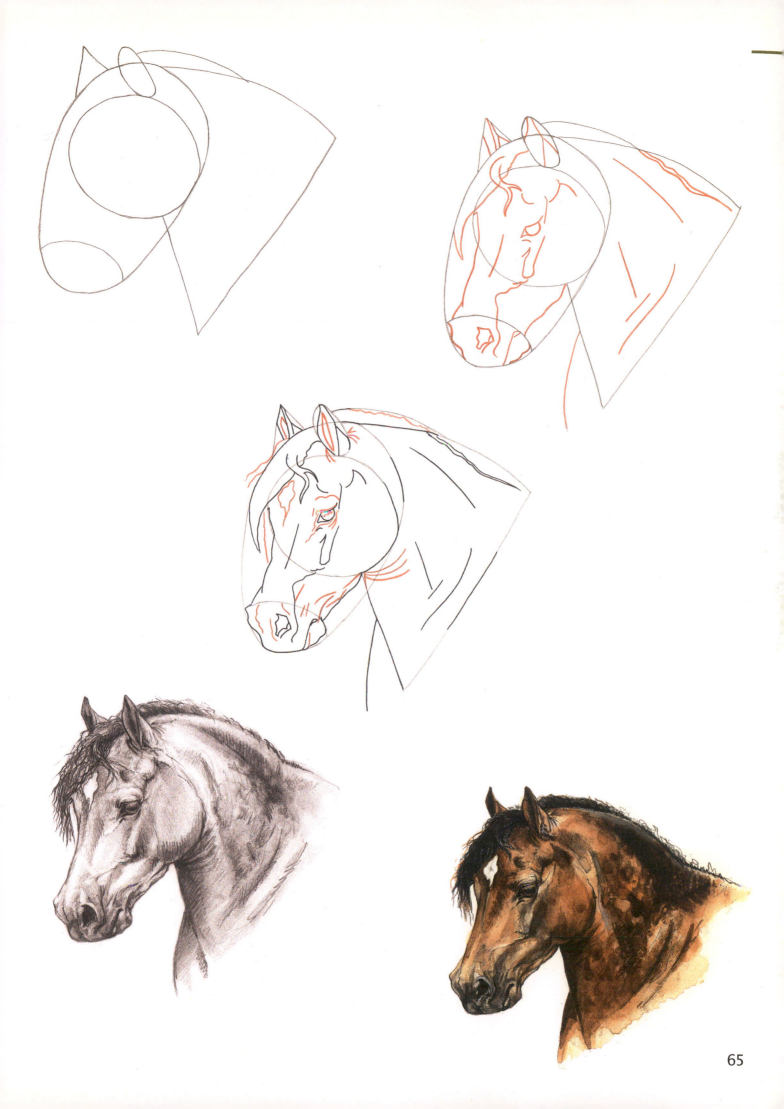

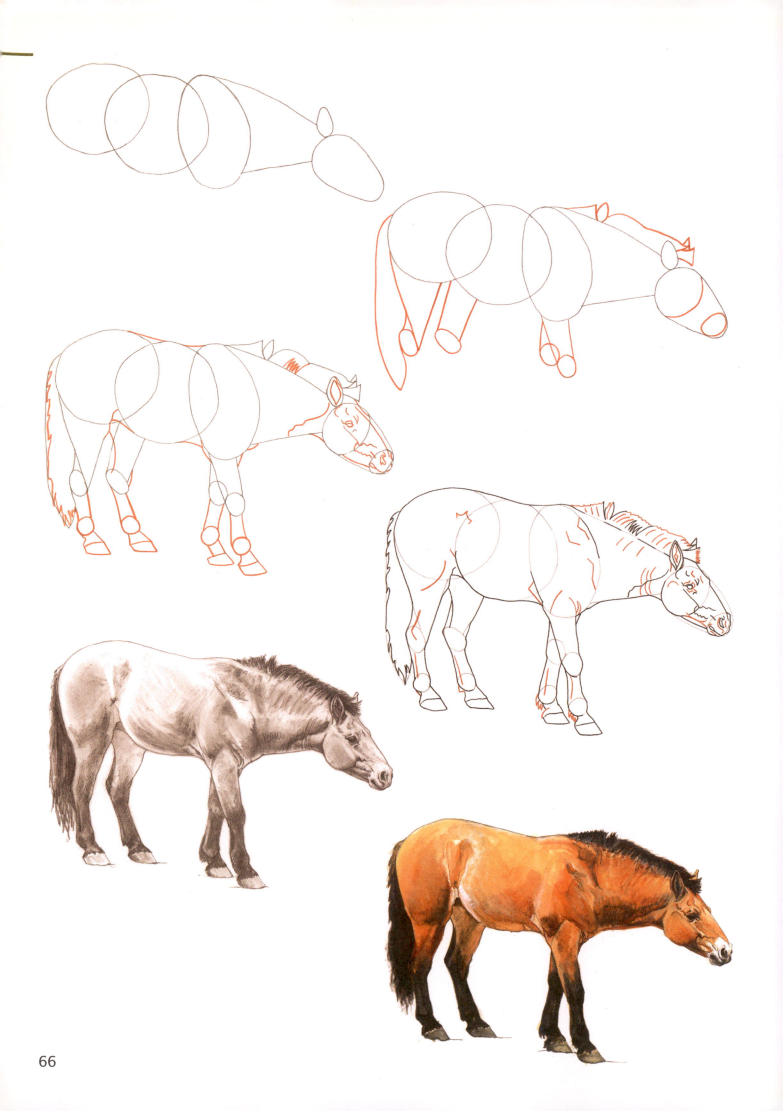

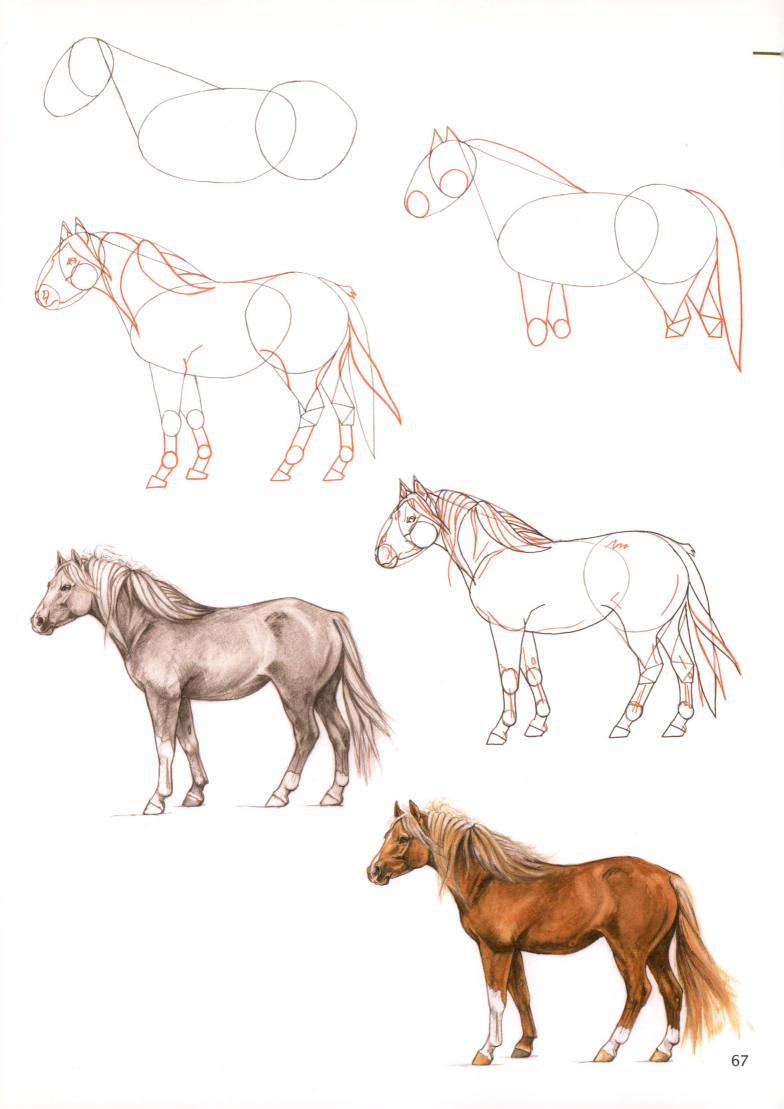

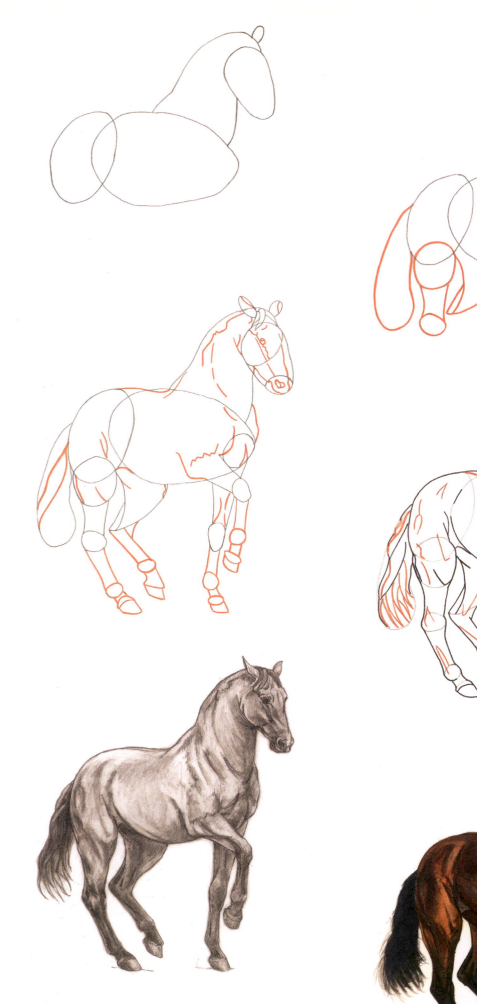
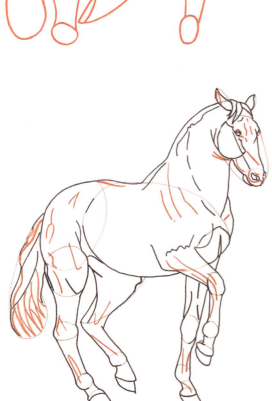
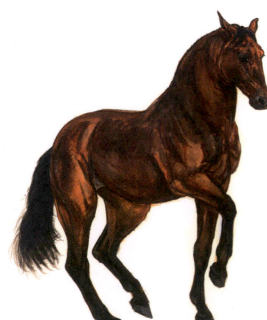

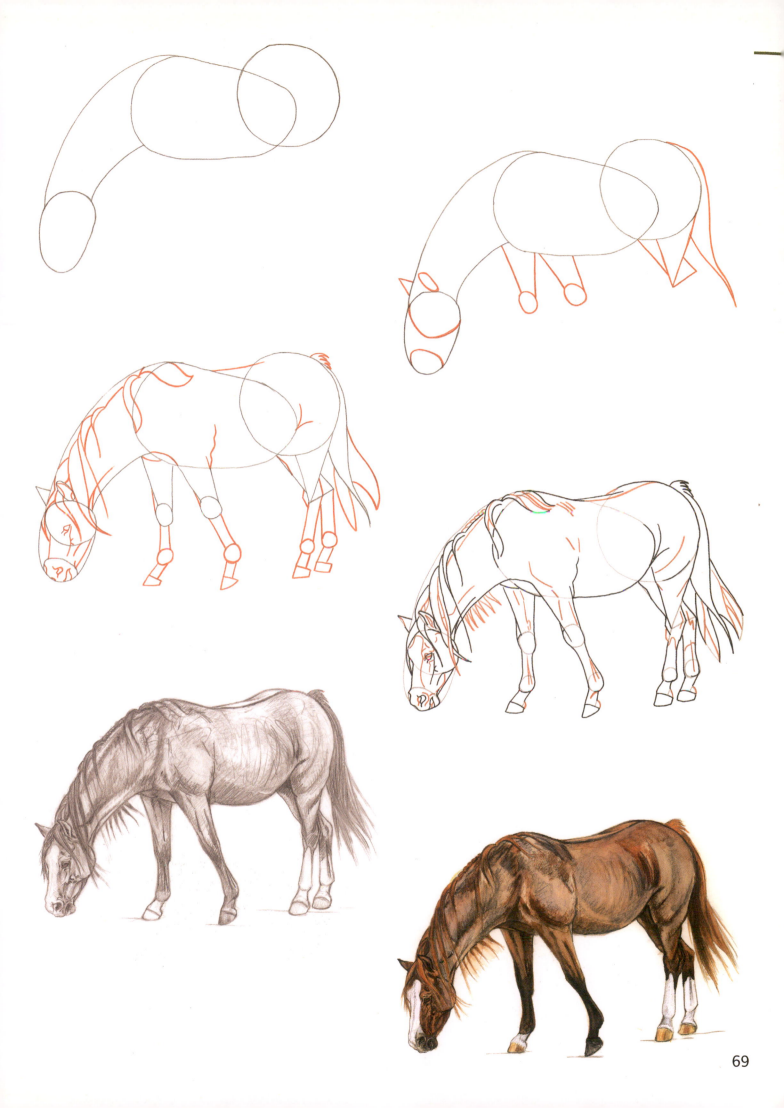

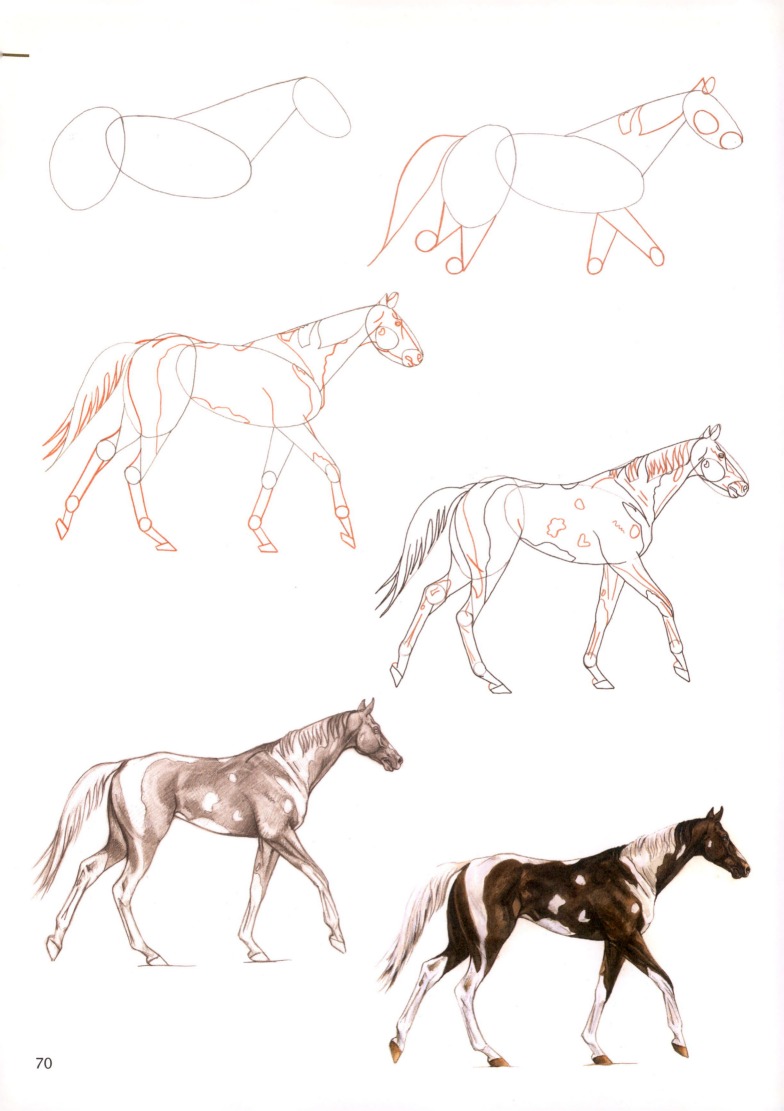

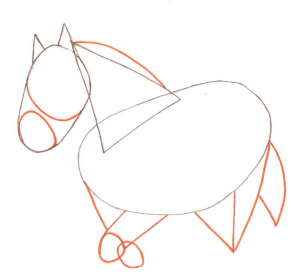
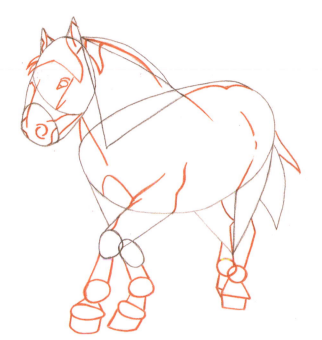
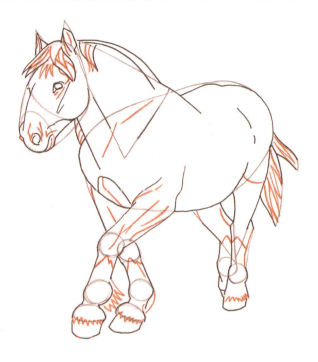
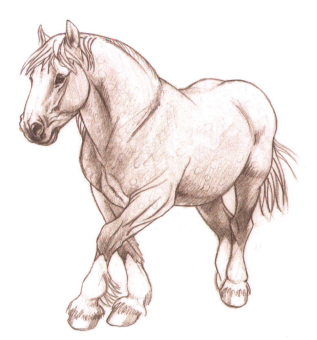
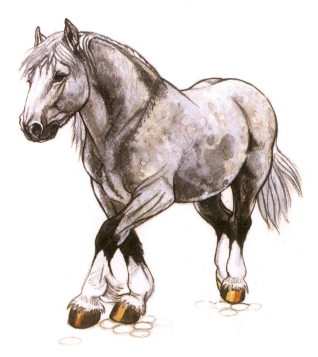

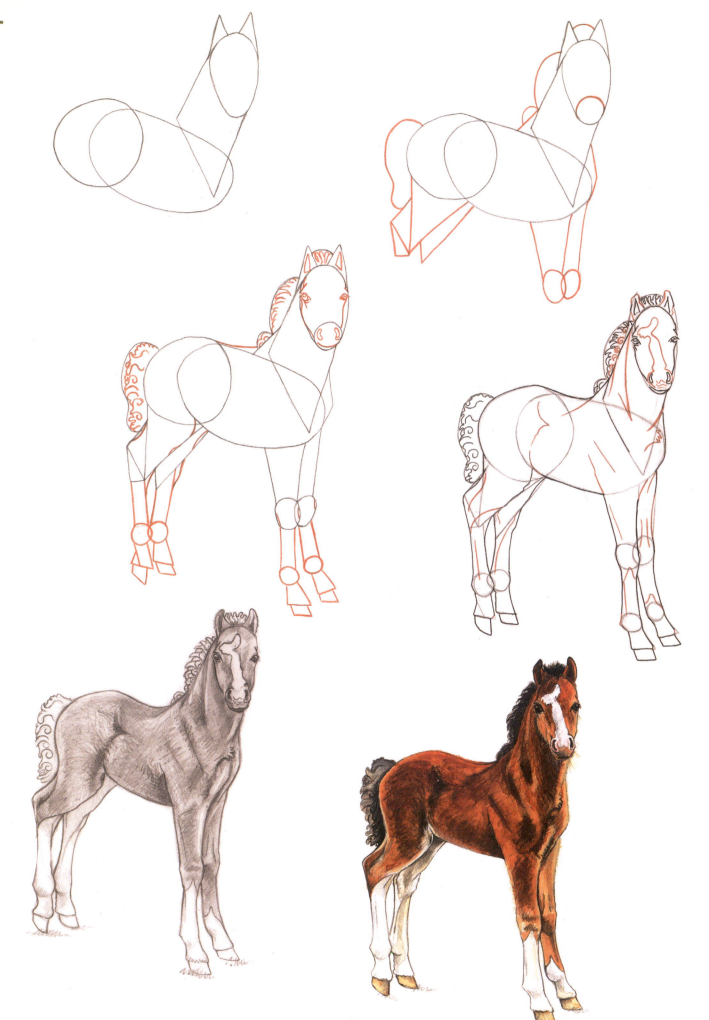

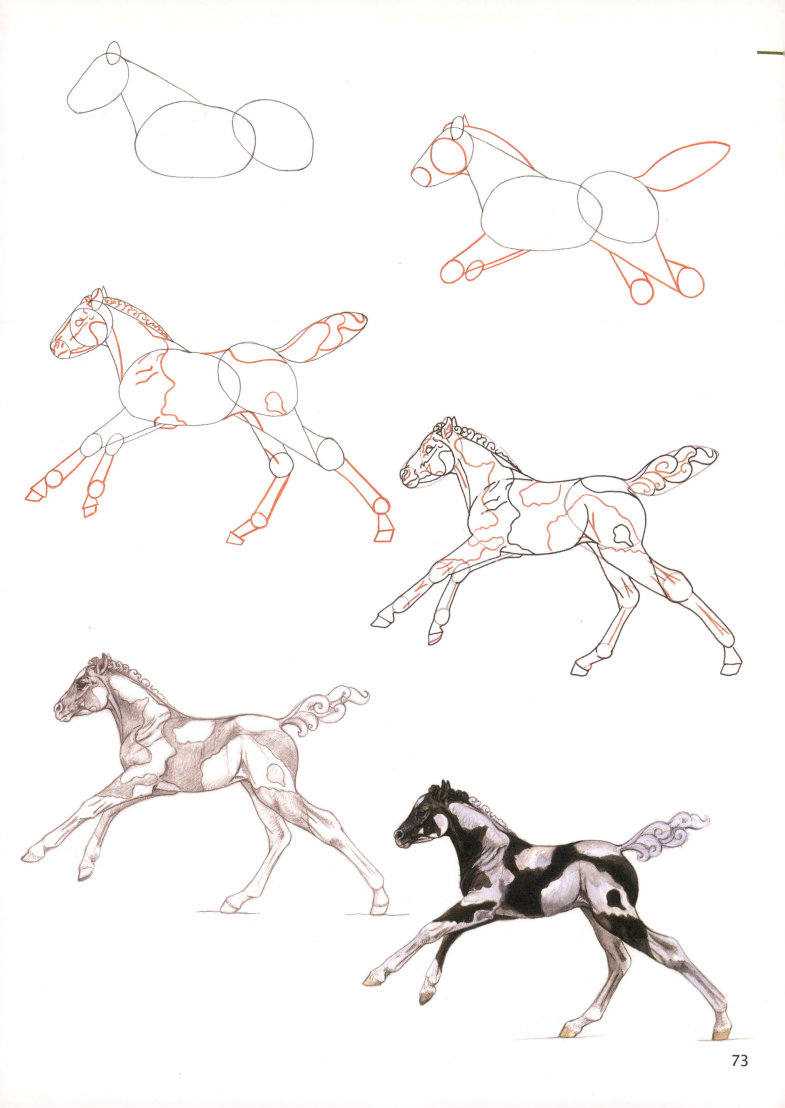

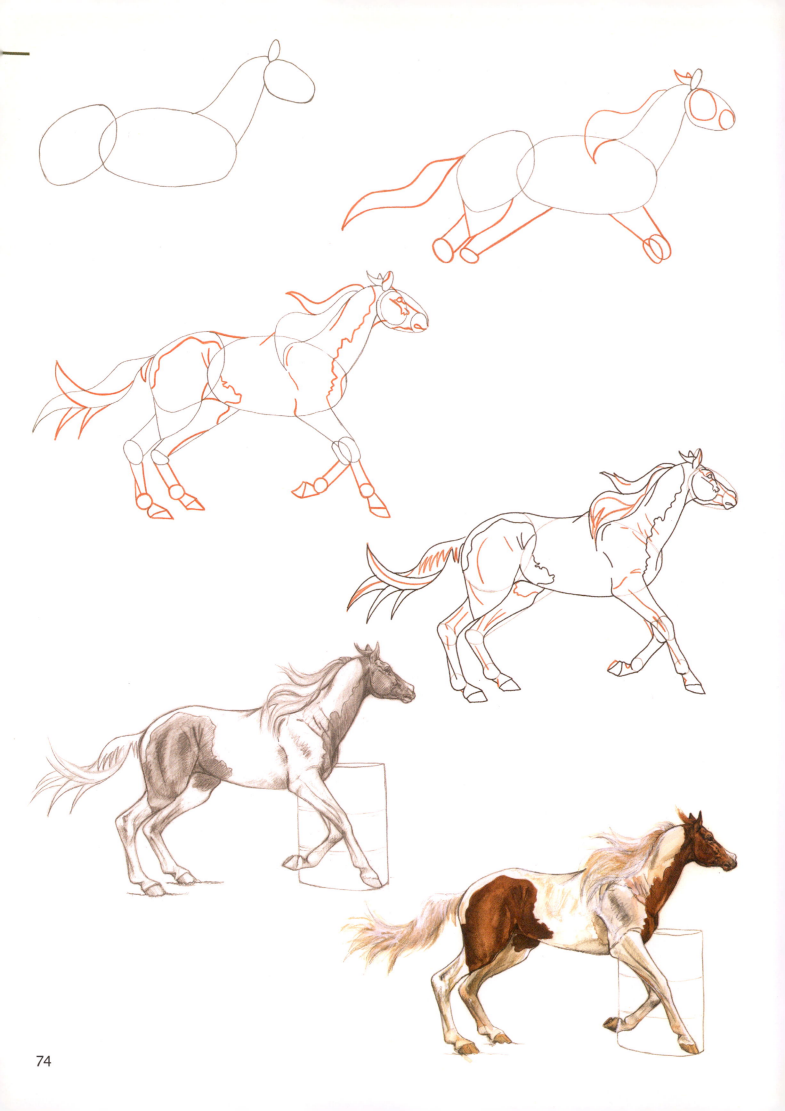

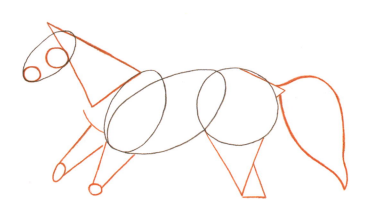
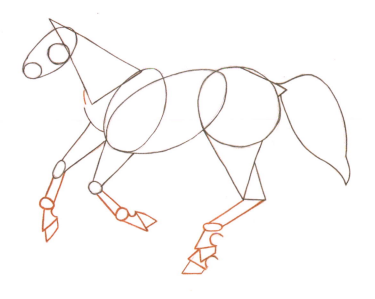
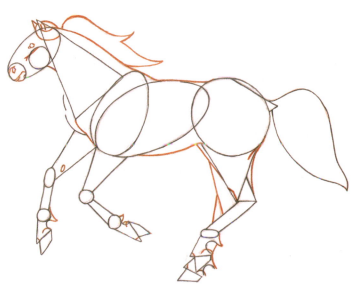
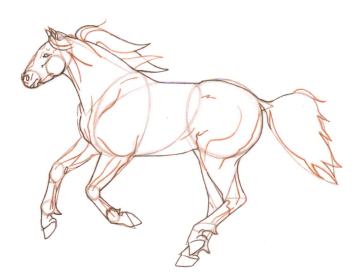
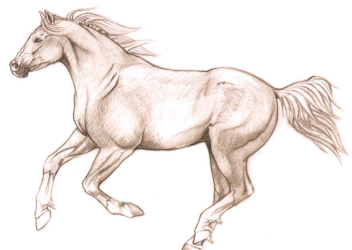
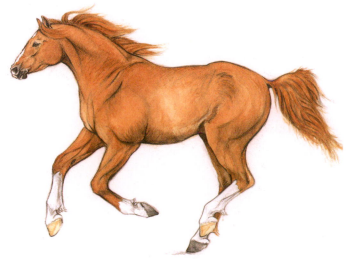

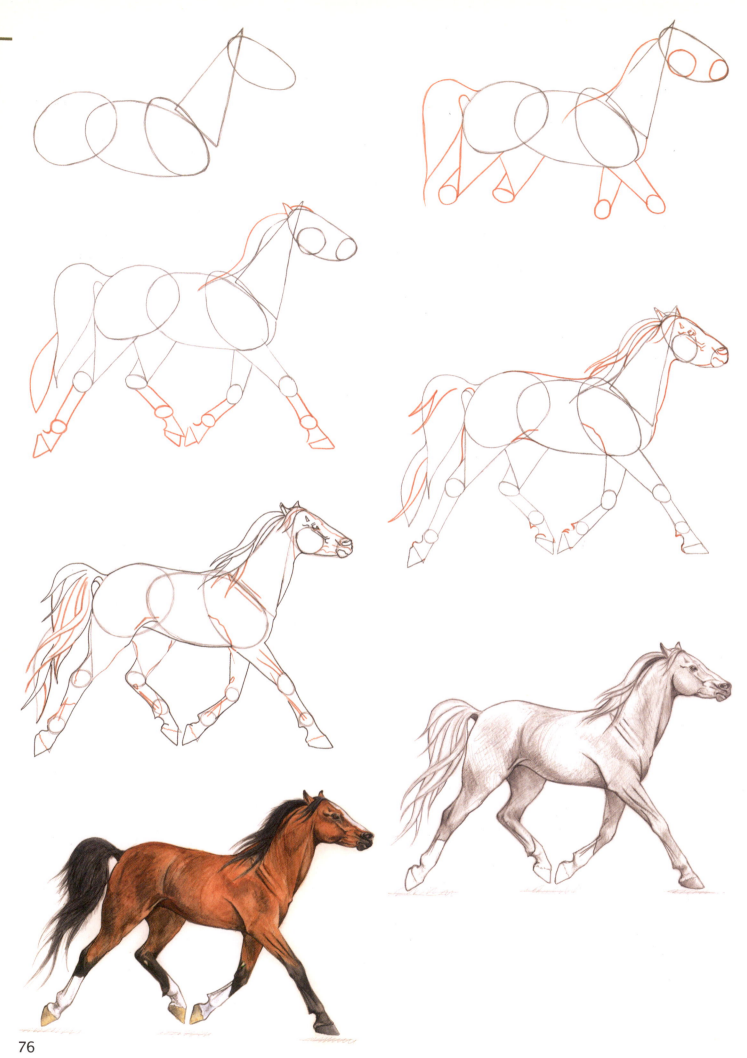

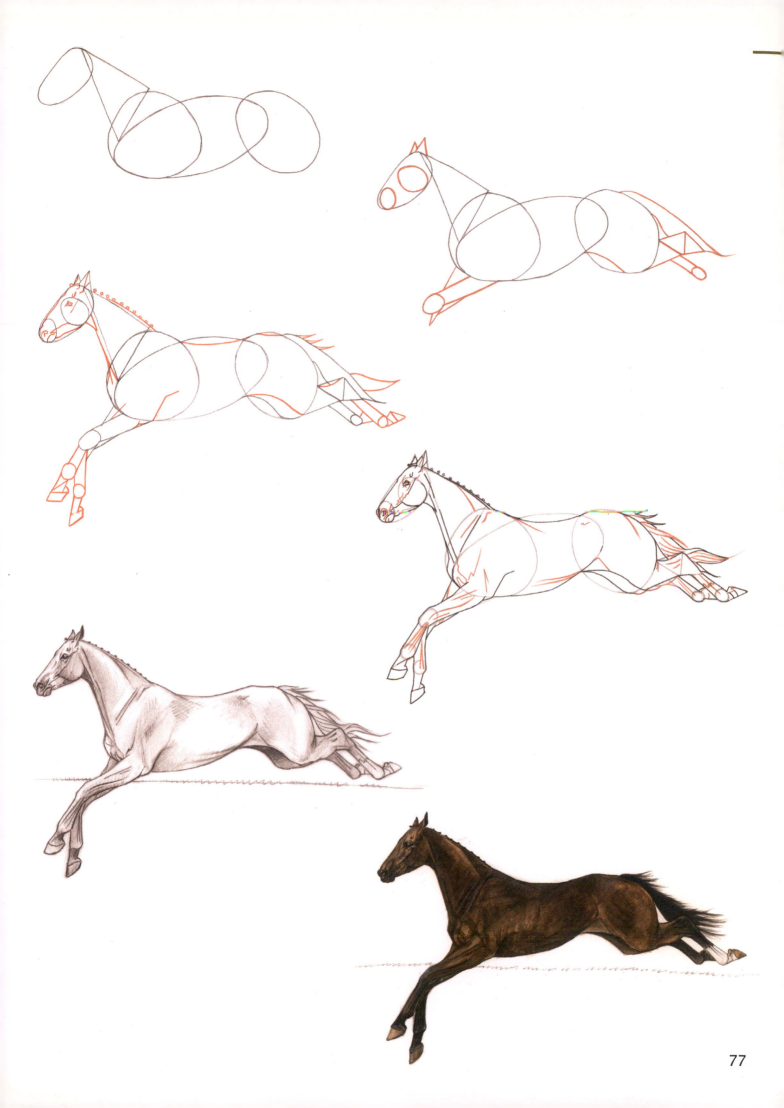

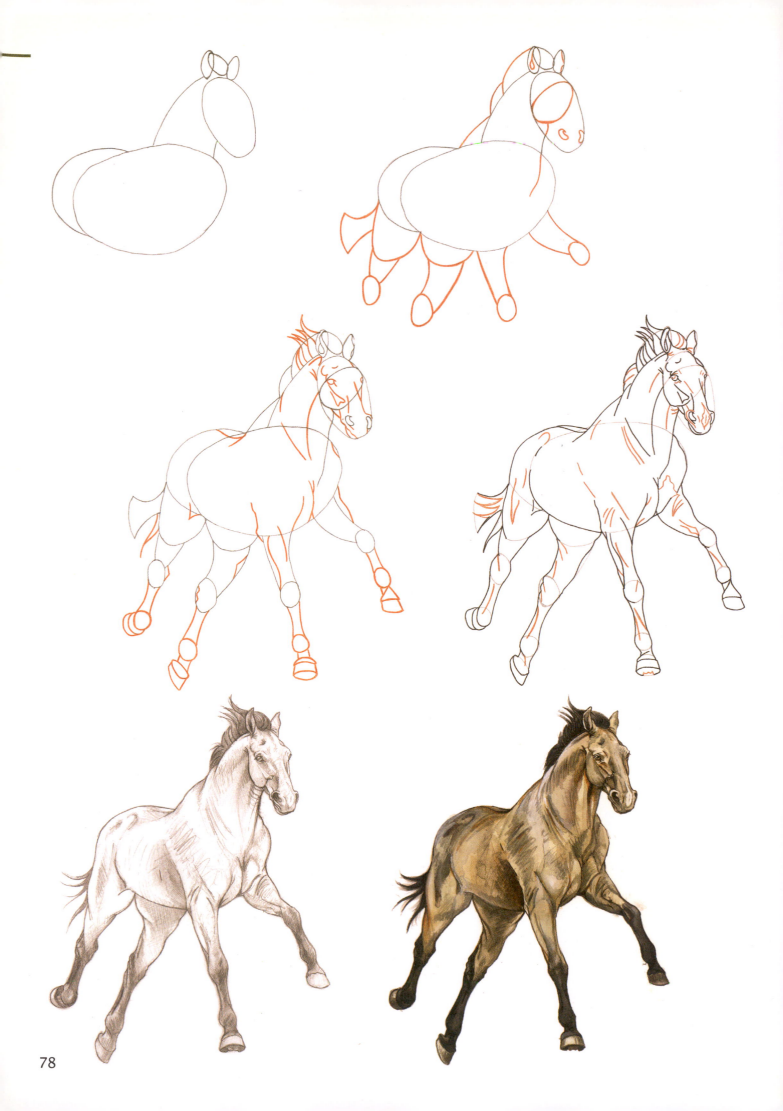

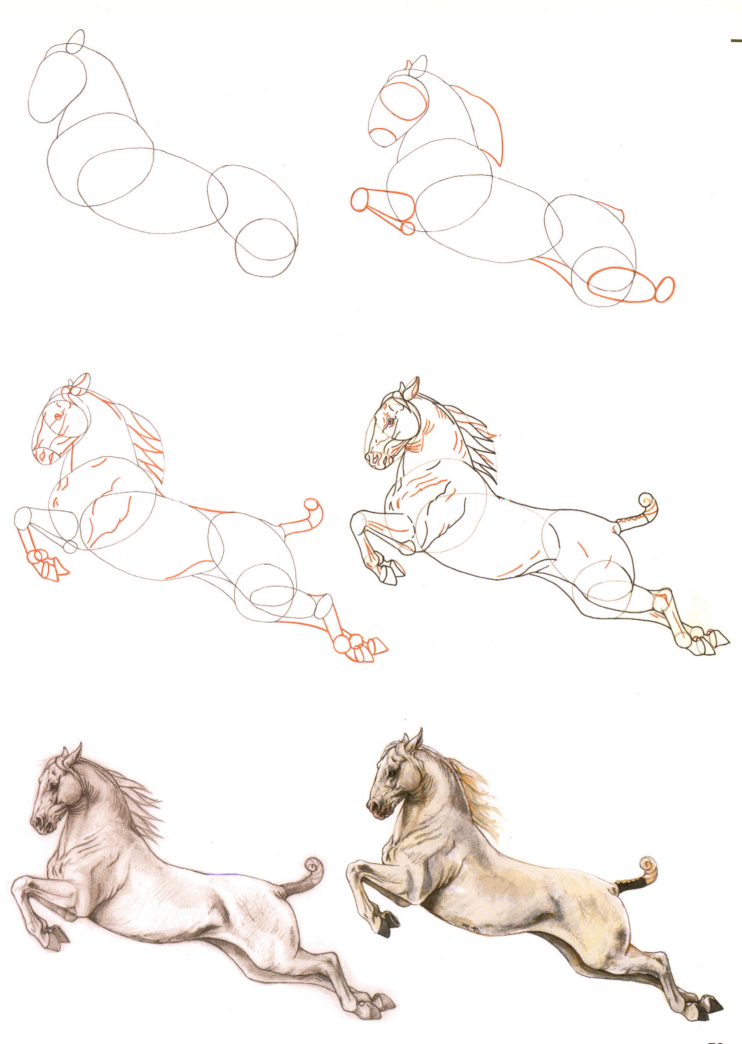

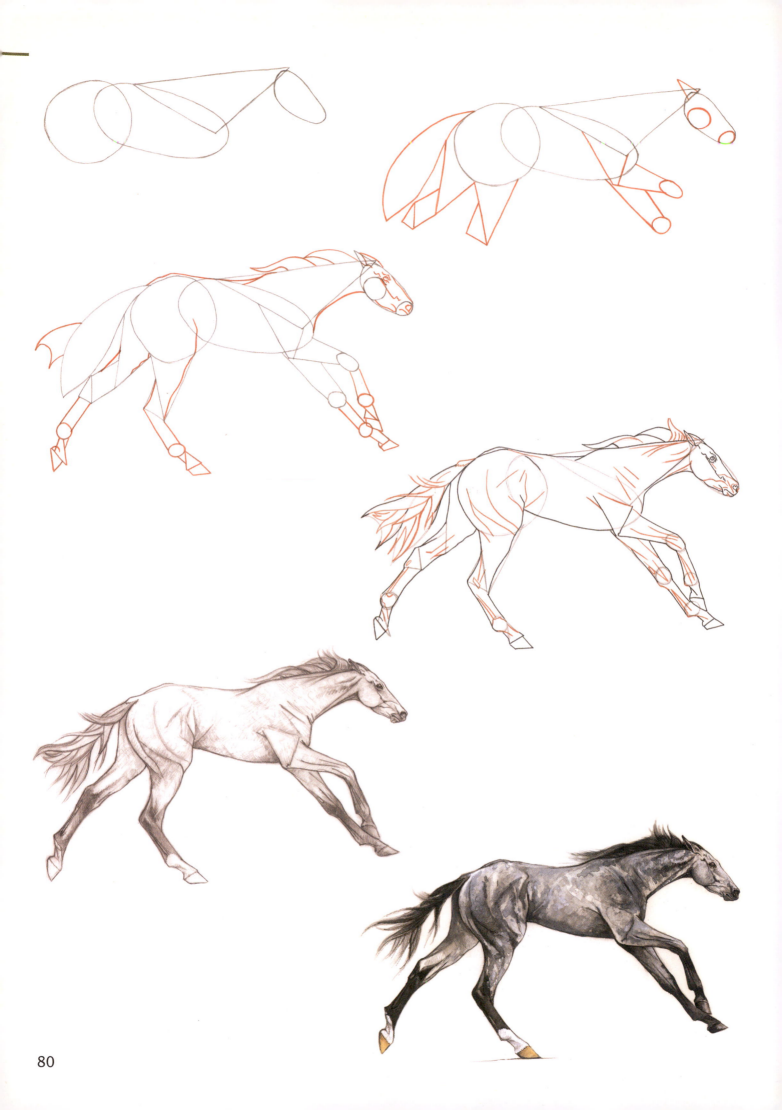

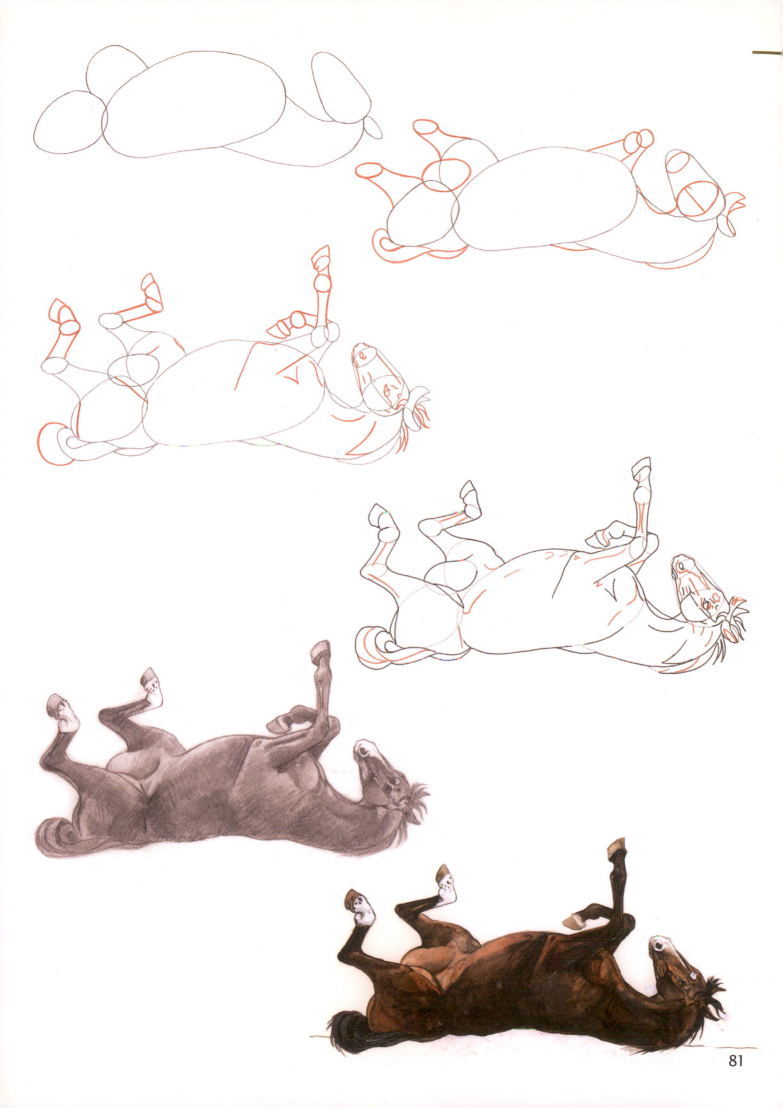

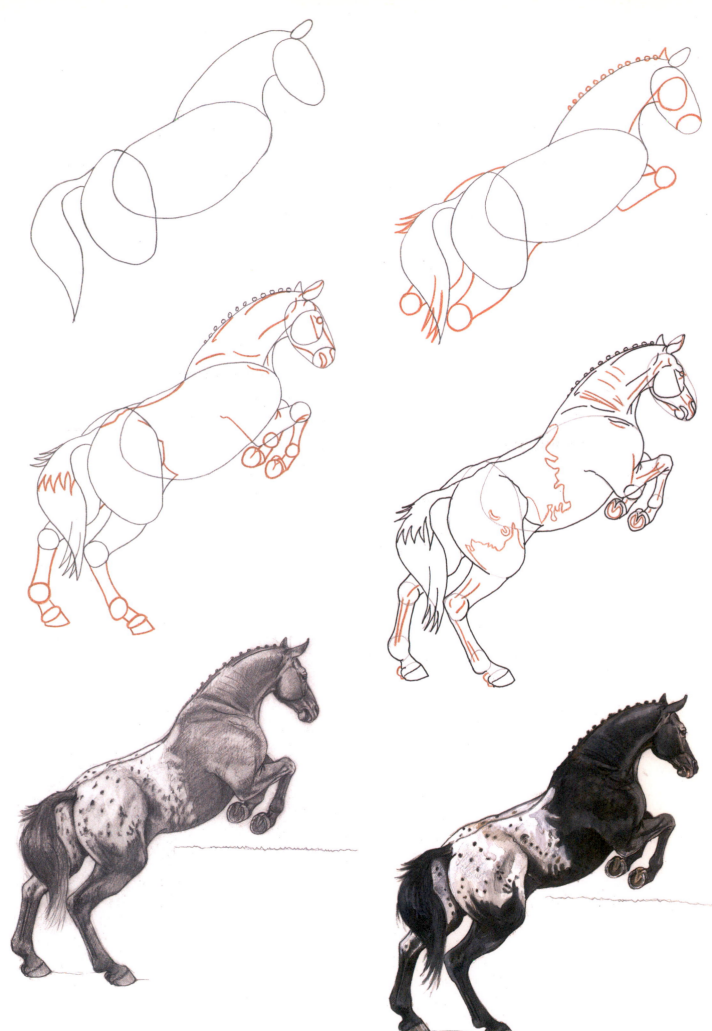

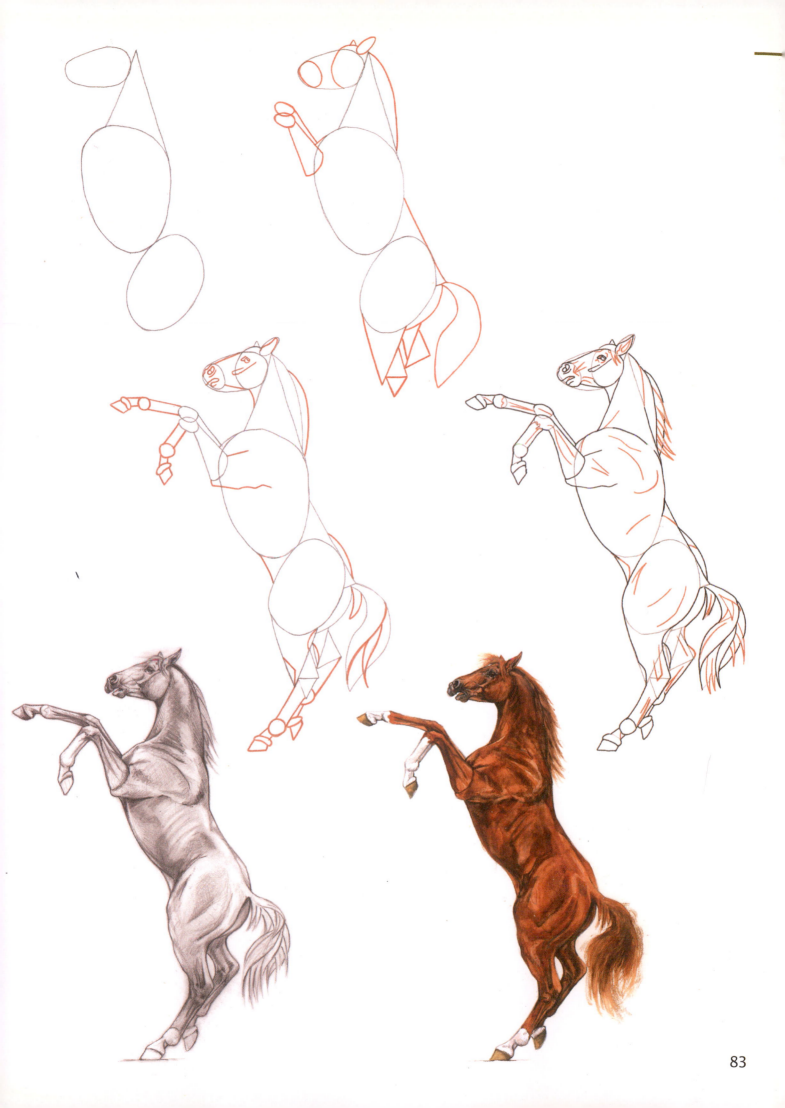

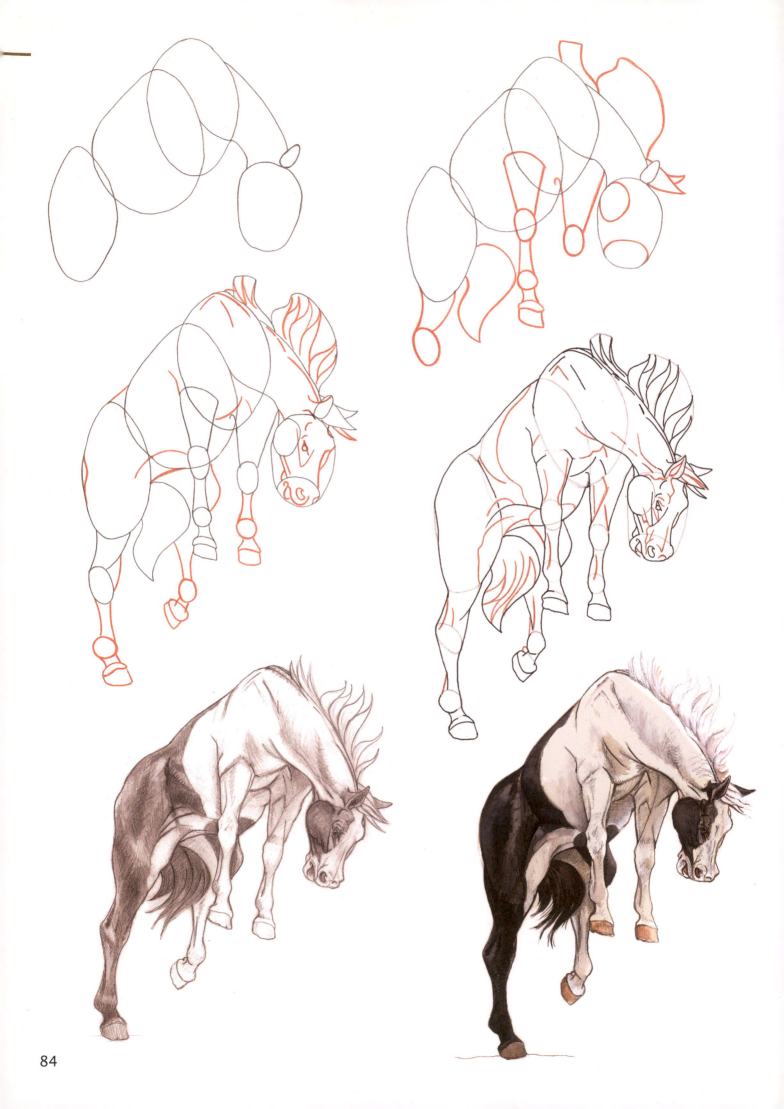

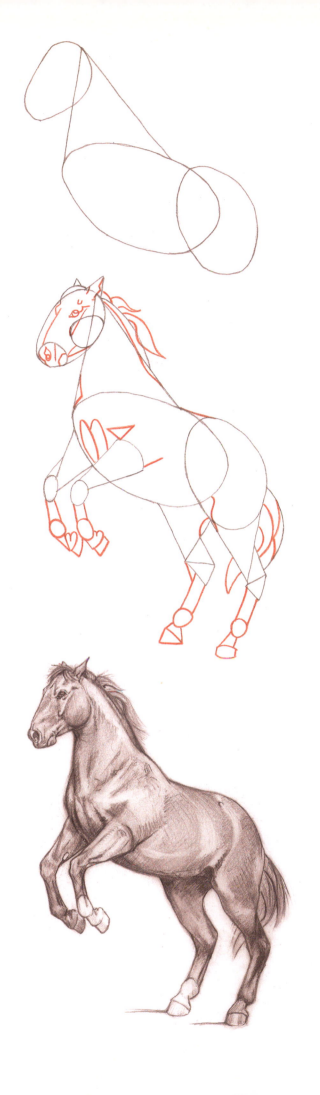
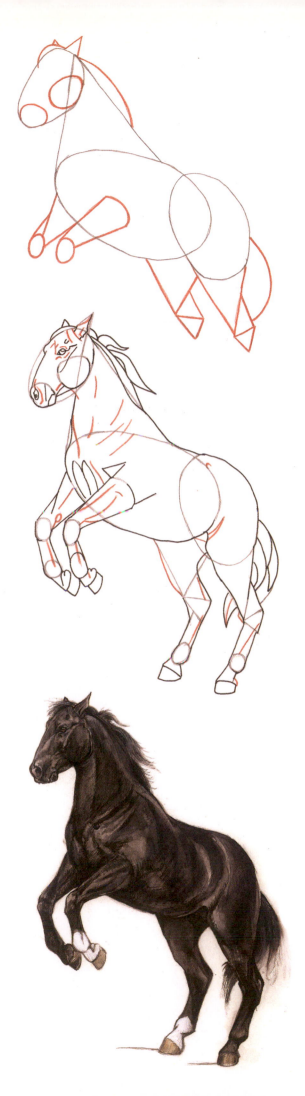

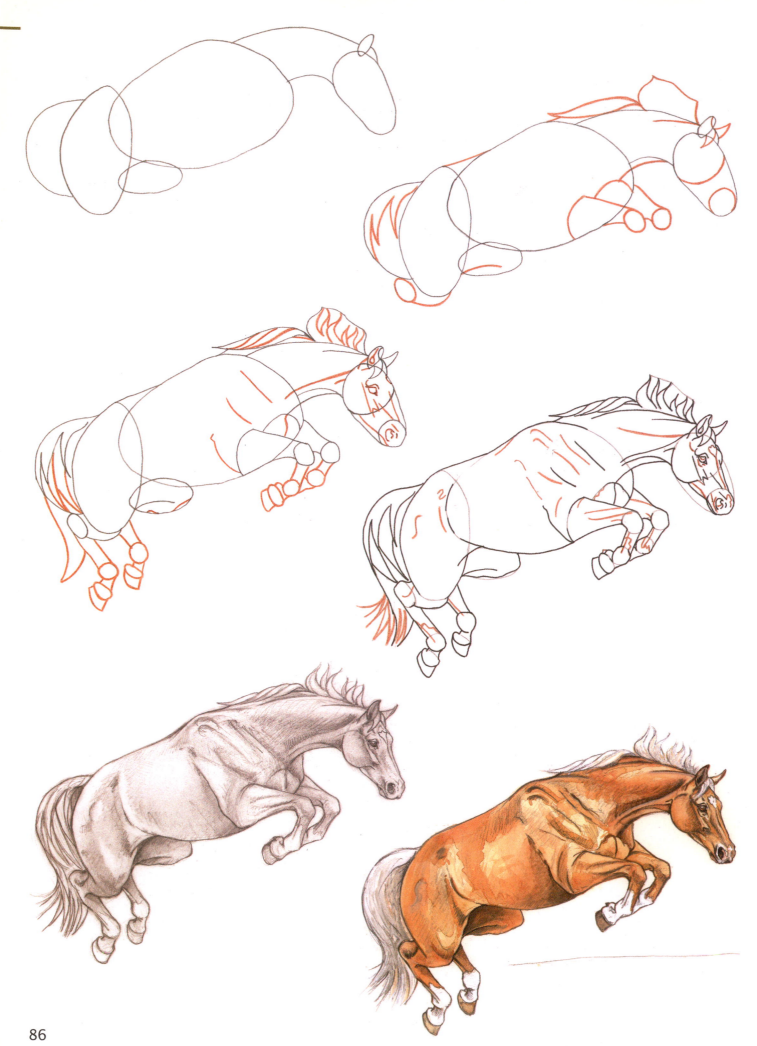

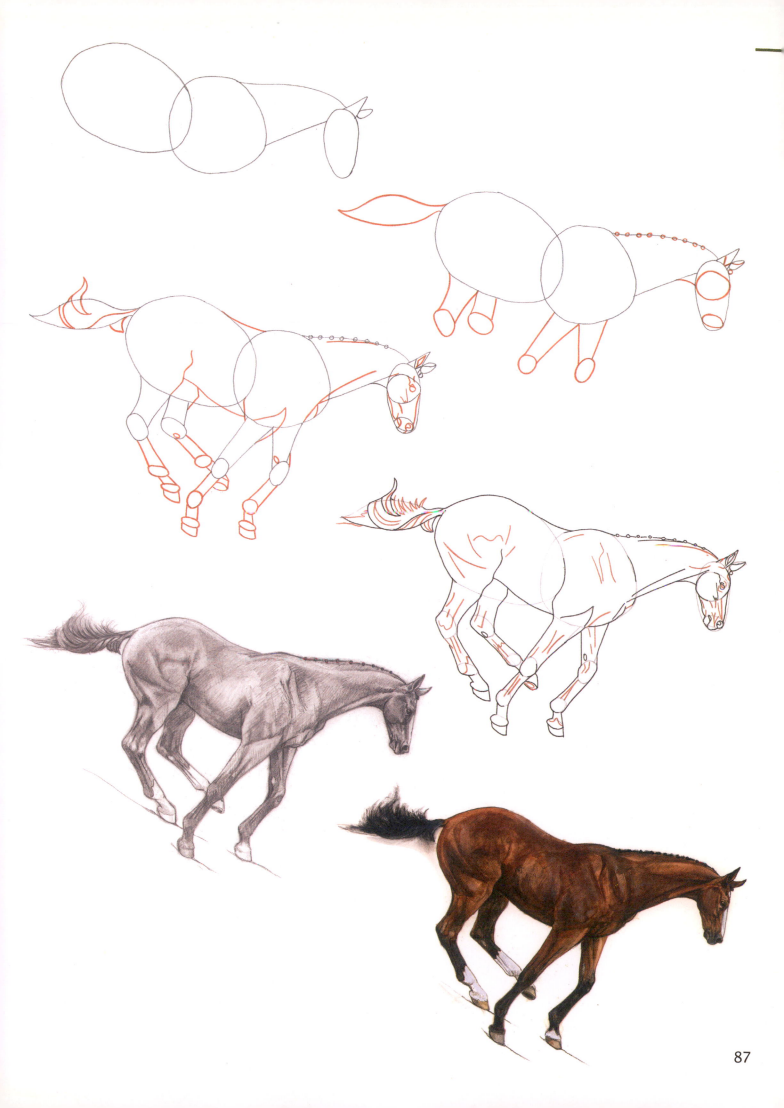

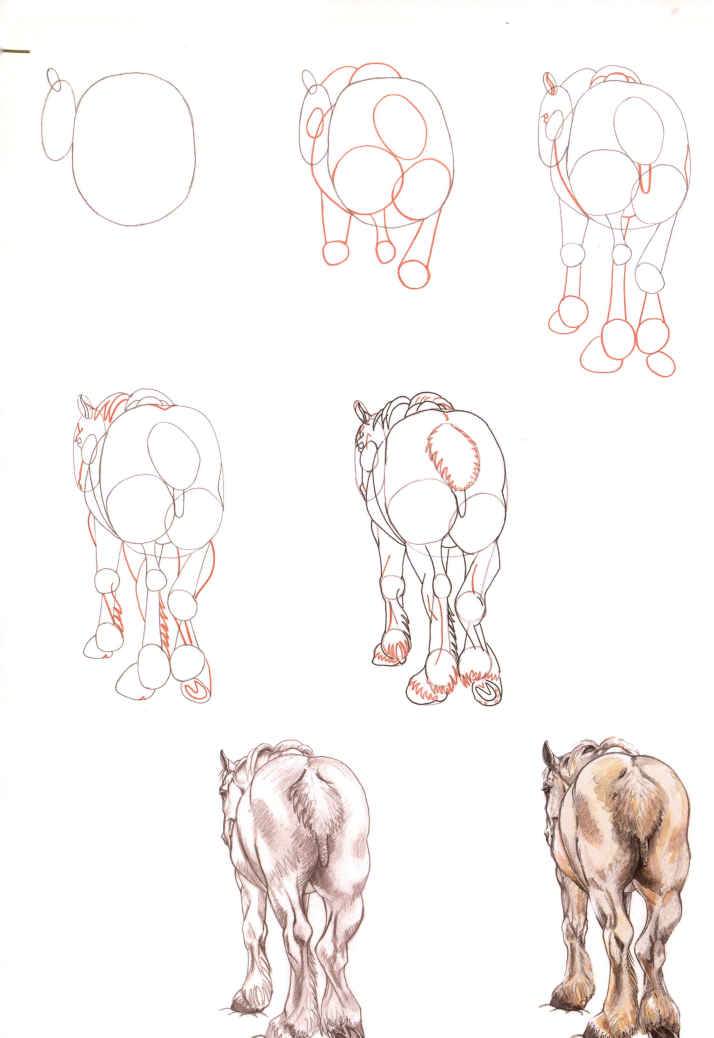

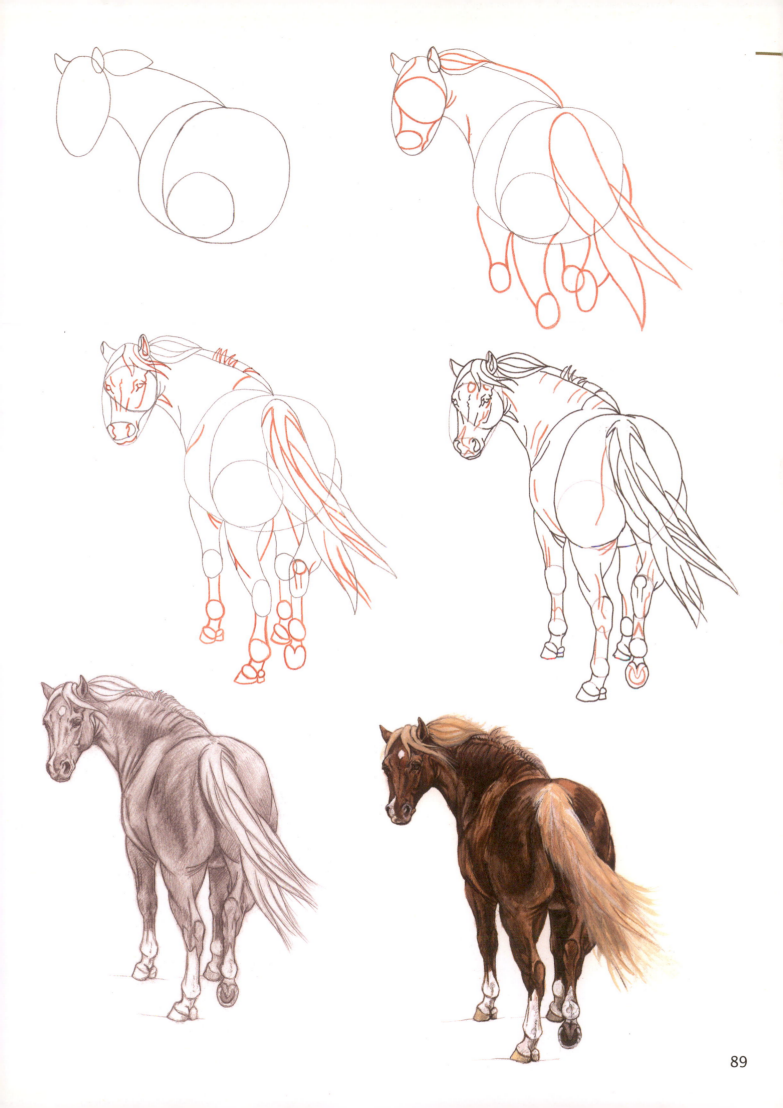

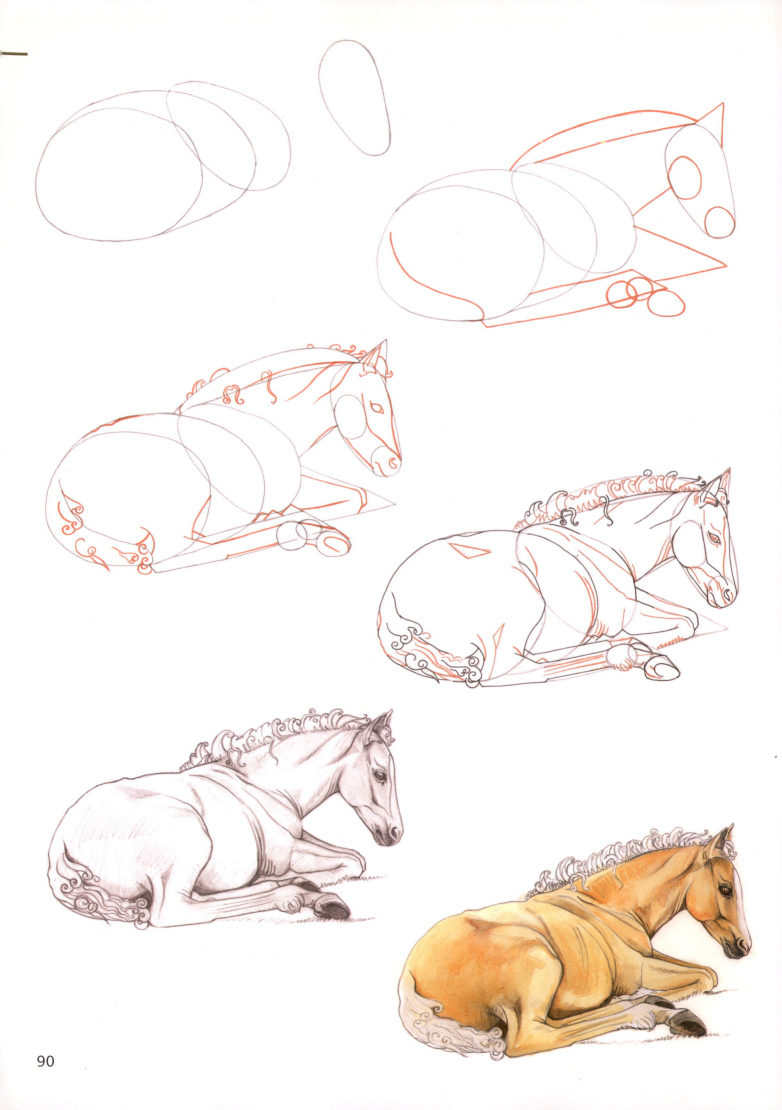

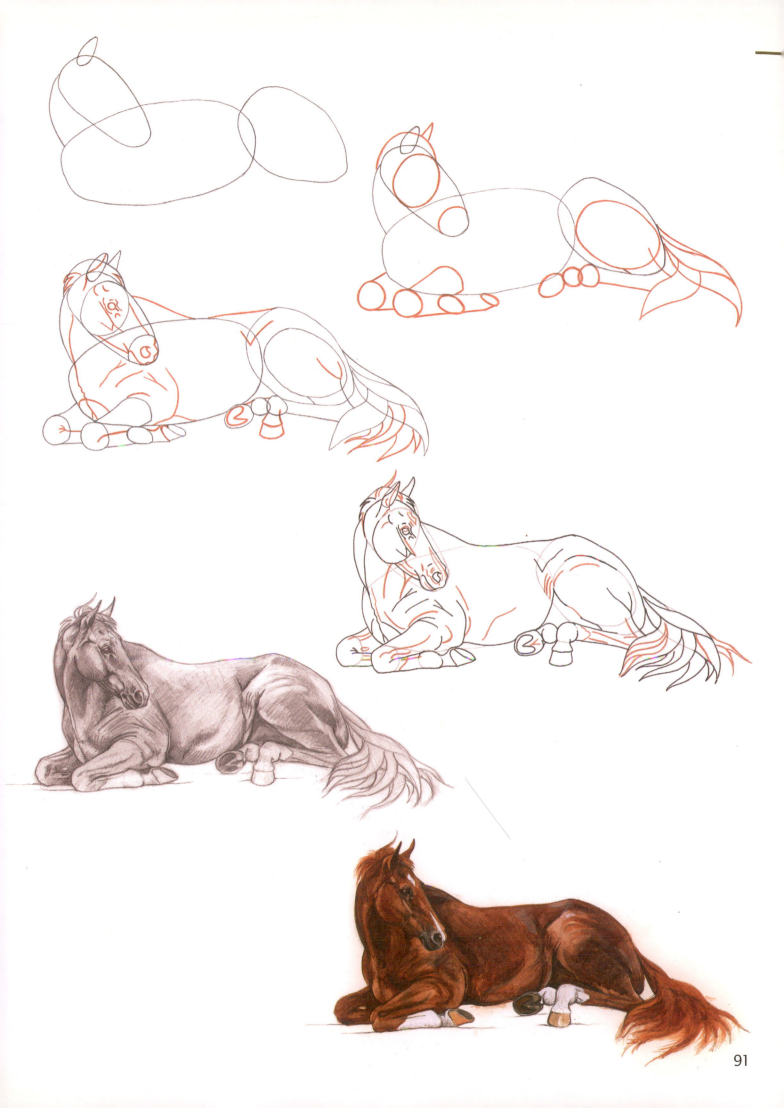

Wild Animals

You will find an excellent selection of wild animals in this chapter. Following the same methods as before, start with basic shapes and lines, and develop the forms to create completed images. A mixture of poses have been included, with details of heads and shoulders, as well as full body illustrations. Movement is important and several of the animals are shown either walking or running. The more you practise, the easier the drawing process will become, so visit zoos and wildlife parks for inspiration and use your own source material. Spend time drawing as many different animals as you can. Each one will be different: even males and females of the same species can vary considerably.

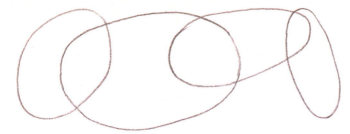

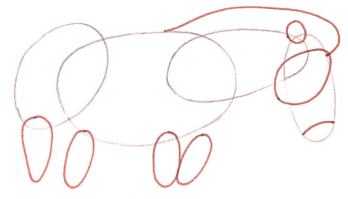

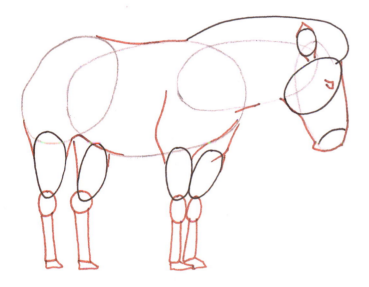

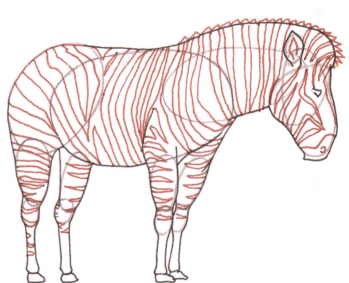

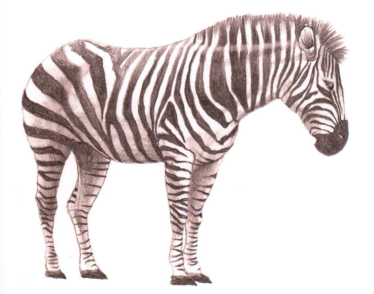

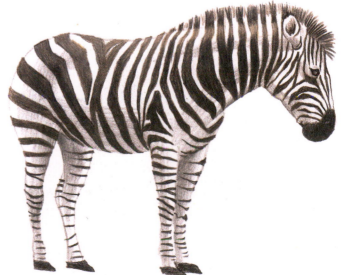

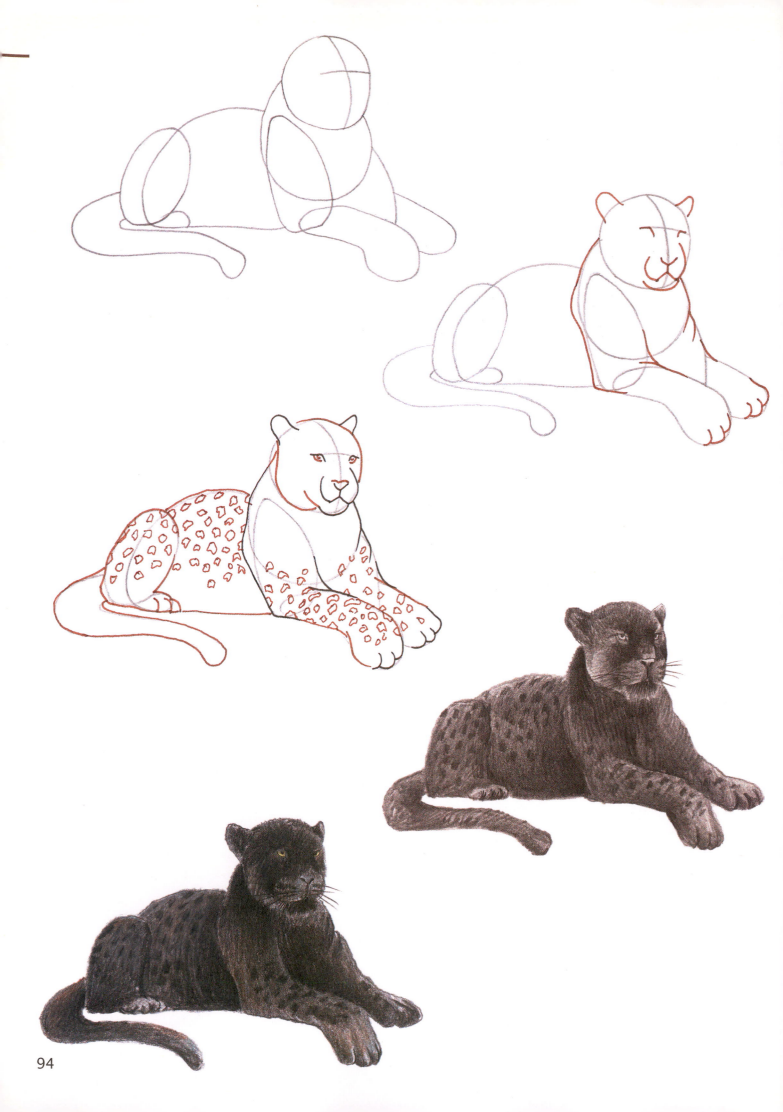

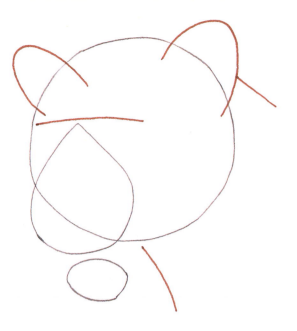
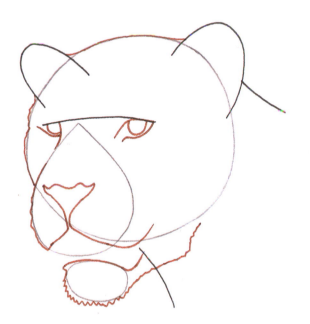
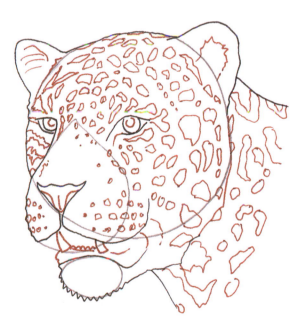
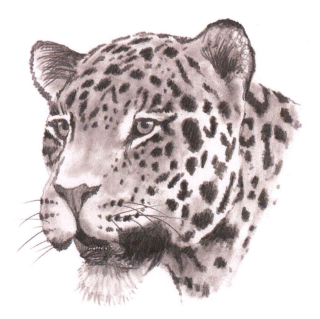
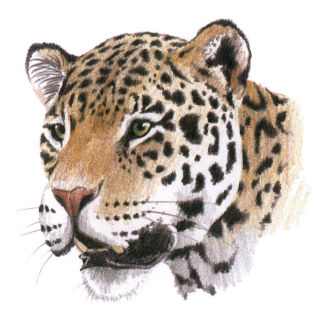

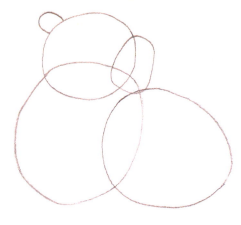

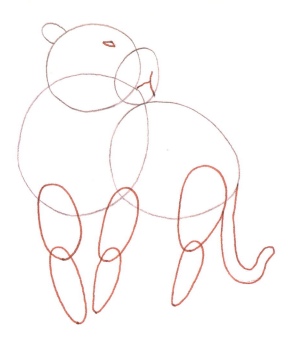

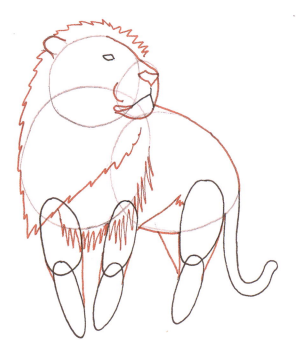

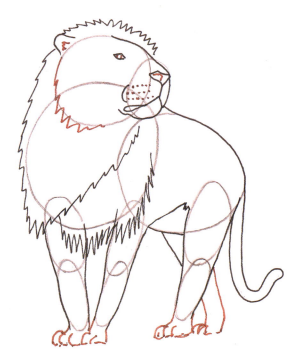

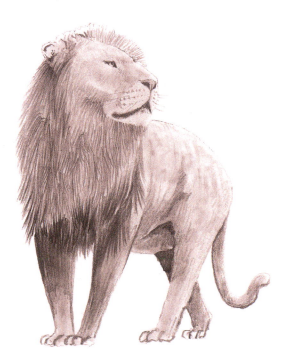

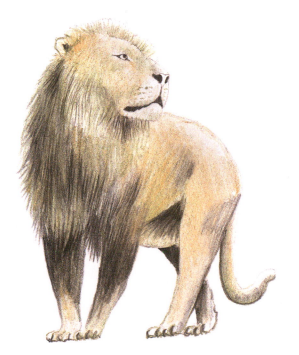

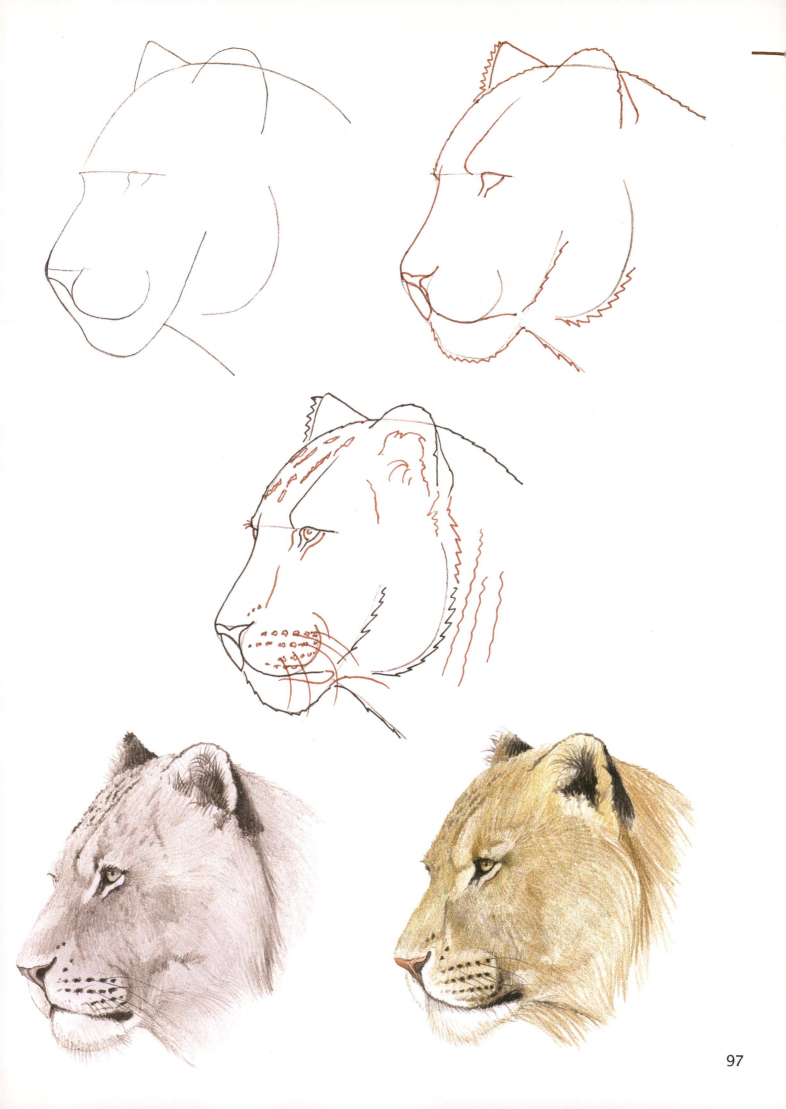

97

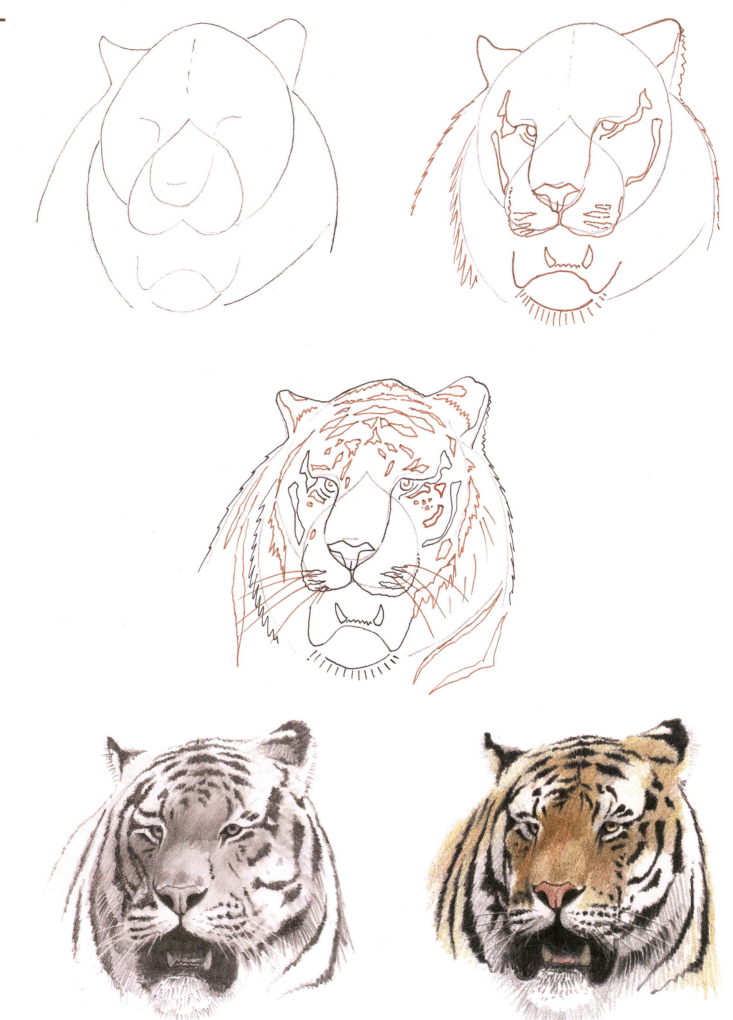

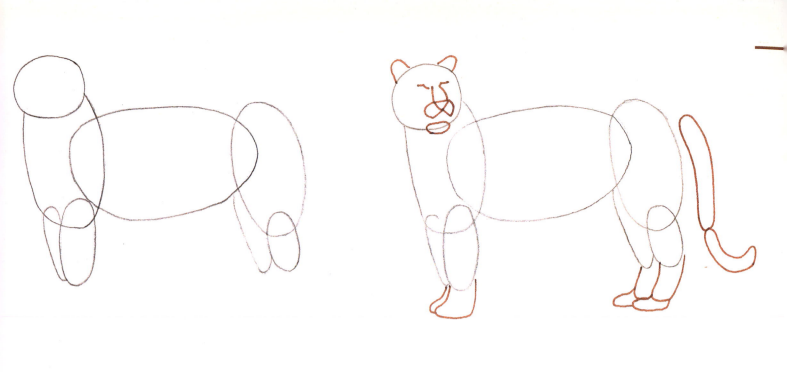

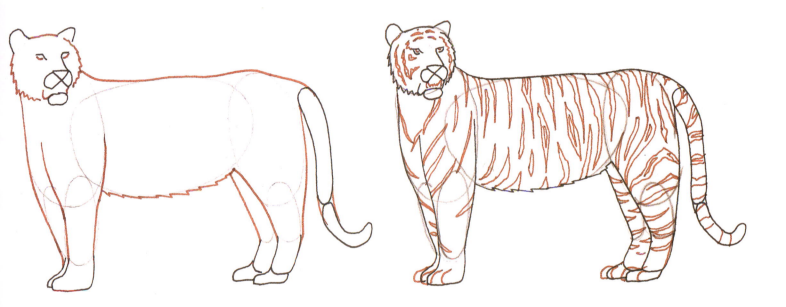

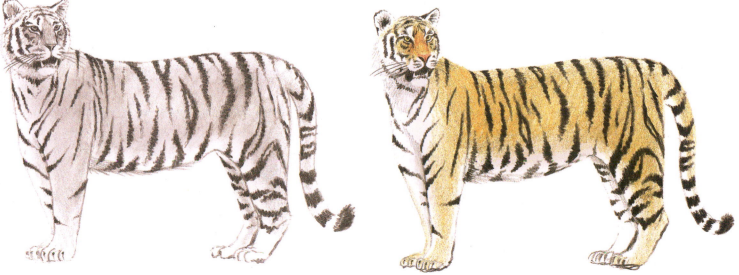

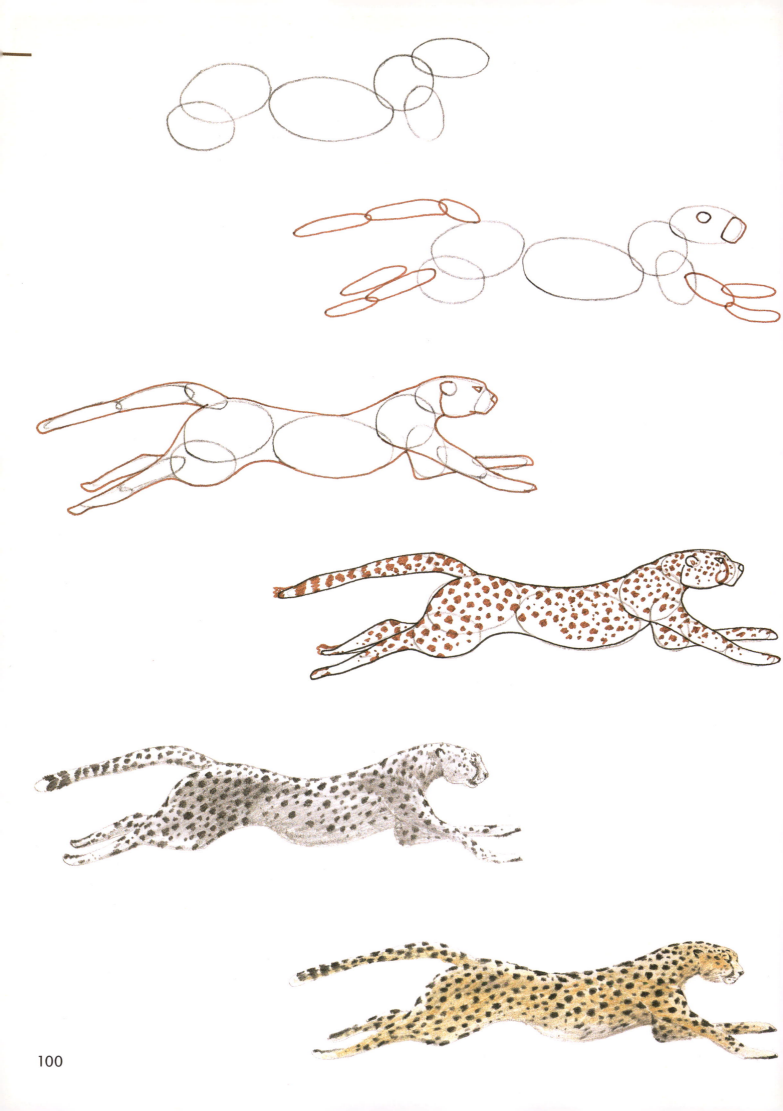

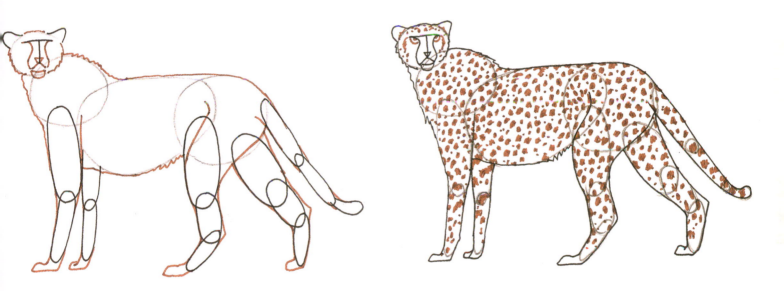
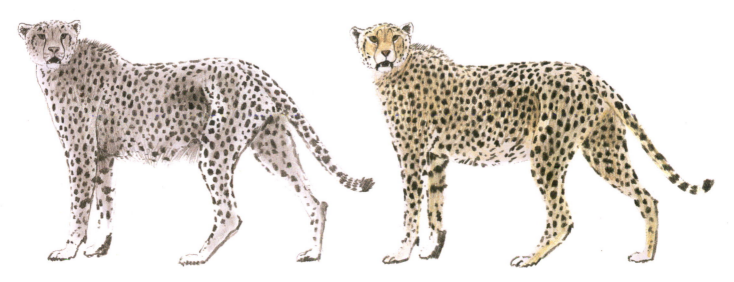

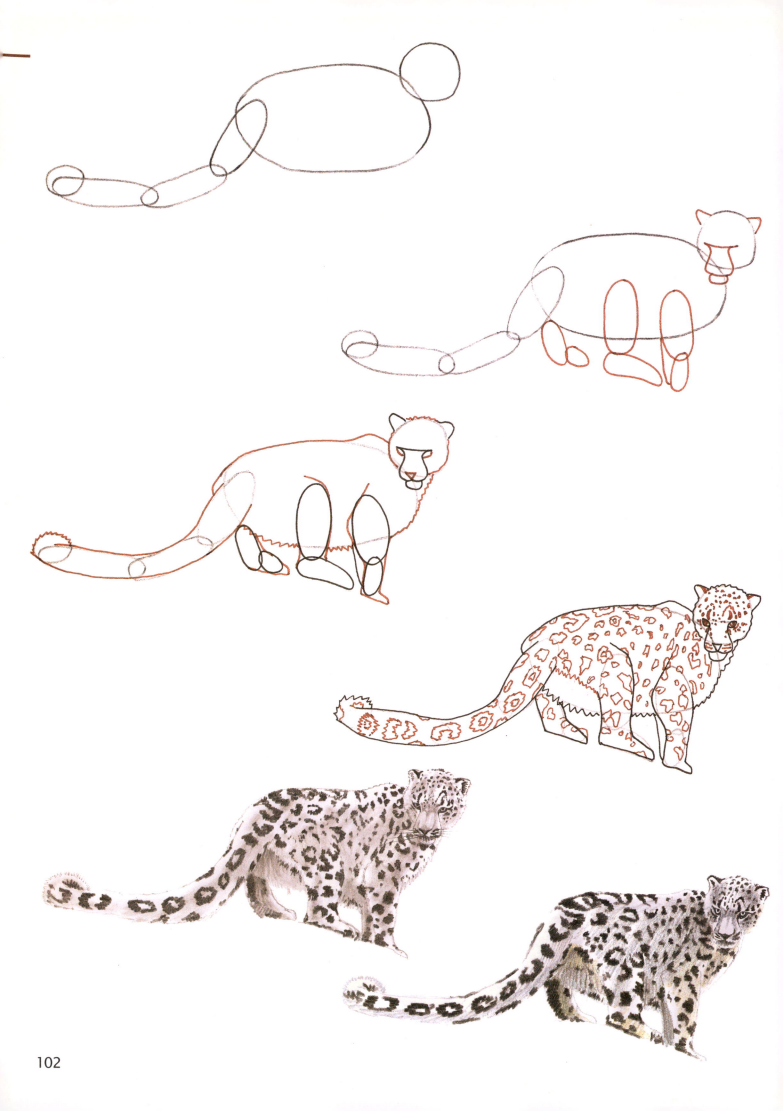

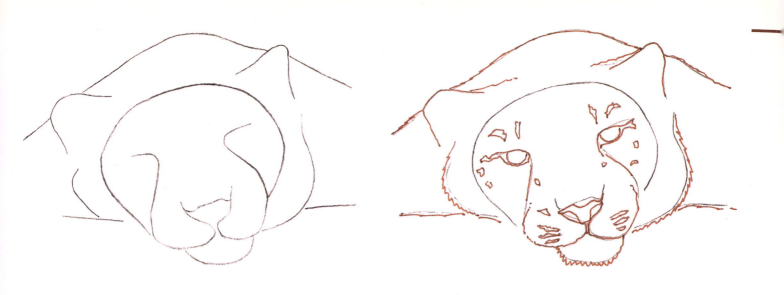

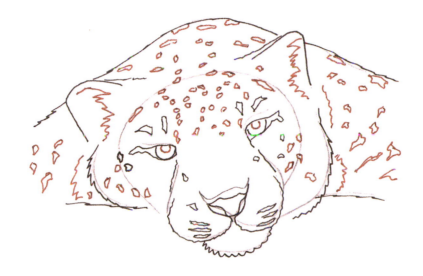

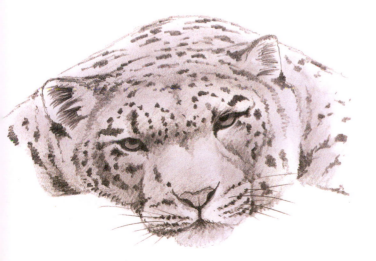

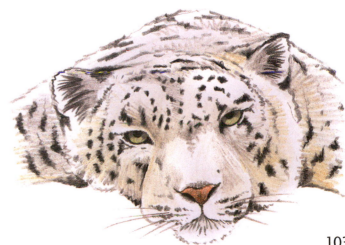

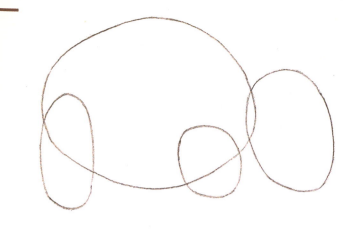
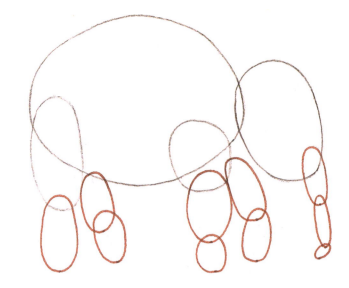
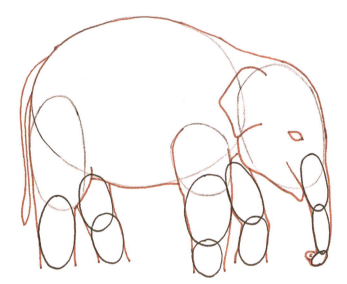
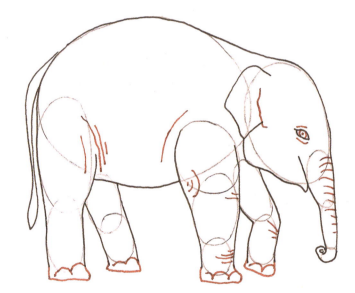
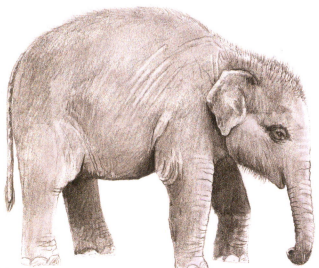
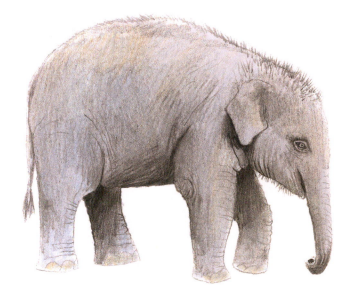

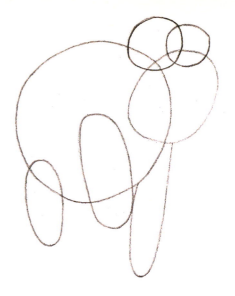
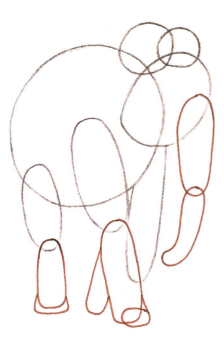
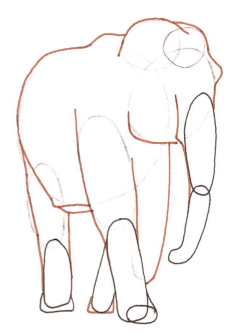
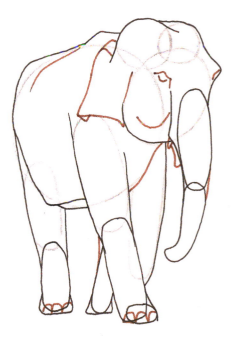
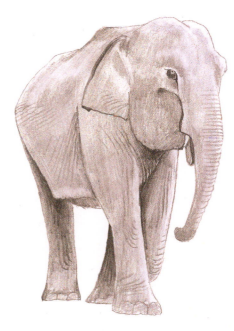
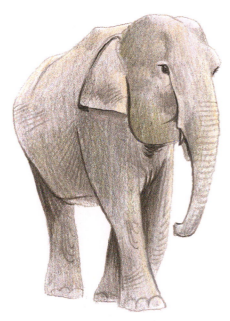

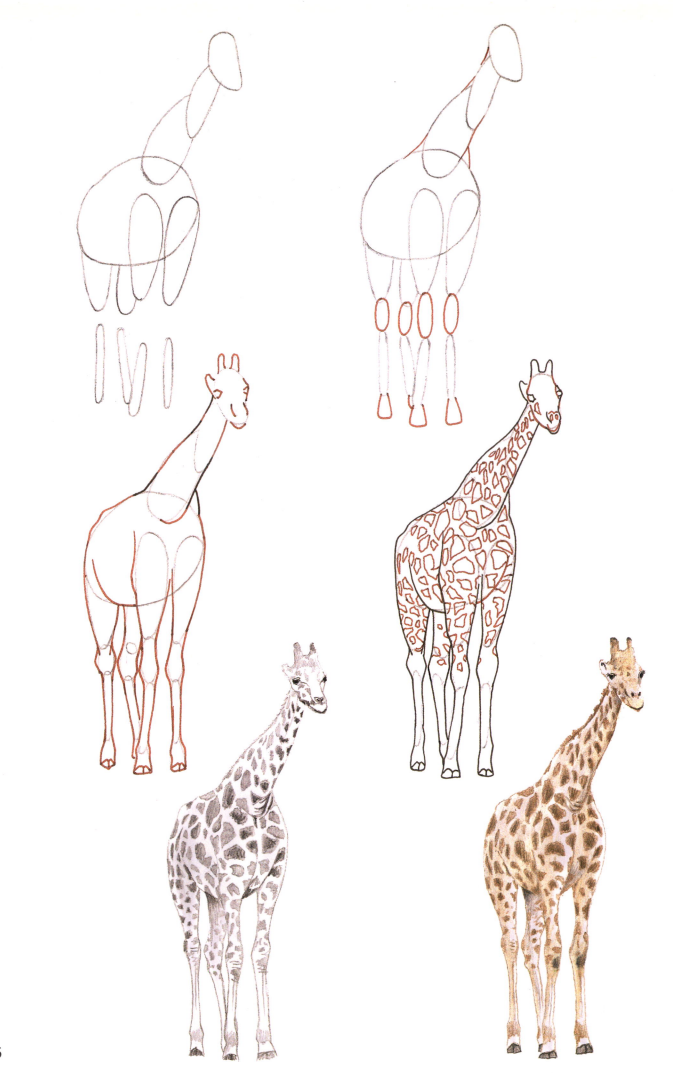

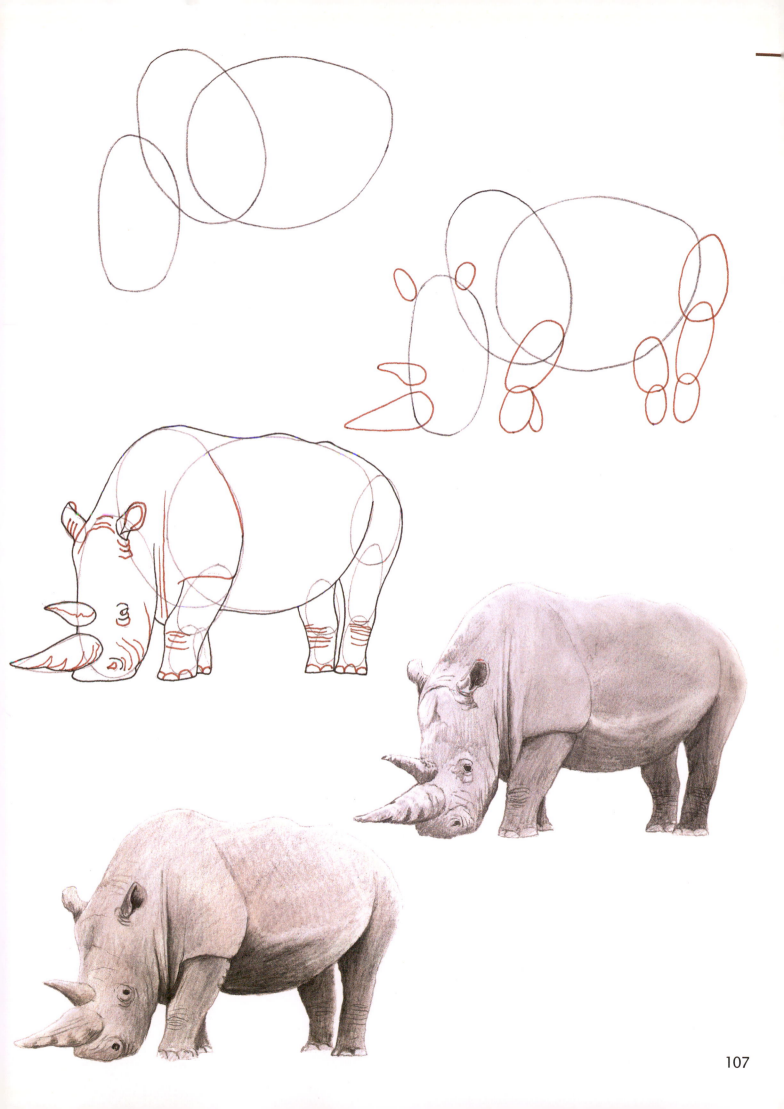

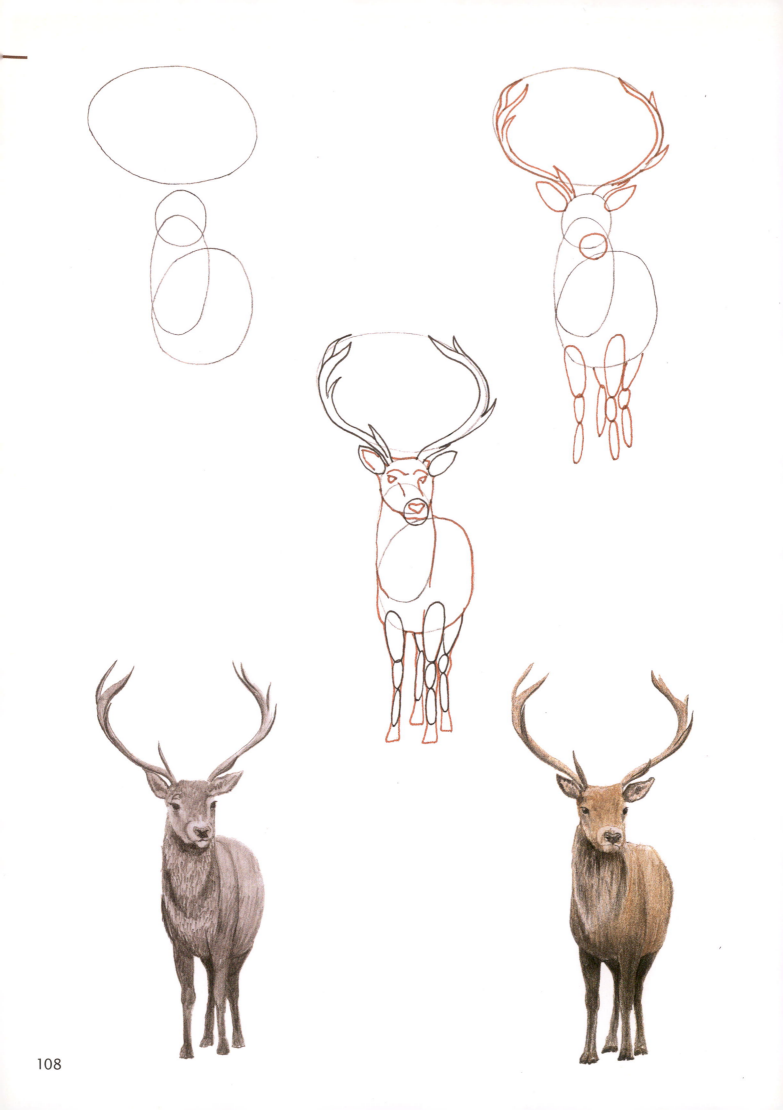

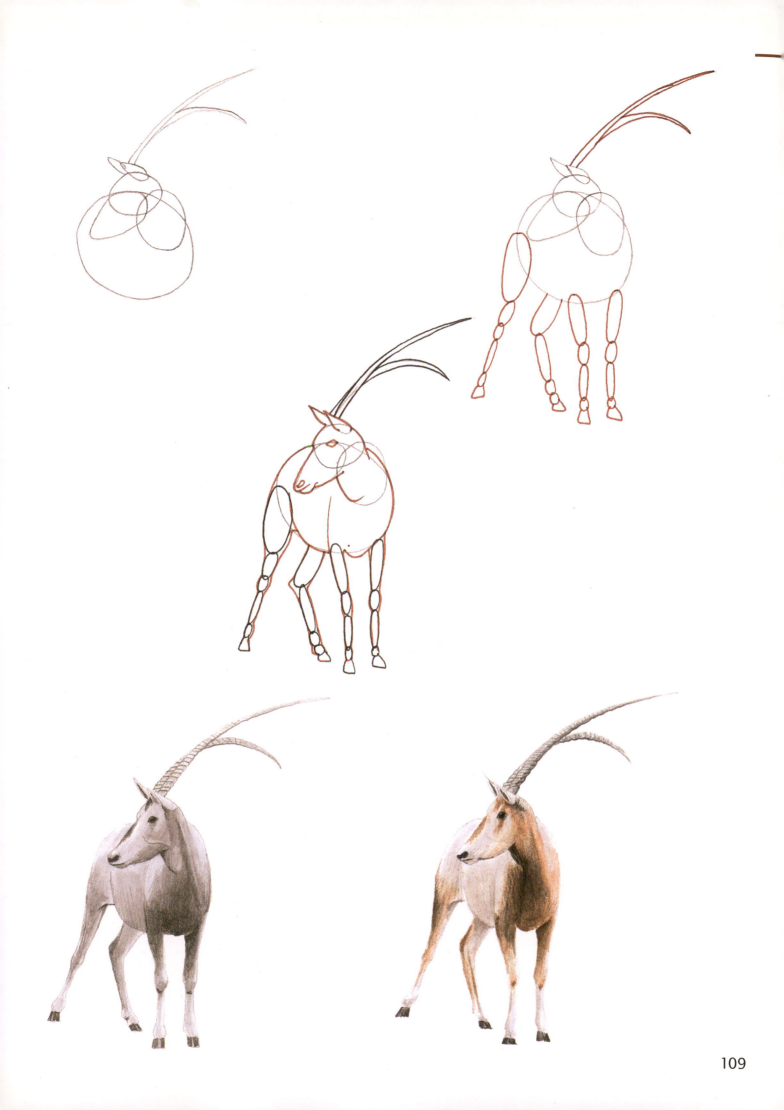

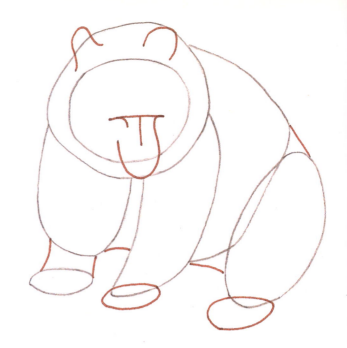

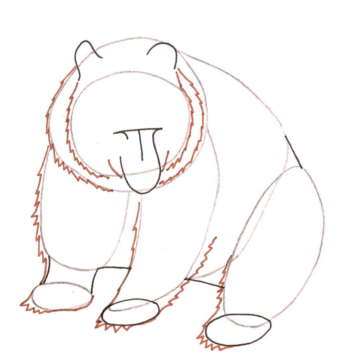

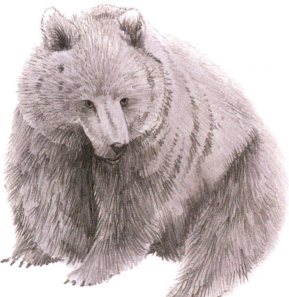

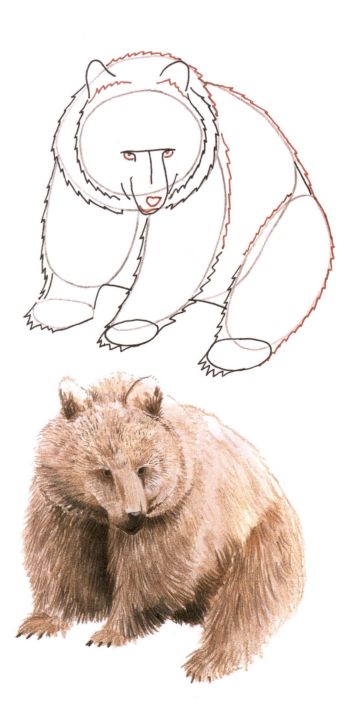

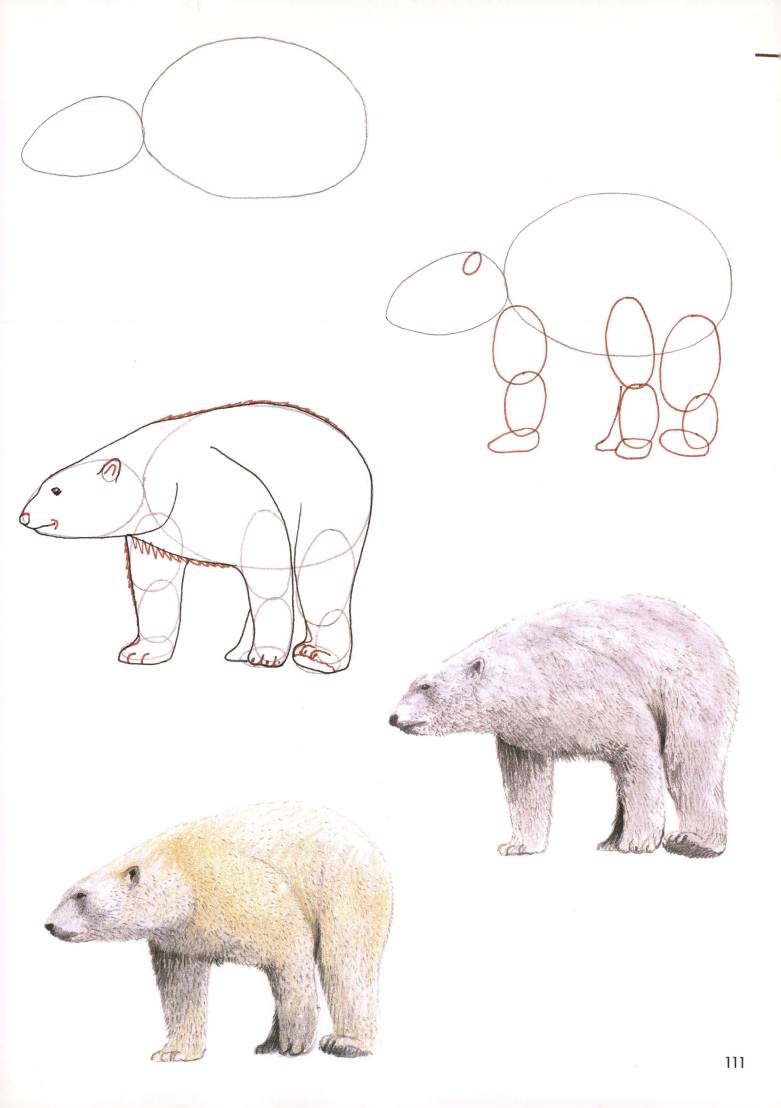

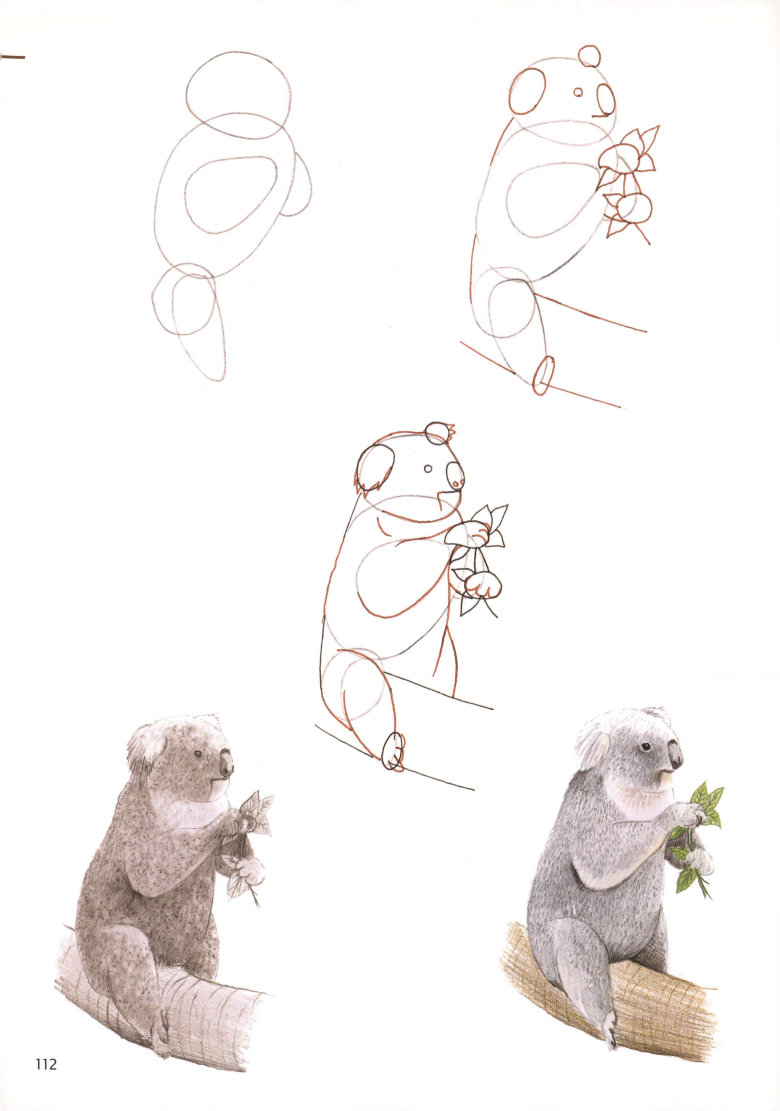

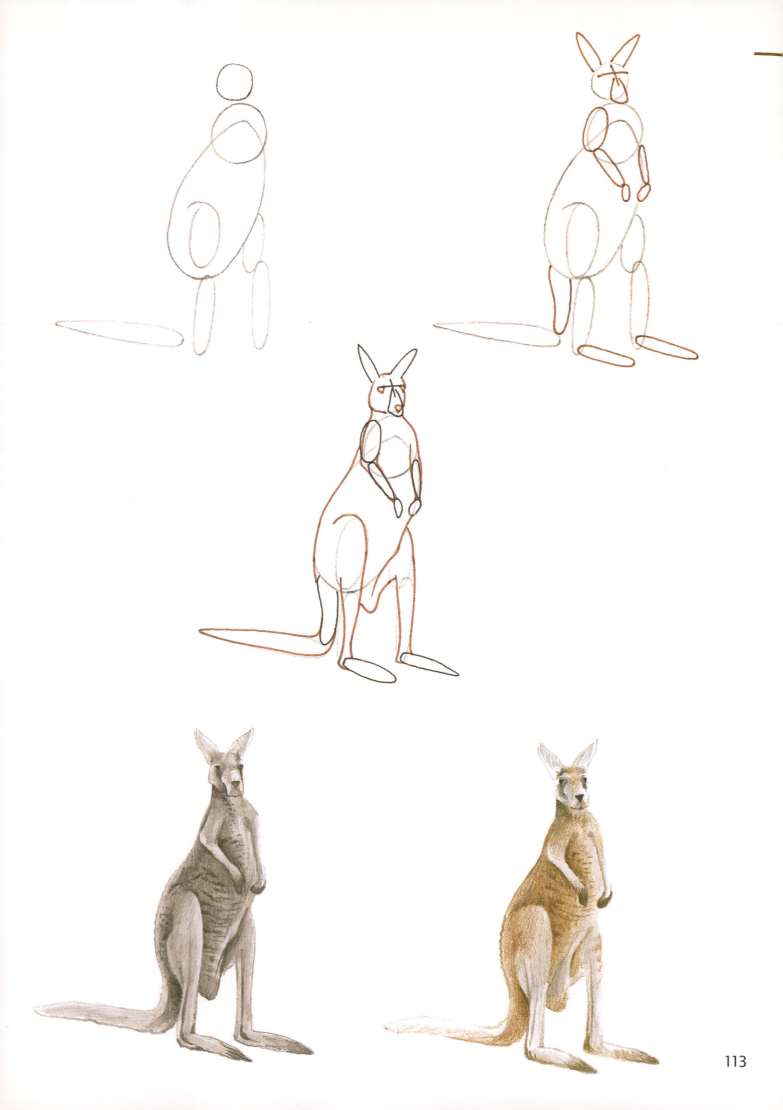

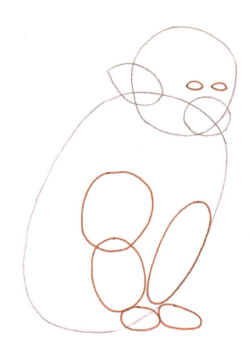

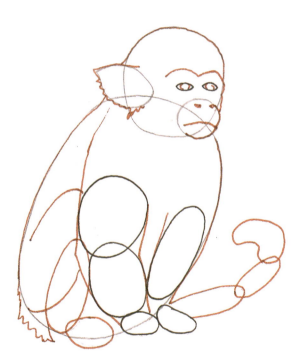

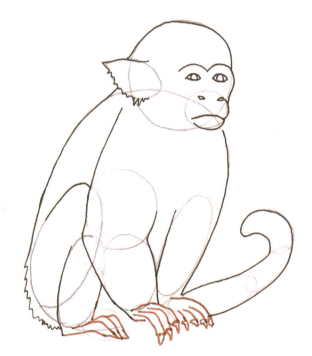

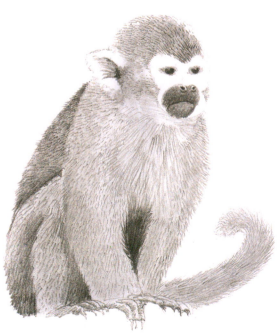

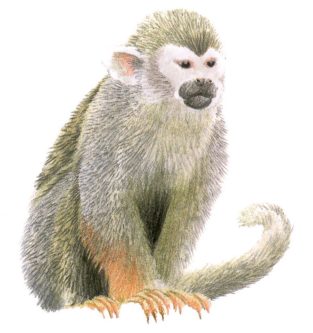

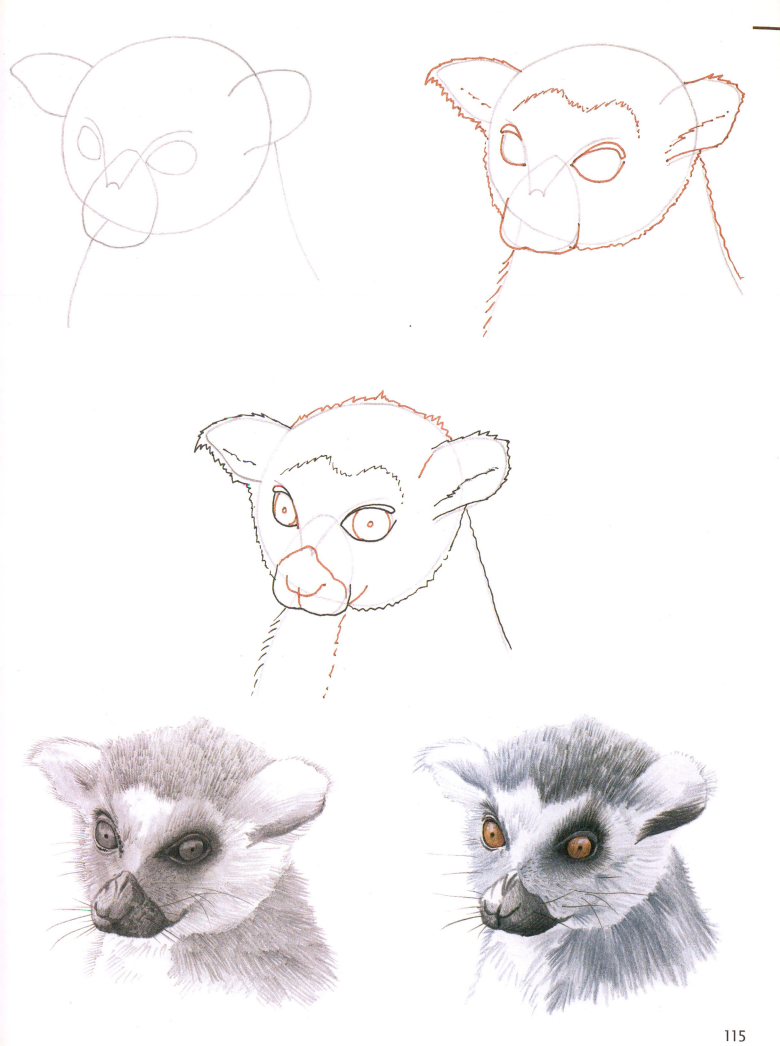

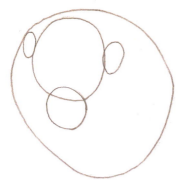
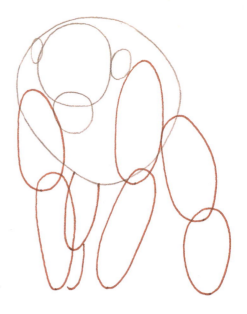
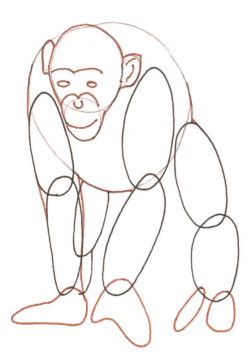
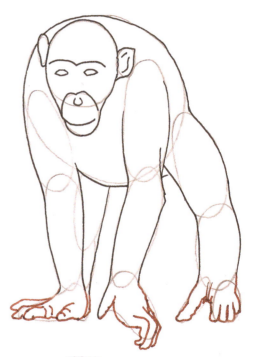
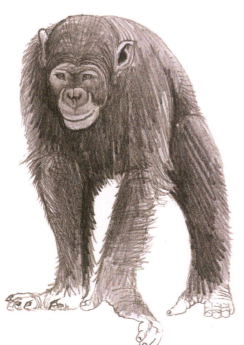
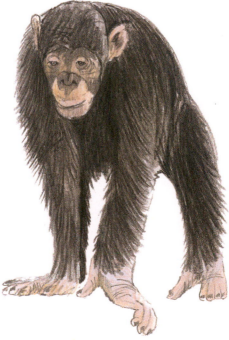

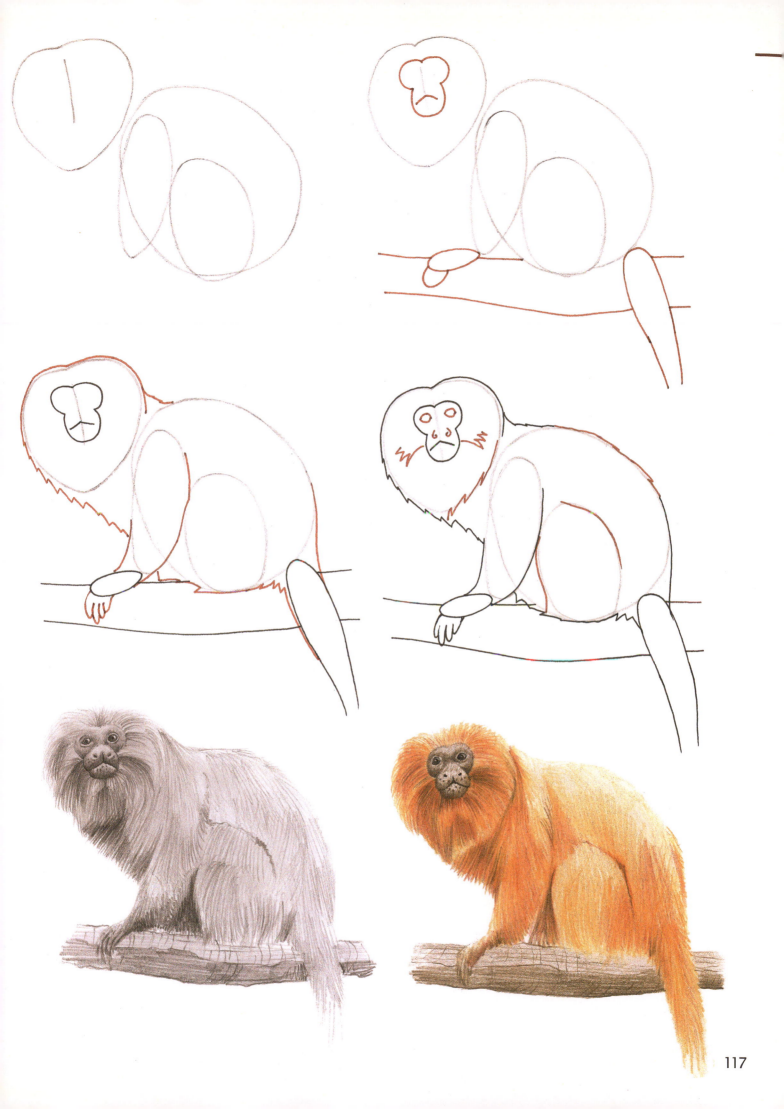

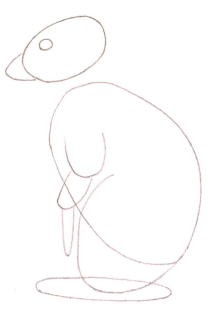
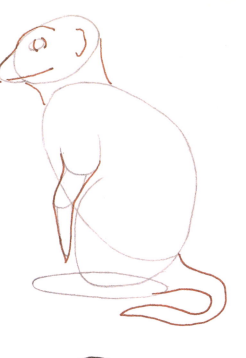
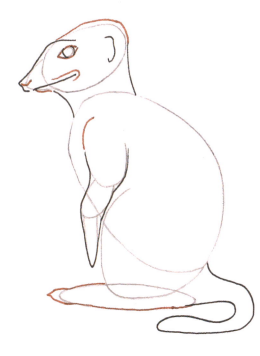
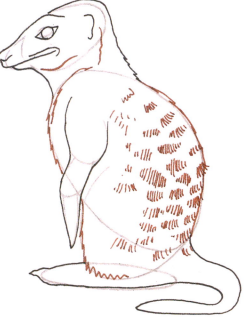
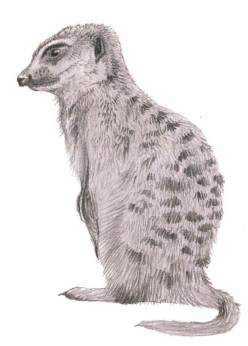
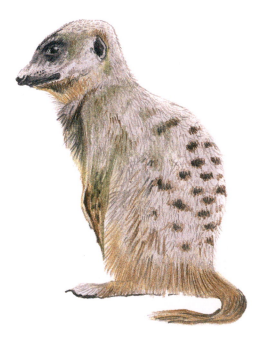

118

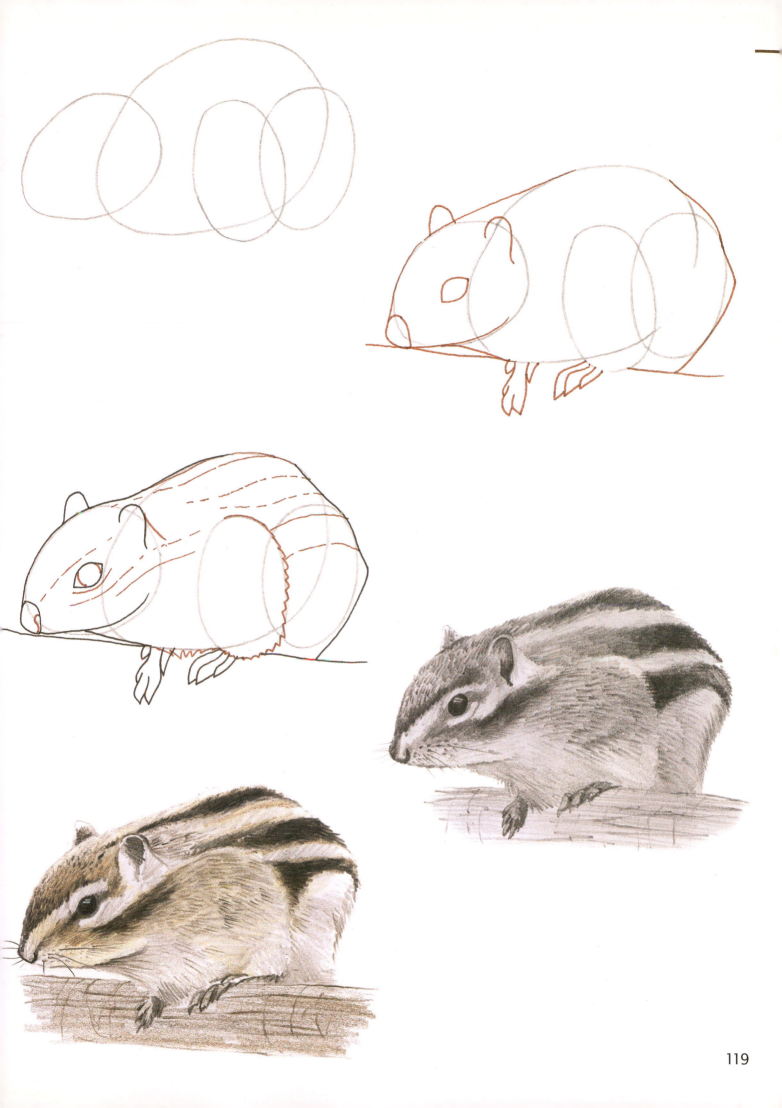

Birds

Birds are an intrinsic part of the natural world. Their habits are fascinating to observe, their calling songs range from exquisite to strangely endearing and the colour of their beautiful, diverse plumage is one of the wonders of the world. The following pages show how to draw a variety of birds using the same method as before in which simple shapes evolve, stage by stage, into the unmistakable form of specific birds. One of the advantages of drawing this way is that the angle of a bird's head and body is captured immediately during the first step, because you start off with basic, simple shapes rather than the complex image of the whole bird.

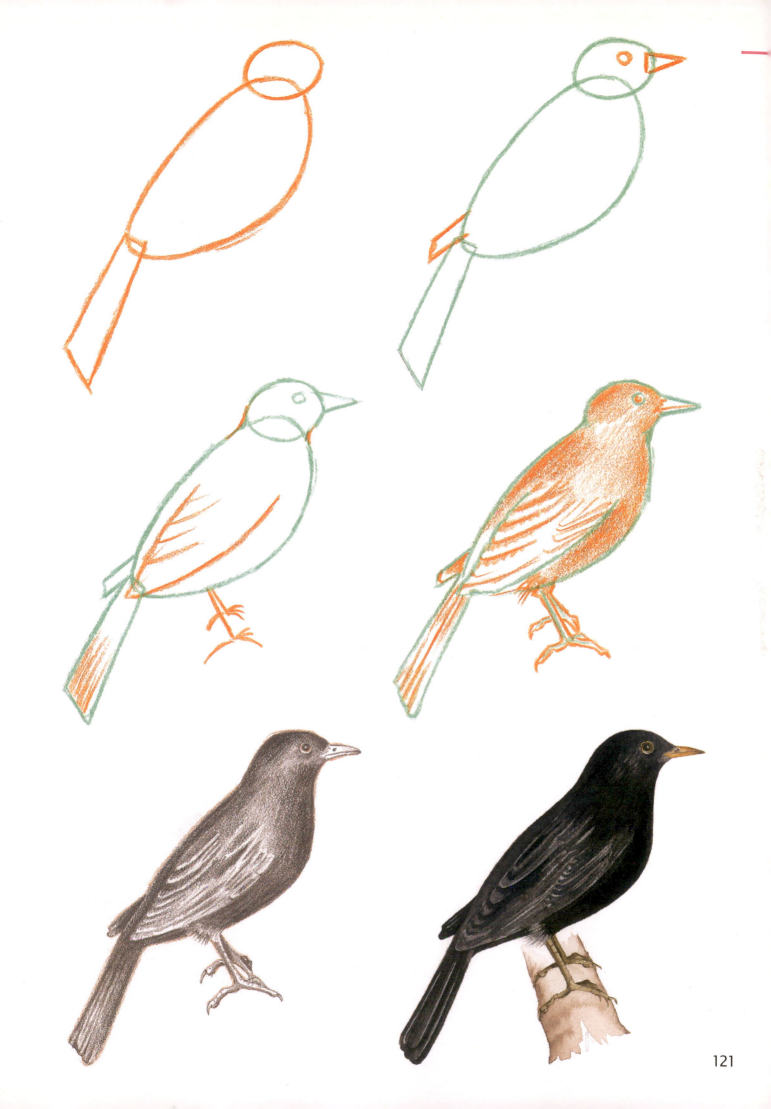

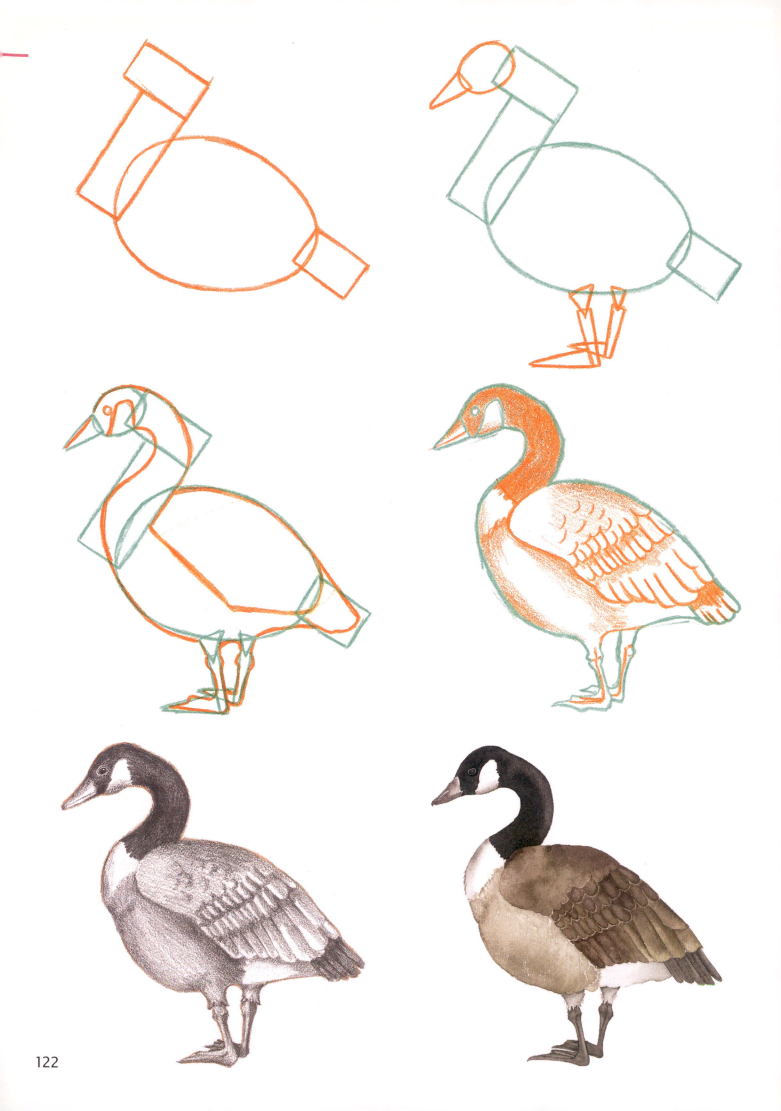

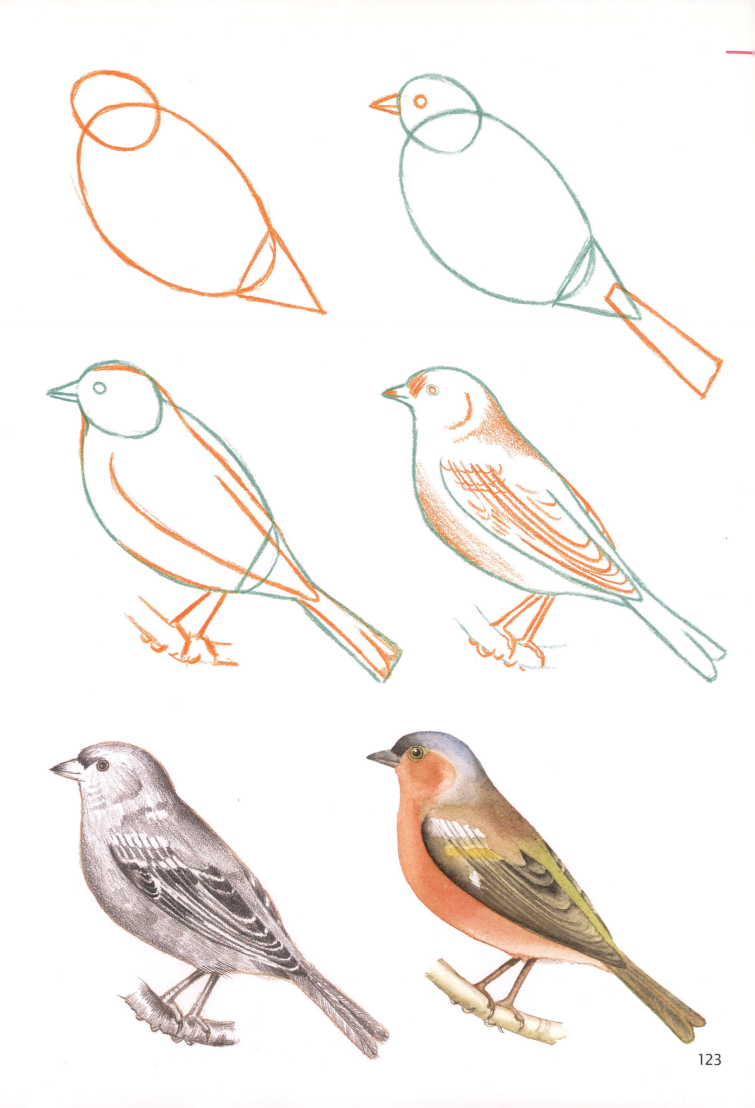

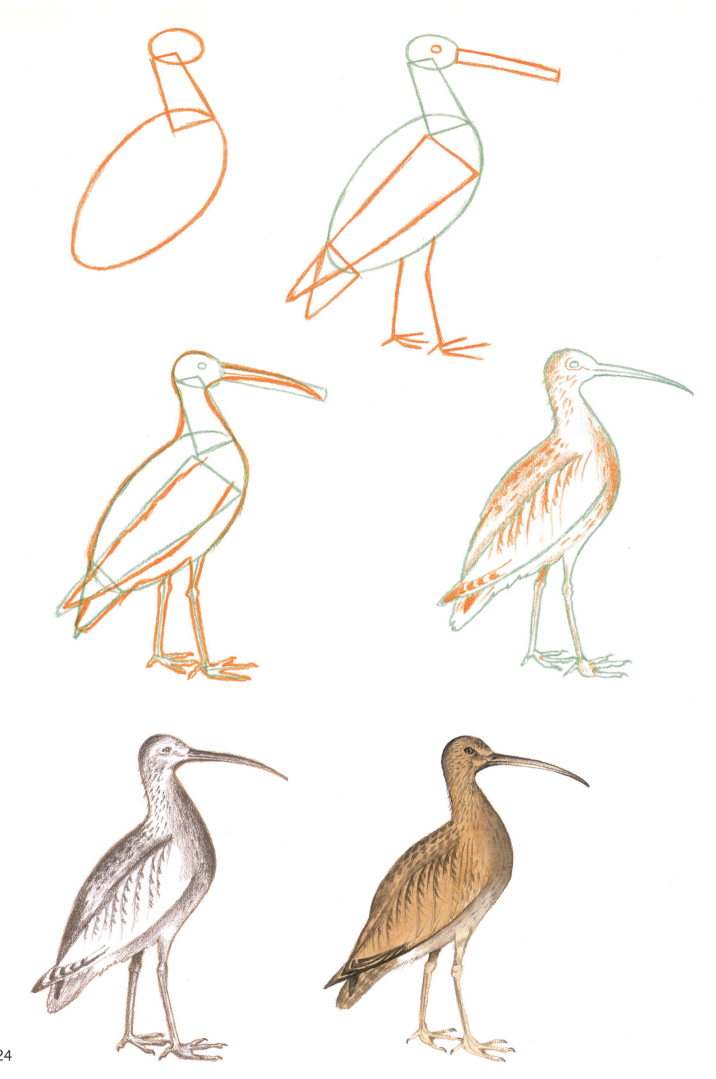

124

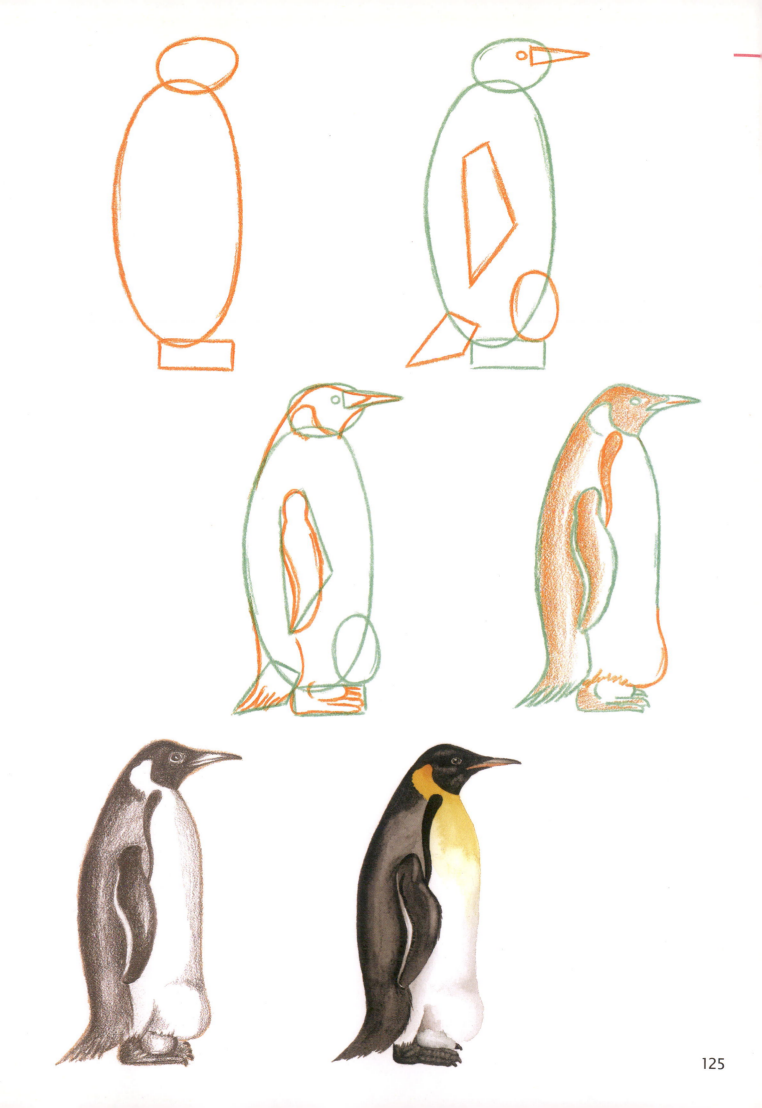

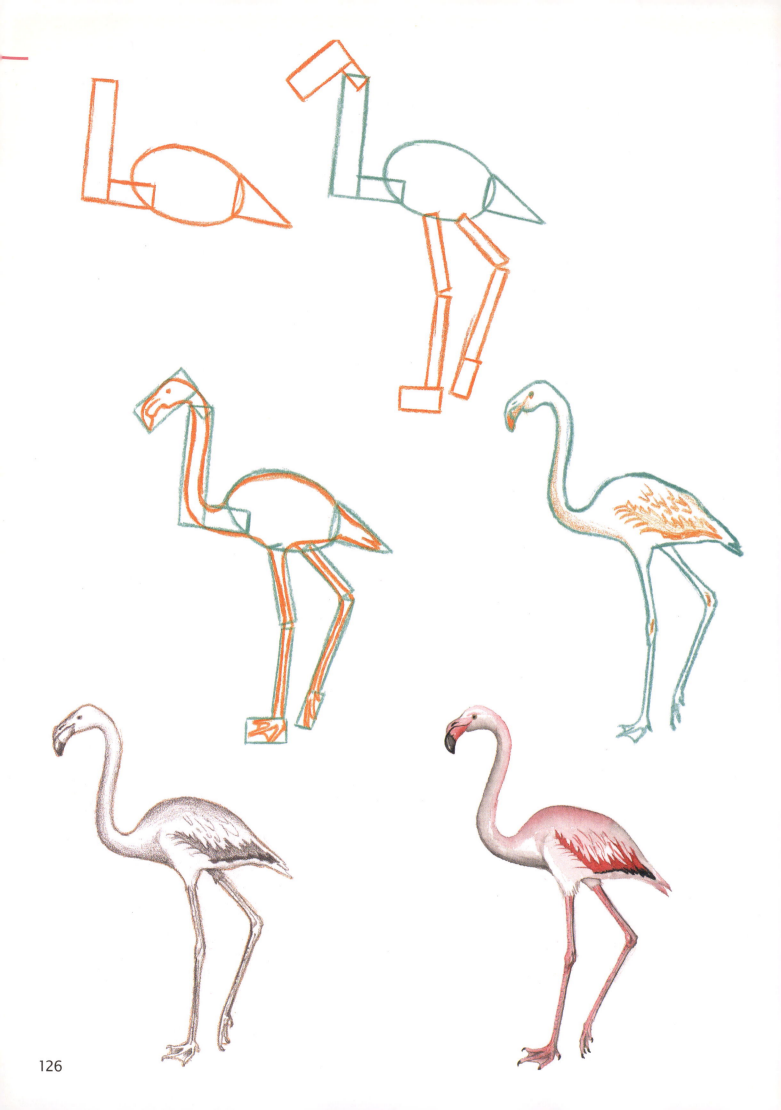

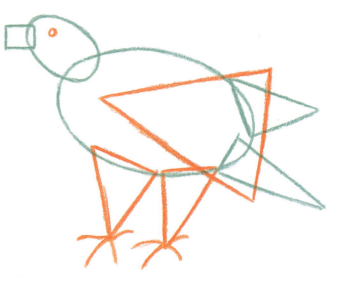

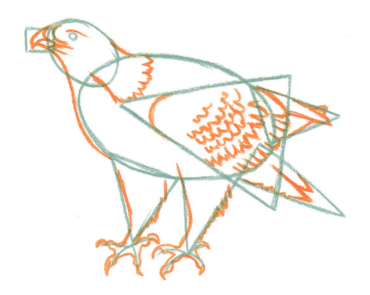

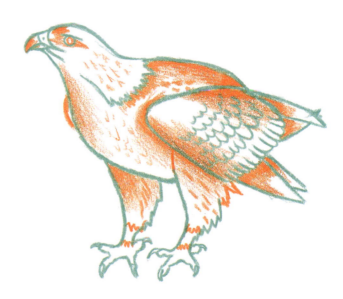

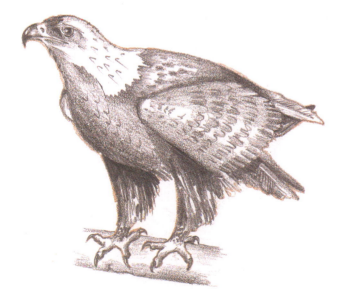

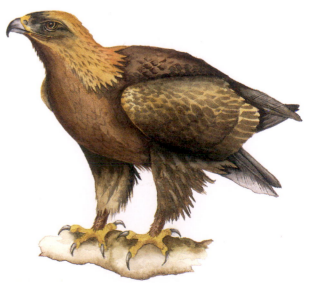

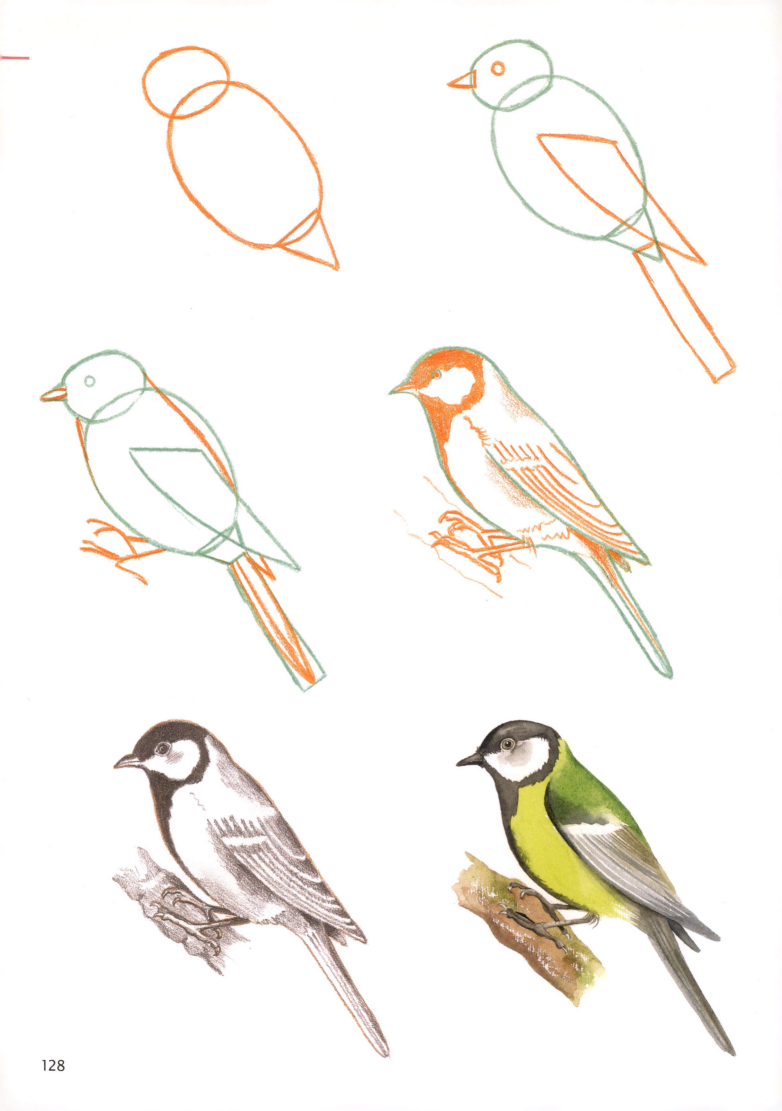

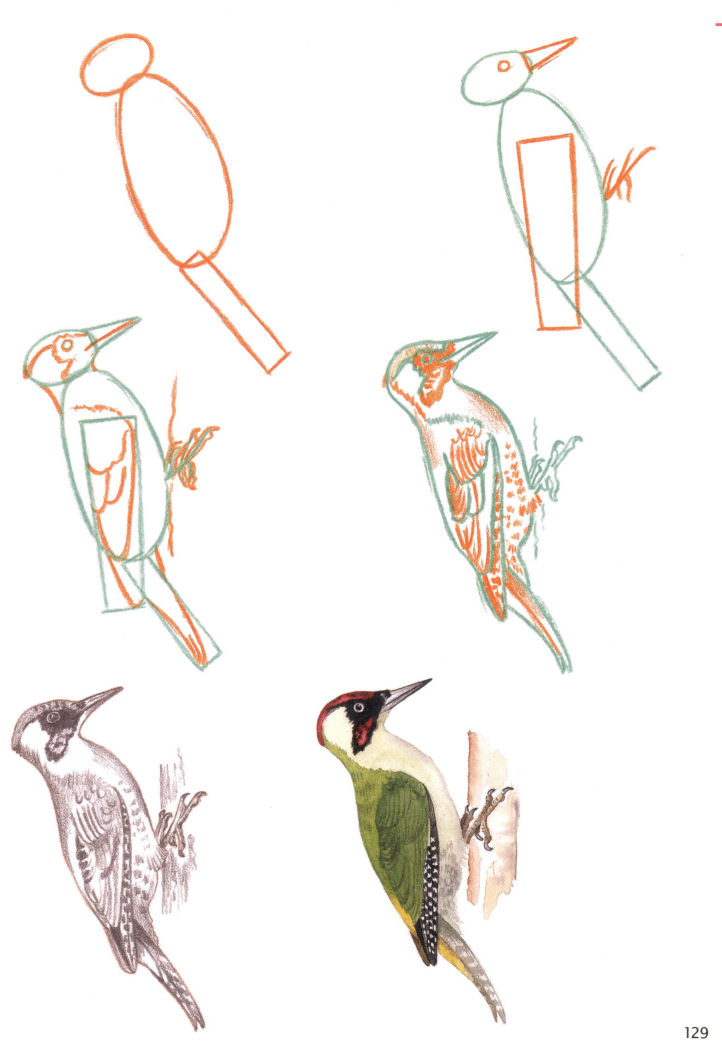

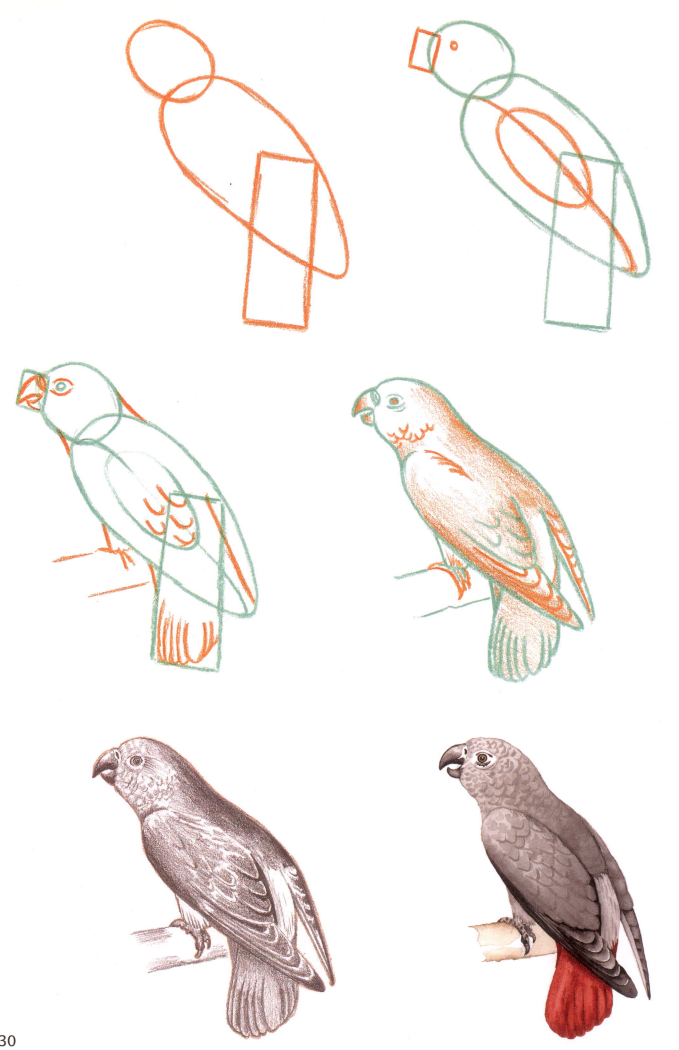

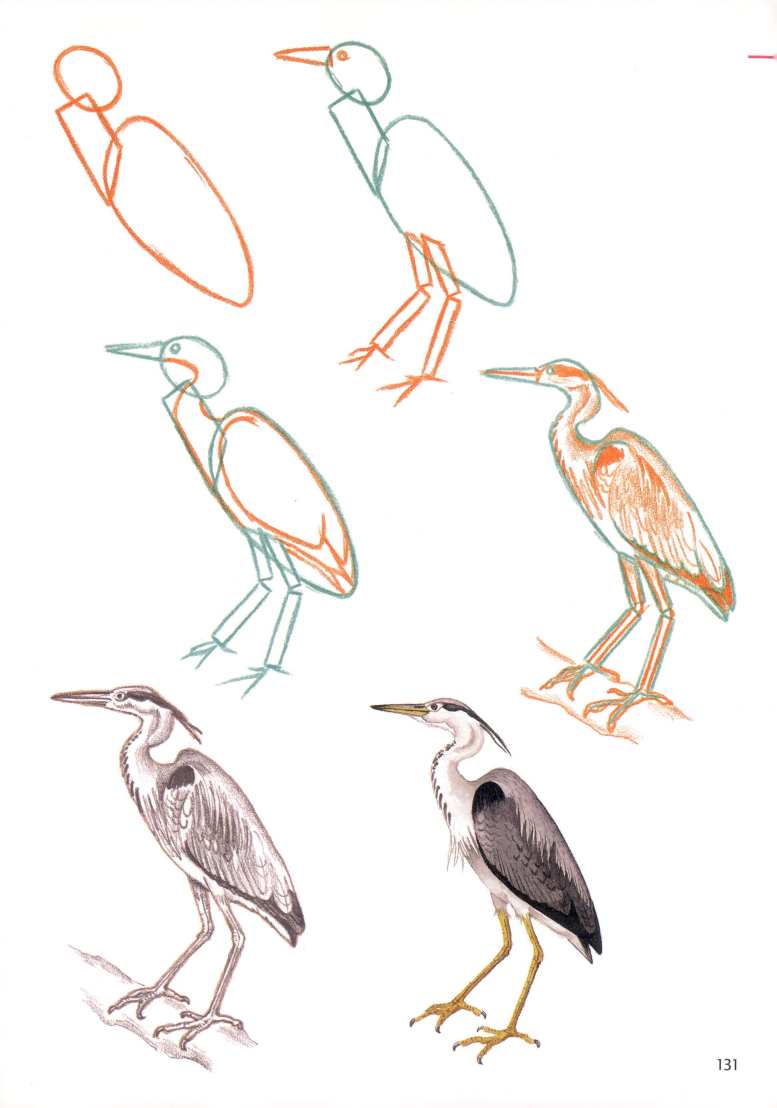

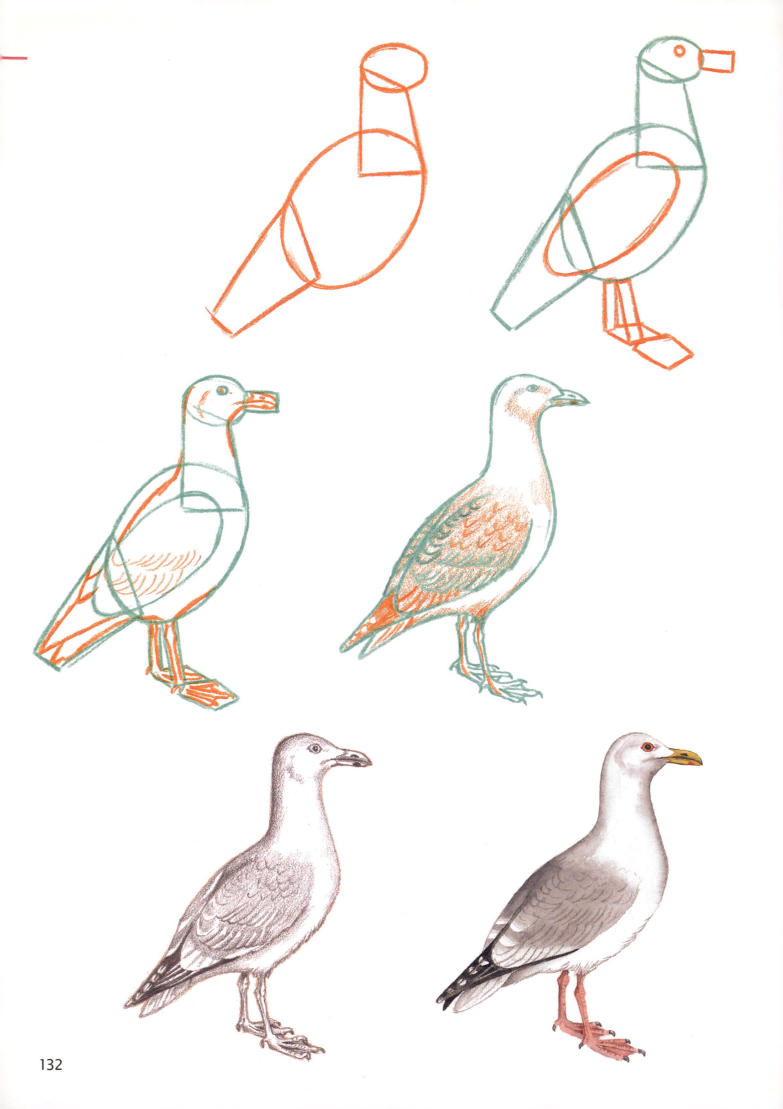

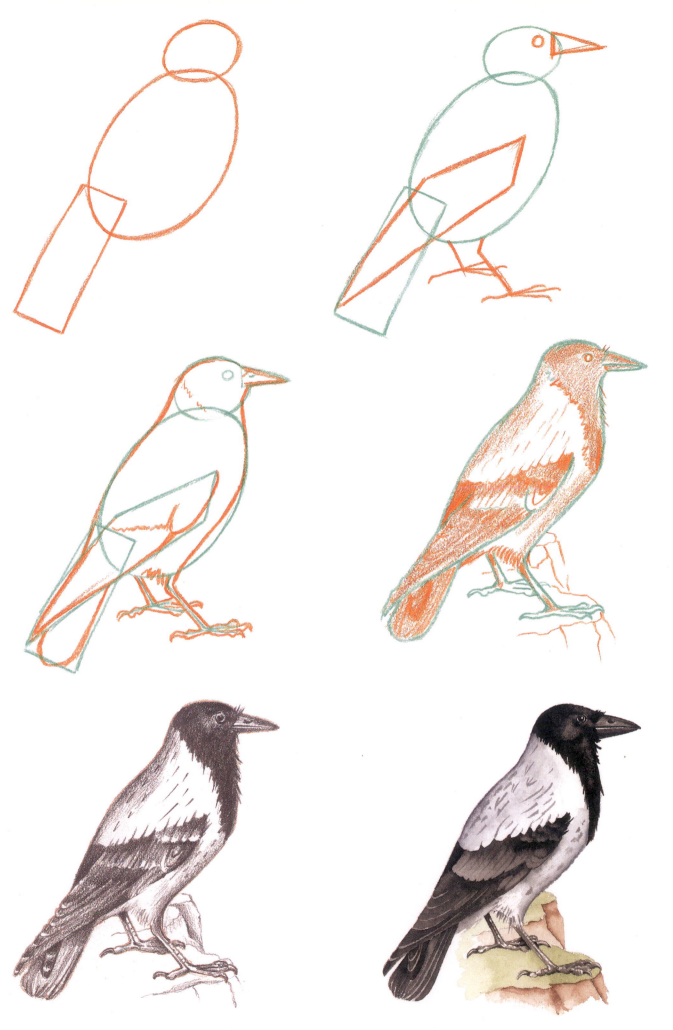

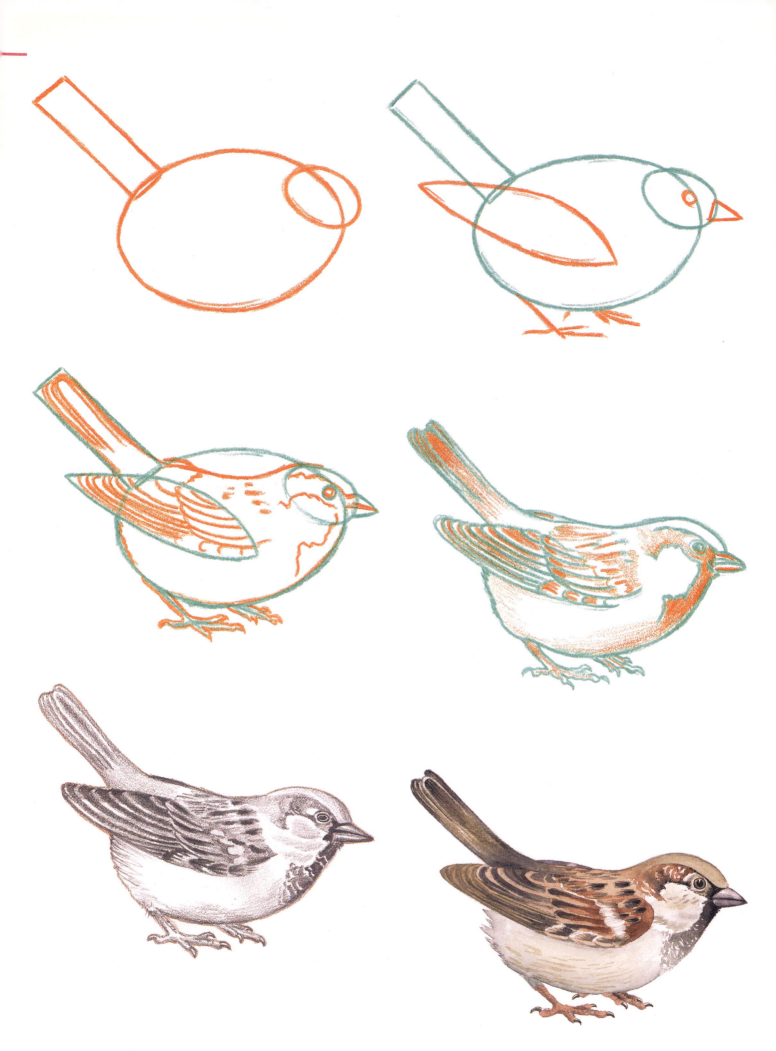

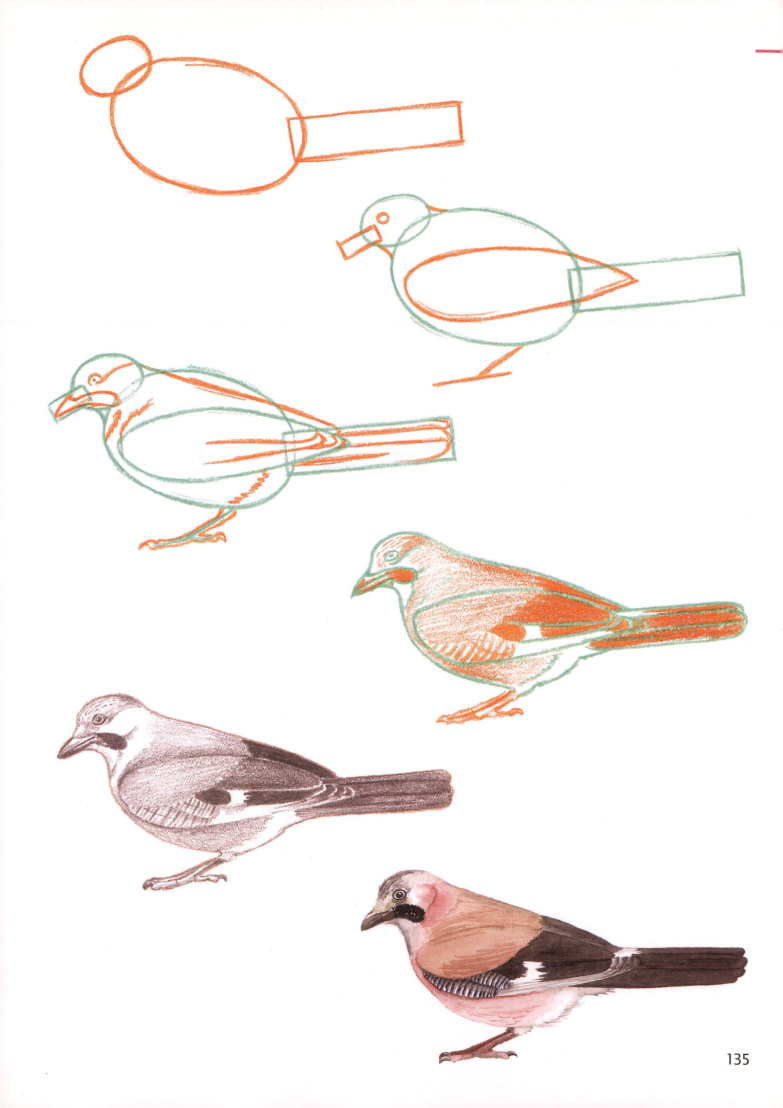

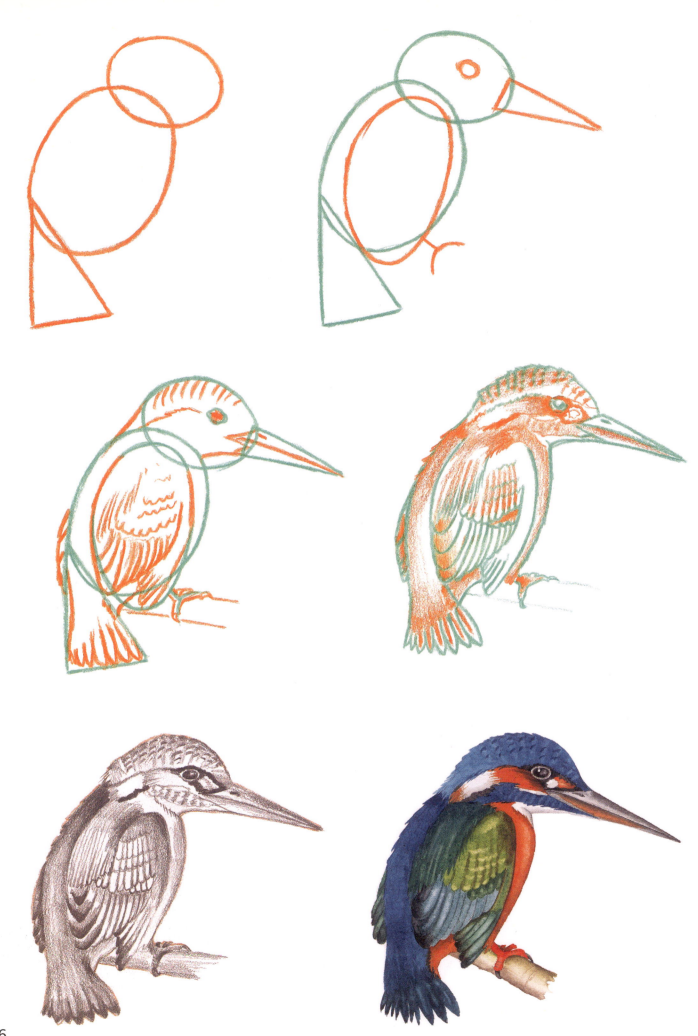

136

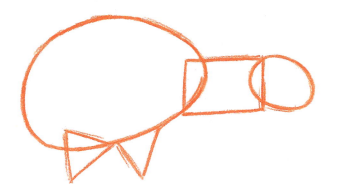
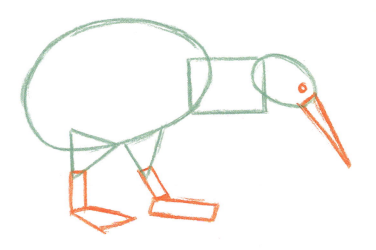
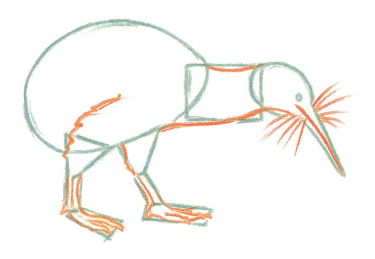
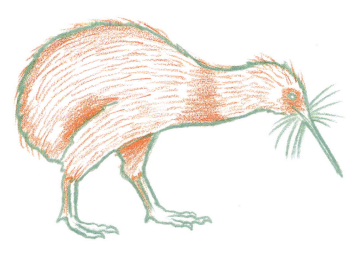
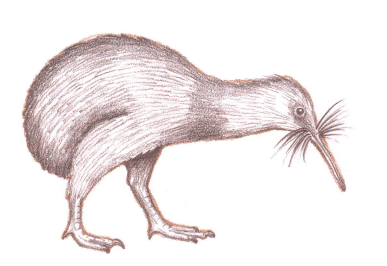
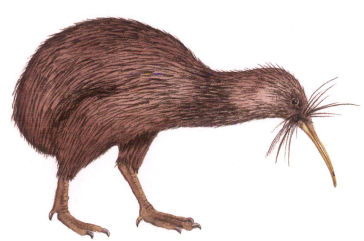

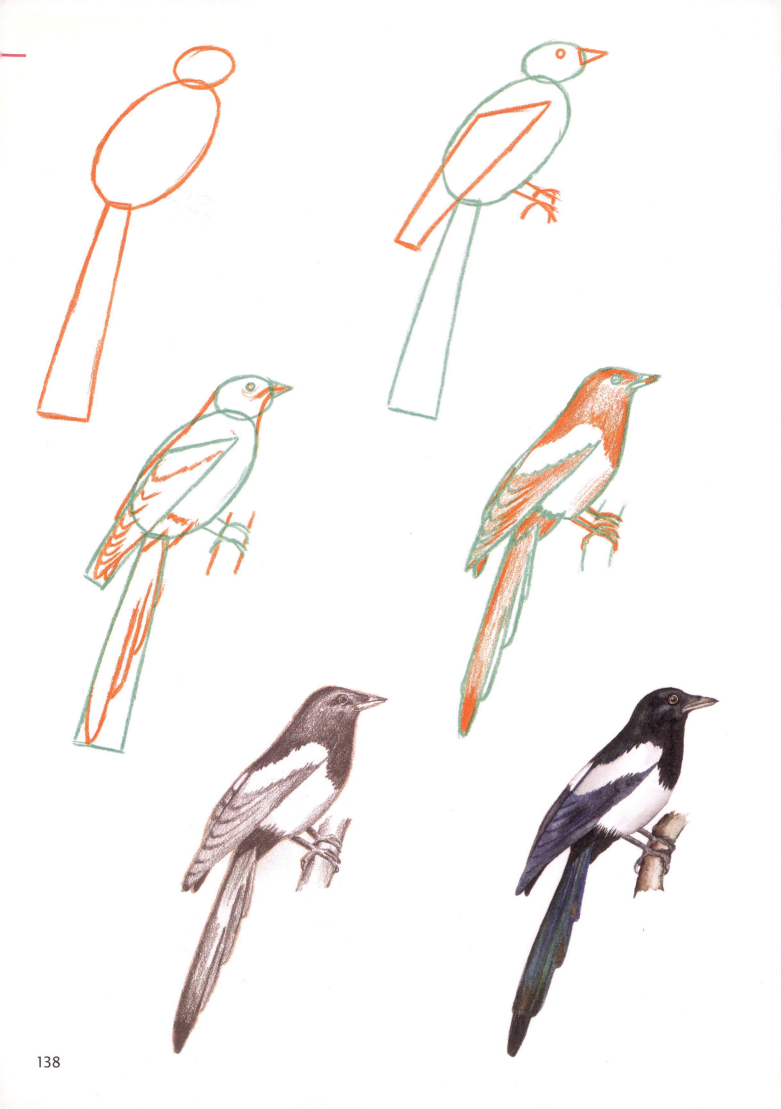

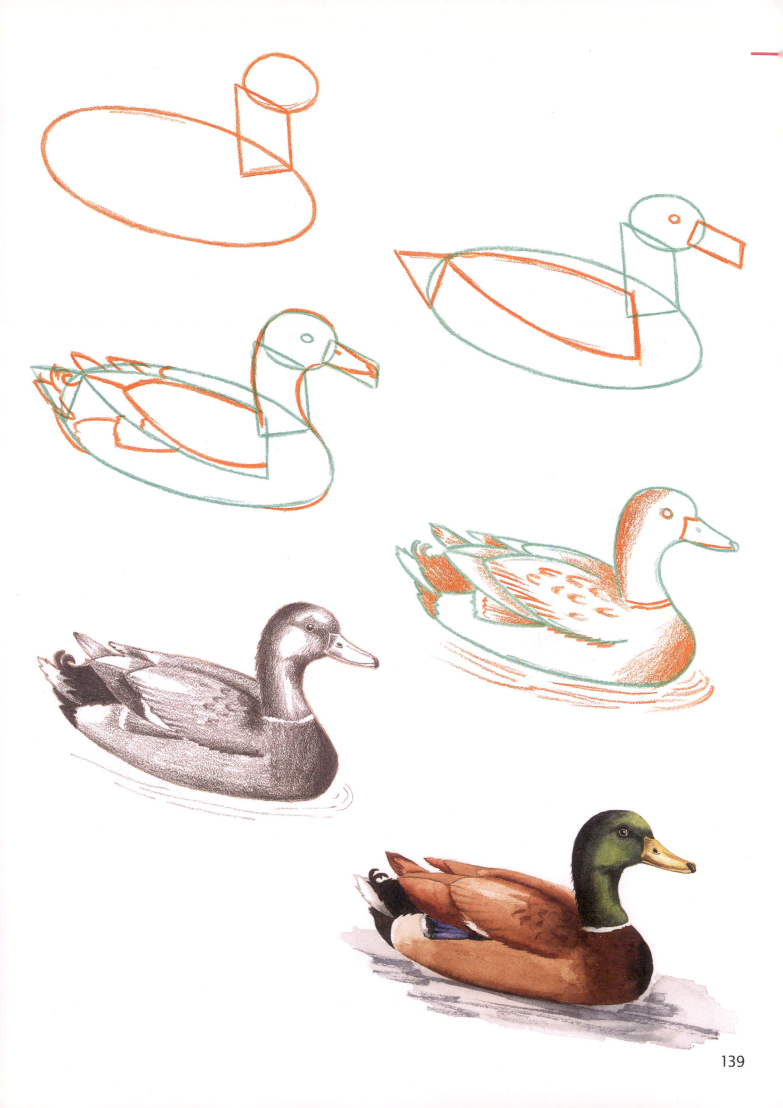

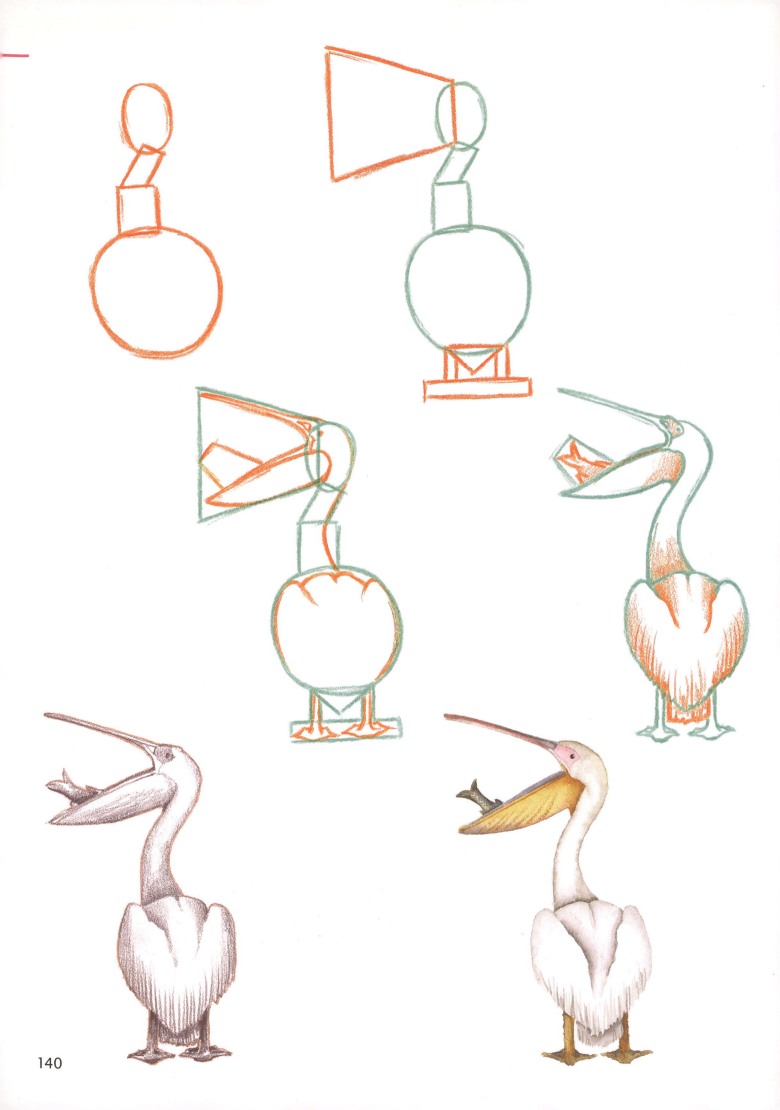

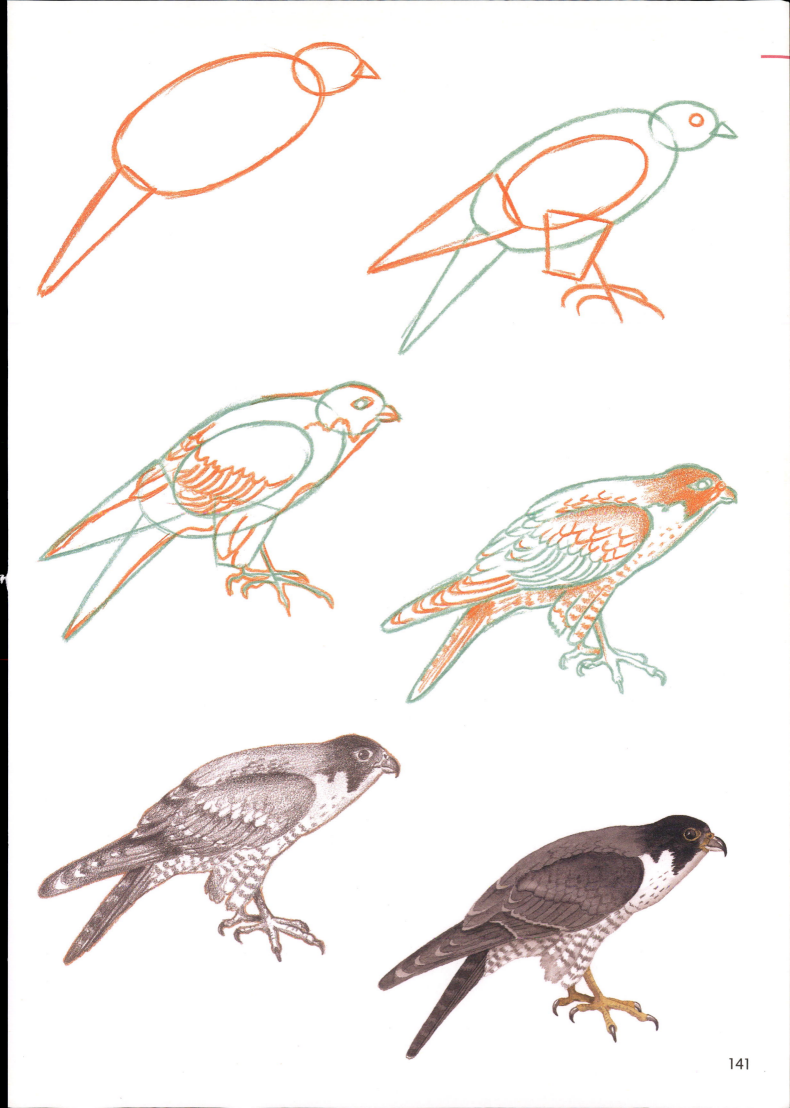

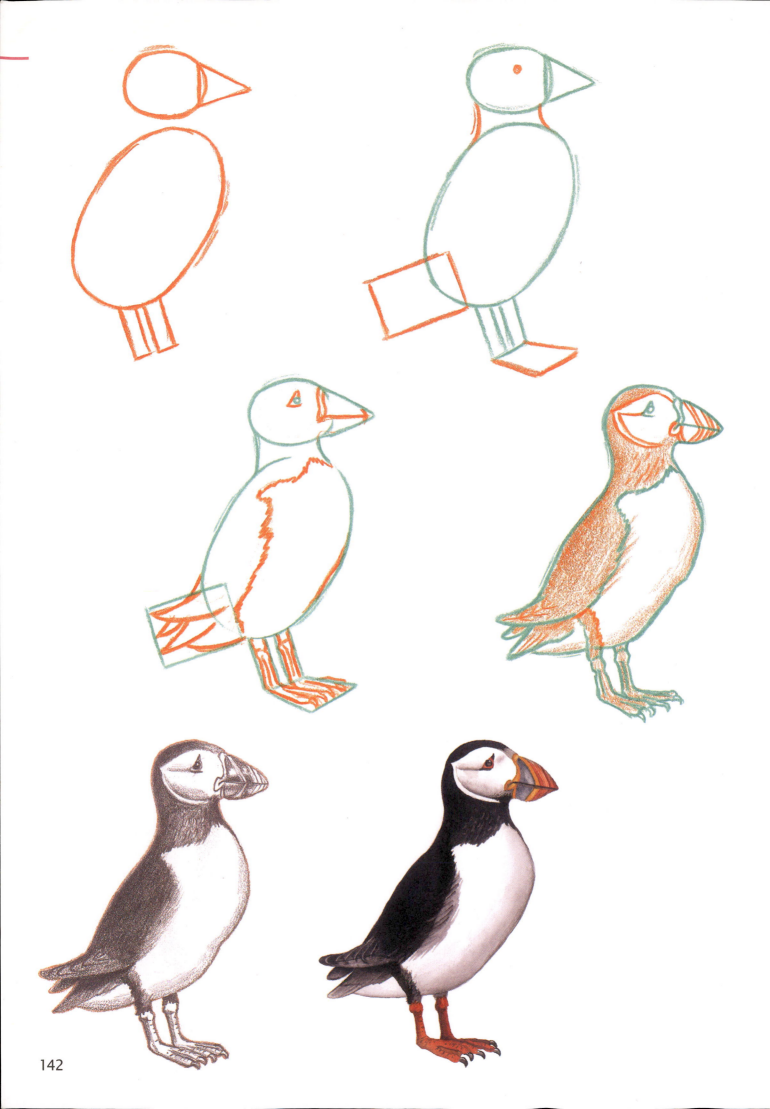

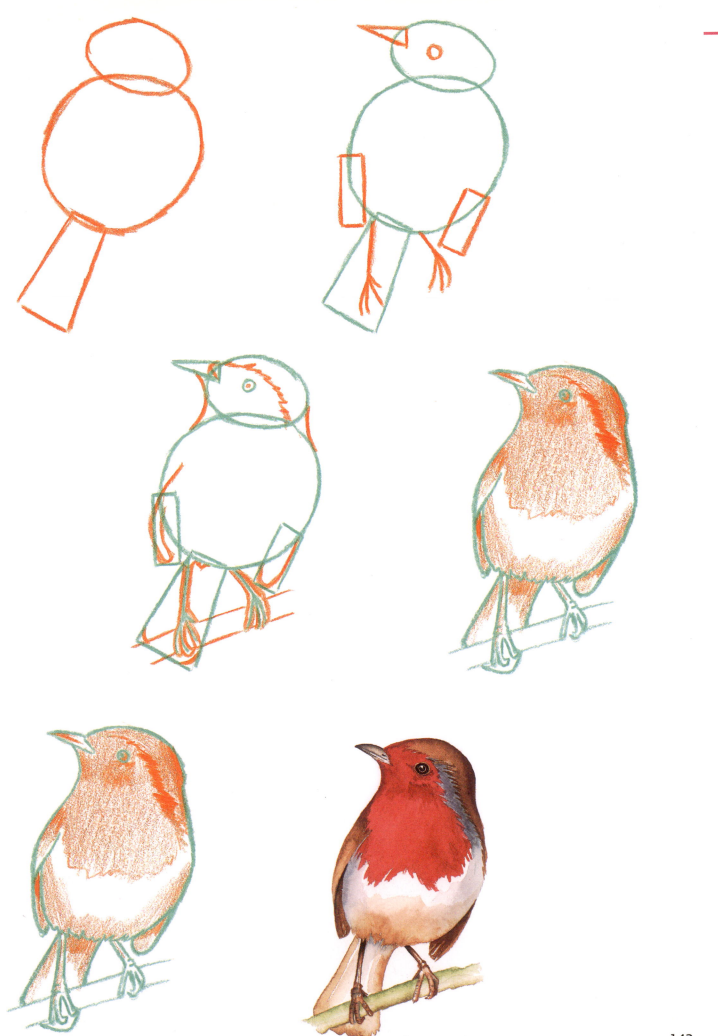

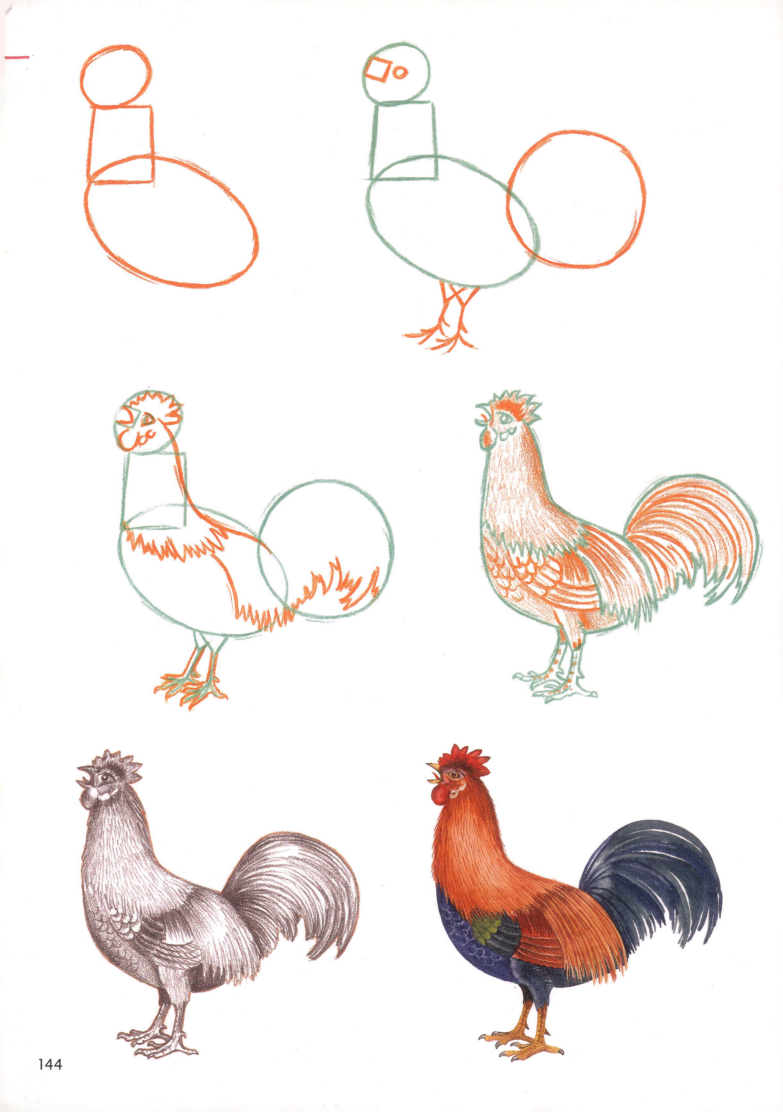

144